CW00767189

ALMOST
FORGOTTEN

ALMOST FORGOTTEN

THE SEARCH FOR AVIATION ACCIDENTS IN NORTHUMBERLAND

CHRIS R. DAVIES

AMBERLEY

Front Cover: Site of Vickers Wellington R1535 Dunmore Hill, Breamish Valley. (Courtesy Sarah Wilson)

Rear Cover: R1535 Memorial and Penny (Author); photograph of pilot climbing into cockpit – Sgt Håkon Langseth Myhre. (Courtesy Peter Warren)

First published 2012

Amberley Publishing
The Hill, Stroud,
Gloucestershire, GL5 4EP
www.amberleybooks.com

Copyright © Chris Davies, 2012

The right of Chris Davies to be identified as the Author
of this work has been asserted in accordance with the
Copyrights, Designs and Patents Act 1988.

All rights reserved. No part of this book may be reprinted
or reproduced or utilised in any form or by any electronic,
mechanical or other means, now known or hereafter invented, including
photocopying and recording, or in any information
storage or retrieval system, without the permission in writing
from the Publishers.

British Library Cataloguing in Publication Data.
A catalogue record for this book is available from the British Library.

ISBN 978 1 84868 0333 9

Typesetting and Origination by Amberley Publishing.
Printed in Great Britain.

CONTENTS

In memory of my most trusted, faithful,

devoted companion and friend

Penny

26 June 1995 – 28 December 2010

For all her life, Penny, as with most pets, was an integral part my family's life. She had accompanied my wife, Sue, and I on all our hikes through the Cheviot Hills. Penny had 'stormed' Cheviot on several occasions. She had climbed Snowdon aged eleven. At the age of fourteen, Penny had climbed Hedgehope Hill in snow-capped conditions. Ever the character and always relied upon to lend a listening ear without complaint or judgement, eager to please and entertain, she was one of the most formidable and trustworthy dogs I have had the privilege to call my companion. Losing Penny feels like a vacuum in our life which will never be replaced. She will be missed not only on the hills, but more importantly at home, by our sides. We will miss her greeting us as we open the front door because to Penny we were the most important people in the world and to us she was and always will be our best friend.

Penny, if there is a heaven, we know you are there watching over us.

Chris and Sue (Ma 'n' Pa)

FOREWORD

Chris Davies' book chronicles his quest to find the sites of aircraft crashes in Northumberland and provides ample evidence of his dedication and passion in pursuit of his interest. It is a remarkable story of determination, application and refusal ever to be deflected from his purpose, no matter the obstacles put in his path. For me, it is doubly of interest, given that it describes an area in which I have lived for nearly forty years and involves many of my friends and neighbours who have found themselves swept up in the Davies project. Many of these, most notably Basil Oliver, have made a great contribution to Chris' researches. Equally, the Davies' dogs have set a splendid example of enthusiasm to the other members of his household!

Each of this book's chapters offers an account of Chris Davies' painstaking research, and of his doggedness in keeping going in all weathers, and reminds the reader of the great human cost of conflict and of training for war. By today's standards, those who crewed the relatively primitive aircraft of the 1940s faced extremes of weather, hampered by the rudimentary nature of control systems, by limited navigational aids and by their own inexperience. The number of fatal accidents recorded here offers a snapshot of the losses sustained through non-operational accidents and of the hazards facing these gallant young men. We are reminded that many died far from their own countries in the battle for freedom that the Second World War undoubtedly was. Those who perished in the Cold War accidents described here are equally worthy of his respect, for they, too, played a part in keeping the peace. The author has dedicated himself to preserving the memory of all who perished and this book will allow others to share his feelings.

There are many reasons to admire Chris Davies, for his tenacity and determination, for his exhaustive research and for his powers of persuasion. He has provided a major piece in the jigsaw of aviation history in Northumberland and is to be congratulated on his achievement and on his forensic skills which allowed him to track down and explain so many tragic accidents.

Air Vice-Marshal A. F. C. Hunter CBE AFC DL

1939 1945

IN PROUD AND GRATEFUL MEMORY
OF THOSE OF ALL NATIONS
WHO LAID DOWN THEIR LIVES
IN THE CAUSE OF
FREEDOM WHILST SERVING AT
R.A.F. ACKLINGTON DURING
THE SECOND WORLD WAR

WE WILL REMEMBER THEM.

Air Vice-Marshal A. F. C. Hunter.

INTRODUCTION

This book was born from my lifelong interest in the history of the north-east of England and the people who have lived and worked here. I have been privileged to have been able to combine my love of the Northumbrian hills and countryside with my connections with the former Royal Air Force Station at Acklington to research the information I have recorded here. I hope you enjoy reading it as much as I enjoyed writing and researching it.

Born in the shire of Bedlington, Northumberland, my interest in local history was probably ignited by my father (South Wales Borderers Regiment) preparing for demob from war service at the Plessey barracks, near Hartford Hall, Bedlington. My grandfather (on my mother's side) was the Regimental Quartermaster Sergeant-Major for the 7th Battalion Northumberland Fusiliers. Listening to my parents' recollections held me captivated as a child. Like many other people, it was not until after both my parents had passed away that I began to research my family's military experiences and became aware of the need to record some of our important recent history which is destined to be lost with our most recent ancestors.

I spent my teenage years on a farm at Plawsworth, County Durham. Even at this young age I was interested in the history of the farm. It had been a monk's refuge with a long and fascinating history. Throughout adulthood I have always been drawn back to the outdoors, firstly as a golfer and a fisherman and then as a keen hillwalker.

In 1996, I was introduced to white-water kayaking and hill walking at Plas y Brennin Welsh National Mountain Centre. I became quite accomplished at the kayaking, becoming a white-water instructor for fourteen years. The hill walking was for my own personal pleasure, enjoyed in the company of my wife Sue and our faithful pooch Penny. Penny was to become my air crash hunting assistant, but this adventure would not start until 2005.

One of my dislikes while hill walking is to follow crowds; I enjoy the peace and solitude of the Cheviots, one of Britain's least publicised national parks. After five years of walking the Cheviots in all weathers, I was beginning to run out of trig points to target. I purchased a local book which recorded aircraft crash sites in Northumberland and noticed there were a few sites on the Cheviot massif itself. This gave me new areas to walk, some much further off the beaten

track, but offering welcome new challenges. I set out to locate them. I started to look for the larger sites which were the easiest to find. However, I noticed that not all the sites had the correct locations recorded, which meant I had to create a search pattern once I was in the estimated crash site area. This proved to be satisfyingly successful.

Having no technical knowledge of aircraft, it had never occurred to find out what had caused the crashes or whether the crews had survived, until I spoke with my colleague Dave Dunn. Dave questioned me about the crew of one of the sites I had located and I was a little embarrassed to be unable to provide any information. I said I would get back to him with what I could find out, which I did, and a whole new adventure began! Dave also passed stories on to me to me from his father, which I have included in this book.

I discovered that not only did I have a knack for locating sites, but also for discovering the social history surrounding the crashes. I interviewed so many interesting people with so much information stored away in their memories that I knew I needed to record what they told me. These stories were as fascinating as the official documents of each air crash.

I have visited over one hundred and forty crash sites, and I believe have been the first to identify the exact location of nearly fifty. Some of the pictures in this book show me smiling; this is not me being macabre, but shows my pleasure in finally locating the fragmented remains of an aircraft after many hours of searching. At each site where there was loss of life I place a Poppy Cross as a small token reminder of what happened there.

At the time of writing, all depictions of the events I have researched are as I have seen them. There are many discrepancies between many of the official documents I have read. Some sources produce a fantastic insight into an accident, but then the same source misses out vital information on another accident. I have made my decisions based on what I believe to be the true account of each event, using weighted evidence.

There are so many people I would like to thank who have supported me during my research: Sarah Wilson, Basil Oliver, Ronnie Oliver, Dave Dunn, Mairi Campbell, John Hardy, Revd Wendy Aired, Jim and Dave Rutherford, Air Vice-Marshal Sandy Hunter, Dennis Gray, Joan Rose, Mike Hatch, Mary Jane Millare-Aldolfo, Edgar Brooks, Frances Gates, Sue Davies, Daisy, air-crash-hunting poodle under training, and Penny my trusted and faithful pooch.

I have interviewed and or have been assisted by over one hundred people; all are mentioned in the reference section at the end of each chapter.

At this point I must advise readers who intend to visit these sites:

- Follow the Country Code
- Wear the right clothing; some of these sites are a long way off the beaten track
- For sites not within the Northumberland National Park, seek the landowner's permission for access
- Do not remove any artefacts from any of the sites; they are the property of the Ministry of Defence (MOD)
- Take time to think of what actually happened at the site and spare a thought for those who lost their lives

PIPER ARCHER N9503C G-BHDG

Piper Archer PA-28-181 N9503C G-BHDG
Edinburgh Airport

Little Hedgehope
Hedgehope Hill
13 February 1979

In early April 2008, I had been asked by Jim Corbett of the Air Crash Investigation and Archaeology group (ACIA) if I would like to help with escorting a Peter Hart back to the site of his crash on Hedgehope Hill in 1979. Jim was completing stories for his section of a book being published along with ACIA members Russ Gray, Jonathon Shipley and Neil Anderson. Being a keen hiker, it would provide an opportunity to get a good day's walking in and have an interesting destination over open country rather than dedicated tracks.

It was here that I was first introduced to Sarah Wilson, author of *Reflections: The Breamish Valley and Ingram*, as Sarah was to be the link with Walter Brown of Langleeford in the Harthope Valley; Langleeford is situated at the northern base of Hedgehope and the eastern base of the Cheviot massif.

Trying to organise a date was a bit of a struggle, as the whole area was in the middle of the lambing season, and not long after that the shearing season would start. Still, a date was arranged via e-mail and telephone for 24 June 2008. Jim Corbett passed on the contact details of Peter Hart and between Sarah, Peter and myself, we confirmed the date. I invited ACIA member Russ Gray along to help inspect the site.

Account of Walter Brown of Langleeford

Walter Brown is a shepherd in the Harthope valley at the farm of Langleeford. Members of his family had been involved in most of the Second World War crashes that had happened in the Cheviot Hills; also, his services have been called upon to assist in searching the hills for lost hikers from time to time.

On 13 February 1979, a terrific blizzard was blowing in the Cheviot Hills, making any venture outside dangerous and even life-threatening. Walter had

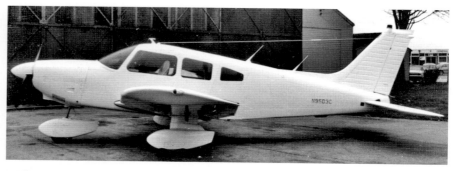

N9503C on delivery, prior to the UK registration G-BHDG. (Bill Bushell/Roger Peperell Collection)

received a call from the police asking if he could go out and have a look around as there was the possibility of a missing aircraft in the vicinity.

Walter took his trail motorbike and headed to the west of Langleeford along the track towards Langleeford Hope, 1.5 miles to the west, to see if he could see anything. Due to the adverse weather conditions the track was impassable, so for his own safety Walter had to return to Langleeford; he had made it to just over halfway (¾ mile) to Langleeford Hope.

An hour or so later, two men knocked on the door of Langleeford in what can only be described as 'Gucci kit'; dressed in Armani suits and best Italian leather shoes stood Jim Winning and Findlay Guild. They had come down from the crash site and, by pure chance in blizzard conditions, stumbled across the shooting lodge of Langleeford Hope. Jim and Findlay had broken into the clearly empty shooting lodge to try and sort themselves out. They had made a hot drink, and then decided to keep going to get help. They turned in the direction that the Harthope Burn was flowing. The conditions were worsening, and they were about to turn back to the shelter of the shooting lodge when they saw the tracks of a motorbike in the snow; they pressed on, following them to Langleeford and Walter Brown.

24 June 2008

We had arranged to meet at Powburn Services for 8 a.m.; from here, we would move onto Langleeford and meet up with Walter Brown. The group consisted of Sarah Wilson, Russ Gray, Peter Hart and I; Jim Corbett was unable to make the trip due to work commitments. This trip was over terrain far too rough for my air crash hunting poodle Penny; she was left at home in the huff.

Peter had travelled down from Edinburgh and transferred into my car along with Russ; Sarah was taking her Land Rover so that we could knock a few miles

off the route by travelling along a rugged track from Langleeford to Langleeford Hope.

After our introductions, I had to admit to Peter that up until the 27th I was totally unaware of the circumstances of his crash as I had only just received details that night. However, I had a good idea of the crash site location as I had an approximate grid reference.

On the way to Langleeford, Peter told of how on the road we were travelling on (the A697), he had been in a serious motoring accident and had been trapped in his car and had to be cut out. Serious as this story was, I matched up the fact that he had been in an air crash, and a serious car crash – now they say things come in threes! I stopped the car and asked Peter to get out! After all, his luck might run out when I was with him (it was all in good fun).

We arrived at Langleeford and met with Walter Brown, who had photographs of the aircraft at the crash site on Hedgehope Hill. This was to be the first meeting of Walter and Peter, as Walter had raised the alarm to the police which had got the RAF Air Sea Rescue to the stricken aircraft on Little Hedgehope.

Heading along the track from Langleeford to the weekend cottage of Langleeford Hope, we stopped 170 metres short of the cottage. Here, Walter was able to direct us to the site near some peat hags on the top of Little Hedgehope. Walter was unable to come to the site due to shearing commitments, but we were to call in at Langleeford on our return journey.

Peter Hart, Little Hedgehope. Hedgehope Hill is in the distance. (Author)

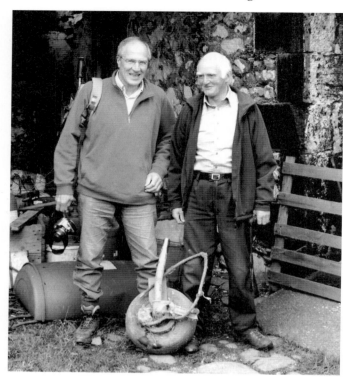

Peter and Walter with the wheel from G-BHDG. (Author)

Parking Sarah's Land Rover at Langleeford Hope, we crossed the Hart Hope burn and decided to take the direct route, straight up! I was aware that Sarah, like myself, was an experienced hill walker; of Russ and Peter I was unsure. Sarah was in full stride and taking the rough terrain and hill by storm; I was keeping a good pace, but did notice a gap growing between us and Peter and Russ. I asked Sarah to slow down a bit as the other two were falling behind. This, you must recall, was my first meeting with Sarah with only formal introductions; Sarah commented that she would forge ahead and I replied, 'We may have just met, but I will drop you if you don't wait!' This, of course, was done with a cherubic smile, as it is best practice not to split your group when on the open fells. Calm restored, Peter and Russ caught up and we arrived on site together.

Walter's description of the area was exact; there were several peat hags on the top of Little Hedgehope. Walter had also mentioned that the aircraft had gone through the fence and passed onto the Linhope side of the hill. After an extensive search, there was no sign of any wreckage being left on the hillside. However, there was evidence of the remains of broken fence posts at the site (a newer fence is now in place).

We stood for a few moments to remember the loss of Mervyn Donnell, the pilot of PA-28-181 G-BHDG.

Moving back down the hill, we headed for the shooting lodge then made our way back to Langleeford. We were met by Walter, who invited us for a hot brew of tea. We gratefully accepted and Walter brought out a few photographs of the crash. Moving into the farmyard, Walter produced one of the wheels from the aircraft. He had it stored for twenty-nine years and presented it to Peter, who now proudly displays this in his garden.

Official Documents

Having been told that the site I was escorting Peter Hart to was his own crash site, I did a cursory check of my reference books to see if it had been recorded. To my surprise, I found nothing. However, I did have a newspaper story of the crash.

I did not need any official documents as I was to meet up with Walter Brown, who was part of the search team, and Peter Hart who was involved in the crash. I must thank my colleague Neal Wharrier for his assistance with some minor adjustments to the quality of the photograph of G-BHDH at the crash site.

I contacted Jacqueline Carlon at Piper Aircraft Incorporated. Jacqueline put me in contact with Roger Peperell, the company historian, who provided a picture of N9503C/28-7890417 after delivery to the UK distributor, CSE Aviation at Kidlington, Oxford, prior to its UK registration, G-BHDG. At the time of the crash the aircraft was only ten months old.

A Brief Account of the Crash as Described by Peter Hart

On 13 February 1979, four members of HG Antipollution Ltd took off from Edinburgh airport at 7.36 a.m., piloted by company salesman Mervyn Donnell. They were heading for Sunderland airport (the former RAF Usworth); planned arrival time was 8.45 a.m.

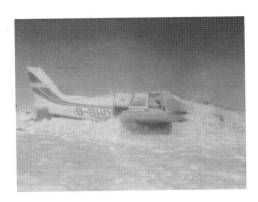

G-BHDG, Little Hedgehope. (Walter Brown)

Sue Davies and the author with Penny on Little Hedgehope, 14 February 2010. (Author)

At first, Peter Hart was at the controls of the aircraft, instructed by Mervyn Donnell. Initially, all went to plan; a height restriction was in place to an altitude of 2,000 feet. Soon, they encountered a lowering cloud base and climbed to 5,500 feet. Once level, Mervyn pointed out the icing up of the aircraft's windscreen and wings. At this point Peter handed over the controls to Mervyn, who in turn disengaged the autopilot and began a manual descent. At a height of 3,500 feet, Peter turned to Findlay and Jim in the rear seats and told them, 'Everything will be OK, as the ice is coming off the wings.' They were still flying in thick snow and it was agreed they should turn around 180 degrees; they were unaware that they had been blown six miles off course. With the aircraft descending, they collided with a fence on top of Little Hedgehope, which ripped the undercarriage clear of the aircraft, then ploughed into a snow drift.

Mervyn was knocked unconscious; Peter had broken his back, while Jim and Findlay were virtually unscathed. They decided to stay with the aircraft and await rescue; Mervyn died from his injuries and exposure five and a half hours later.

By midday, the weather had not subsided, so it was decided that Jim and Findlay would seek help. Leaving the aircraft and not knowing where they were, they made their way off the hill, eventually arriving at the shooting lodge of Langleeford Hope. (Note: Had they gone in the other direction, they would have ended up on Linhope Rig, nowhere near any habitation).

Reaching the lodge, they realised there was no one at home; they were dressed for business, not the hills or this weather. Both soaking and freezing, they decided to break into the lodge to get warm.

Meanwhile, Peter managed to drag himself into the luggage compartment in an attempt to shelter from the blizzard. Peter thought he was going to die due to oncoming darkness and the drop in temperature; he prepared a goodbye note for his wife and one-year-old daughter.

Jim and Findlay had found fuel to make a fire and food. Once they had dried off and warmed up, they set off again for help. The weather conditions were worsening, and they were about to turn back to the lodge when they spotted the motorbike tracks which had been made when Walter Brown had been called out to search. Following the tracks, they arrived at Langleeford where Walter was able to raise the alarm with the authorities.

Peter Hart was coming to the end of his goodbye note when the search light of the Air Sea Rescue helicopter scrambled from RAF Boulmer lit up his aircraft, bringing an end to his ordeal. Peter was rescued some twelve hours after the crash; the body of Mervyn Donnell was recovered on 14 February 1979.

The Site of the Crash

Piper Archer PA-28-181 G-BHDG

Pilot (Instructor):	Mervyn Donnell +
Pilot (Pupil):	Peter Hart i
Passenger:	Jim Winning
Passenger:	Findlay Guild
Airport:	Edinburgh
Site:	Little Hedgehope, Harthope Valley
Grid Reference:	NT93923 19627
Map:	OS Outdoor Leisure 16
Note:	No wreckage remains at the site

Bibliography

Corbett, Jim, *Air Crash Northumberland*
Earl, David W., *Hell on High Ground*

Reference

Jacqueline Carlon and Roger Peperell – Piper Archer Incorporated
Jim Corbett
Neil Wharrier
Ordnance Survey Maps
Peter Hart
Russ Gray
Sarah Wilson
Sue Davies & Penny
Walter Brown

BEAUFIGHTER EL457-9Y

Bristol Beaufighter Mk VI EL457-9Y
132 Operational Training Unit
RAF East Fortune

Threestoneburn Wood
Hedgehope Hill
16 May 1944

I had first met Sarah Wilson, author of *Reflections: The Breamish Valley and Ingram* on 24 June 2008. We were involved in escorting Peter Hart back to his crash site of some twenty-nine years previous on Hedgehope Hill in the Cheviots, as described in Chapter I. While searching Hedgehope Hill for possible remains of the aircraft, Sarah brought to my attention Basil Oliver, who had lived in the Breamish and Harthope valleys of the Cheviots during the Second World War. This man would prove an invaluable source of information to crash sites in the Cheviot Hills. I recognised Basil's name due to a meeting with Malcolm Elliot at Hartside farm in early 2008. Malcolm had informed me that the previous tenants of Hartside had been the Oliver family. Malcolm was able to point out three crash sites in the close proximity of his farm from tales he had been told by Basil's brother Ronnie, but could not pinpoint the exact locations. He had also mentioned Basil, so when Sarah mentioned his name my ears pricked up; this was a man I needed to meet. Since this first meeting, I have become friends of both Sarah and Basil.

Bristol Beaufighter Mk VI. (RAF Museum Hendon)

We met at Ingram farm on 2 July 2008 to look for three sites: those of Bristol Beaufighter EL457 at Threestoneburn Wood, Junkers 88A-14 at Linhope Rig and Hawker Hurricane N2522 at Megrims Knowe. This account is of one of these sites, that of Bristol Beaufighter EL457.

Account of Basil Oliver

Basil was aged fifteen at the time of this crash, and at the time of our first visit he was seventy-nine.

In 1944, Basil had wanted to be a blacksmith; his father gained him employment as a 'horseman' at Langleeford in the Harthope Valley, at the base of Hedgehope Hill and the Cheviot Massif. He was not overly keen on shepherding, as he said in his own words: 'Being a shepherd would have been great, but I had one problem … I divn't like sheep, they're awfurl smelly, stupid things.'

Basil had been the only civilian in the rescue team of three sent up to the site of EL457 to recover the crew's bodies; the other two were RAF personnel. This would have been a daunting task for anyone, let alone a fifteen-year-old boy. He recalled seeing that the shoulder flashes of the crew had 'Belgium' on them. The bodies were wrapped in their parachutes, placed on to a hay sledge and brought down by the quickest route off Hedgehope hill, which was to Langleeford in the Harthope valley.

Basil recalled the aircraft lay above an old drove road that travelled from Langleeford round the eastern side of Hedgehope, heading south across Dunmoor Hill to Hartside, the farm of his father. This drove road on the eastern slopes of Hedgehope Hill has all but gone due to the planting of Threestoneburn Wood. Basil was involved in the ploughing of the ground to the west of Threestoneburn farm (on the eastern slope of Hedgehope Hill) in the 1960s. 20-mm cannon shells were unearthed by another ploughman; some were taken away, but the rest were re-buried. Basil had 'liberated' a short belt of 20 mm cannon shells from the site in 1944. At the western side of Hartside farm there is a dry stone wall which runs north–south; it joins with another which runs east–west. Along with his elder brother Bill and younger brother Ronnie, they waited until their father, Alex, had left the farm. The boys wedged a cannon shell into the corner of the dry stone wall; they lit a fire beneath the brass casing and waited for it to go off. Bill was about to return to the shell (as he believed the fire had gone out), but Basil pulled him back and told him to wait. Suddenly there was a large explosion, and the wall collapsed. The boys cleared away any evidence of the exploded shell, letting their father believe a stray shell had hit the wall from army manoeuvres. Evidence of the repair to this section of wall is still visible today.

4 July 2008

This promised to be an eventful day which would either provide exact crash site locations or positively identified search areas. Meeting at Ingram Farm for 9.15 a.m., along with my faithful air crash hunting poodle Penny, we loaded into Sarah's Land Rover and headed up towards Threestoneburn Wood. Sarah had gained permission to access the woods and had secured the key required to open the gate into the wood.

Following the forestry track in a westerly direction, we stopped near an area marked on the map as Kelpie Strand, a wet land area. Near here, on 29 May 2008, I had been directed to large piece of alloy tucked away under some outlying trees. I was never convinced that this was part of the aircraft, but it did form part of the build-up to the search. It has been written that the crash site was near to Kelpie Strand, but no trace has ever been found.

Basil directed us a further 500 metres up the forestry track, explaining that when the hill was ploughed for planting, the 20 mm cannon shells were unearthed by what was to be a fire break. He pointed to a site, directing me some 50 metres into the fire break and 30 metres to the south, into the trees. A quick scan of the surrounding area proved fruitless and with the density of the trees, this site would have to be revisited at a later date for a more constructive search. At least I had an area to search in what is really a 6-square-kilometre wood.

Return to the Search Area

I returned to this search area on two more occasions between May and July, walking in from the Langleeford side of the hill, an hour and a half's walk each

Above left: Penny guarding cairn at EL457-9Y site. (Author)

Above right: Fragments found at the EL457 crash site. (Author)

way, and I allowed for three hours searching on each occasion, starting from Basil's location. This wood was a nightmare; on every occasion it was raining by the time I got to the search area. The trees are so dense that I had to wear waterproofs and safety goggles while pushing through the branches up and down the tree lines. I was losing faith in my ability to search; I had marked out the wood so as not to cover ground already searched, and I was also beginning to wonder about the site location itself! On my fourth visit on 10 August the weather was, as usual, raining! My waterproofs had failed, I was soaking wet through and covered in green slime off the tree bark. Sitting with a limp, wet chicken sandwich from a garage, I was feeling sorry for myself and about to give up for good. A thought occurred to me that beyond the first part of the wood I had searched was an open piece of ground which, if nothing else, got me out of the trees. As I walked into the area I noticed it looked like a fire break, but it was closed at the western end. I took a calculated guess that this area was 50 metres deep, remembering Basil's original measurements I walked to the south side of the clearing and found a drainage ditch. Here, I found a fragment of oxidised alloy the size of a 50p coin; Basil was close with his directions. After a further hour's search I drew a blank. I returned to the site in September and found no further remains.

At a loss, I asked Basil to describe the site when he helped retrieve the bodies of the crew in 1944. Basil recalled that the aircraft was removed from the hill to Langleeford. The fence was taken down next to and above the 'drove gate'. The fence has been replaced a few times over the years.

14 October 2009

I returned to Threestoneburn Wood and, for a change, it was sunny. This time I would try a new approach: I would look for the position of the 'drove gate'. After all, I would imagine when farmers replace fences they put the gates in the same place as before! I set off up the northern side of the wood, passed Kelpie Strand and located the 'drove gate'. From here, I carried on west up the hill to skirt round the top of the wood and try to get an aerial view of the area and imagine the line of the original drove road. This seemed like a decent plan and all was going well until I entered the wood. Although I had marked the areas I had searched on my previous visits to the site, nothing was familiar in the wood. My last search had finished next to some fallen trees. I decided to switch on my metal detector and sweep as I tried to locate the fallen trees. I could not see any light penetrating the wood. Through the branches, I spotted some light and a fallen tree; when I got there, the area was unfamiliar so I pressed on to find one of my markers. As I passed the fallen trees I got a massive reading on my metal detector… this was it … I had found the main site. The site lay some 300 metres to the south-west of Basil's original instructions, but what's 300 metres between

friends? (It's a lot if you consider thrashing up and down the tree lines for what been a total of 15 hours, all rounded up). I upturned fragments of batteries, a large piece of airframe, a jack plug (off the intercom set), a fire extinguisher and one or two broken 20 mm cannon shells as Basil had so rightly reported. All of these items I placed into a cairn I built at the site, and placed a Poppy cross on top. I do intend to place a memorial post at the site but at the time of writing, plans are being drawn up to fell Threestoneburn Wood.

17 August 2010

Since discovering the site of EL457, I wanted to take Basil Oliver back to help satisfy him that I had located the remains of the aircraft. Basil is eighty-one years old and fitting in a date that matched with Sarah's and my own commitments was proving difficult. Then came the snow, which wrote off the early part of 2010. Eventually, we agreed for Tuesday 17 August.

We met at Ingram for 1.30 p.m. I had come straight from work so Penny was not with me. The Land Rover ride was bumpier than the last time, but it saved the hour and a half's walk to the site. We arrived near the edge of the site. After explaining to Basil the vast area I had searched, we moved into the wood. I was surprised to find all my markers, which I had used to break the wood into search areas, had stayed in place. Once at the cairn, I revealed the artefacts that I had unearthed. Basil commented, 'Christ, it's been sixty-six years since I had last seen any of this aeroplane, I can still remember it clearly. The nose was crumpled and the tail had broken off.' Since we were on site, I had taken my metal detector with me (it would have been rude not to). A few fragments of fuselage were uncovered, but nothing identifiable. We were about to leave when I picked up a strong signal; approximately 6 inches (15 cm) below the surface was the face of a 'Fuel Gauge' dial, a positive piece and easy to identify.

Official Documents

I firstly checked my reference books for any possibilities and came up with 132 OTU (Operations Training Unit) from RAF East Fortune near Kelso.

This being Bristol Beaufighter Mk VI EL457 9Y, I next contacted the national Archives for copies of the 132 OTU Operational Records Book (ORB). This came under AIR 29/696 for May 1944 and confirmed the crash of Bristol Beaufighter EL457, but not the site.

My next move was to contact the RAF Museum Hendon for the F1180 (Loss Card) for this aircraft. What I needed to know was where, or as near as possible,

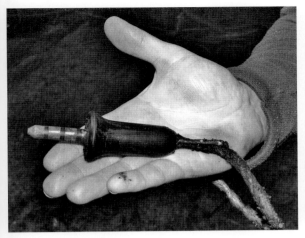
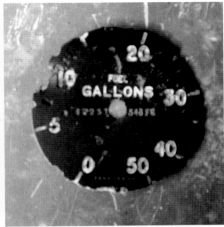

Above left: Intercom jack plug from EL457. (Author)

Above right: Fuel gauge from EL457 found on 17 August 2010. (Author)

was the crash site. This revealed that the aircraft had crashed at Hedgehope Hill.

I then contacted the Registrar Office at Morpeth, to obtain the pilot's death certificate; this revealed that two Belgian crew had been killed on Hedgehope Hill, F/O Gilbert Albert Eugene Malchair RAFVR and F/Sgt Roger Henri Lucien Closon RAFVR.

A Brief Account of the Crash

132 OTU were training Beaufighter crews for anti-shipping attacks. On the night of 15–16 May 1944, EL457 took off from RAF East Fortune on a cross-country training exercise followed by a gunnery exercise over the North Sea. There isn't a lot of information with regards to the flight, but its last contact with base stated that it was 20 miles south-east of Coquet Island and reducing altitude due to icing up. Nothing more was heard of the aircraft until it was found on 17 May by gamekeeper Adam Sisterson. According to a police report the aircraft crashed on Hedgehope Hill, 1 mile west of Threestoneburn House, 7 miles south of Wooler, district Glendale, Northumberland, at 01.51 hours on 16 May 1944.

Both crew were initially buried on 22 May 1944 at Brookwood Military Cemetery, Woking, Surrey. After the cease of hostilities, at the request of their famlies, they were exhumed and reinterred at the Parc d'Honour, Belgian Pilotes at Evère near Brussels, in October 1949.

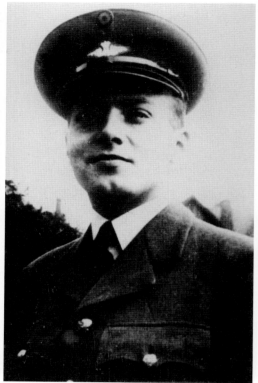

Above left: F/O G. A. E. Malchair. (Achille Rely via David W. Earl)

Above right: F/Sgt R. H. L. Closon. (Achille Rely via David W. Earl)

The Site of the Crash

Bristol Beaufighter Mk VI EL457 132OTU RAF

Pilot: 132969 Flying Officer Gilbert Albert Eugene Malchair RAFVR +
 (age unknown)

Navigator: 1424811 Flight Sergeant Roger Henri Lucien Closon RAFVR +
 (age unknown)

Squadron: 132 OTU RAF

Site: Hedgehope Hill (area known as Threestoneburn Wood)

Grid: NT95128 19716

Map: OS Outdoor Leisure 16

Note: Fragments remain buried at site. A memorial is planned to be
 located at the site

Bibliography

Chorlton, Martyn, *Airfields of North-East England in the Second World War*
Clark, Peter, *Where the Hills Meet The Sky* (1st and 2nd edn), Glen Graphics 1997
Earl, David W., *Hell on High Ground Vol. 2*
Walton, Derek, *Northumberland Aviation Diary 1790-1999*
Wilson, Sarah, *Reflections: The Breamish Valley and Ingram*

Reference

AIR 29/696 – 132 OTU, ORB
Basil Oliver
Commonwealth War Graves Commission
Dave Gray
David W. Earl (photographs of crew)
Dennis Gray
F1180 Loss Card
Google Earth
Ian Hall (Lilburn Estates)
Mike Hatch AHB
Mrs Joan Rose, Northumberland and Durham Family History Society
Ordnance Survey Maps
Penny
RAF Commands website www.RAFcommands.com
Sarah Wilson

JUNKERS JU 88A-14 144354 3E+BH

Junkers Ju 88A-14 144354 3E+BH
I./KG 6 (Kampfgeschwader)

Linhope Rig
25 March 1943

Not many German aircraft have crashed in the Cheviots (which is my favourite place for hiking), but they are well recorded. My reference books are my first port of call. To my surprise, a grid reference was quoted so the site should have been easy to find. On 10 April 2008, I set off for what was to be a two-site search, starting with that of the Ju 88 on Linhope Rig; in the afternoon, I would divert to Dunmoor Hill to search the site of Vickers Wellington R1535 GR-G.

At 8.30 a.m., I parked my car at Hartside Farm in the Breamish valley and set off for Linhope Rig and grid reference NT945169. This should be an easy site to find: I had a quoted grid reference! I did note, however, that it was reported that pieces of the aircraft were still left, although no one had seen any for years. I also took note that one of the books records that the crew were found hanging upside down in their harnesses.

Logging the co-ordinates into my GPS, I arrived on site with my trusted air crash hunting poodle Penny by 9.15 a.m. I had read a report that the Ju 88 was seen to circle the hamlet of Powburn a few times and that its engines were running rough. The part of the hill I was on looked reasonably flat; I could imagine the crew of this stricken aircraft looking for somewhere to crash-land. I felt I was close, so I started to methodically break the area into smaller sections and search each section in turn. Two hours later, all I had found was very deep heather and three spent shotgun cartridges. Penny was not impressed as it was cold and windy, but her sheepskin flying jacket kept most of the cold out.

We headed back towards Hartside Farm, as we were heading for Dunmoor Hill. I ran into Robbie Cowens and Michael Purvis at some sheep pens situated next to the road between Linhope and Hartside. Never one to miss an opportunity to draw information from the locals, I could hardly contain myself. Robbie could recall seeing bits of the Ju 88 back in the 1960s, explaining they were in a 'sike' near to what he believed was a Stone Age grave. He guided me to where he believed the crash site

was from a different route. Robbie suggested I head for Linhope Spout and carry on along the track until I came to a shooting lodge. From here, head straight up the re-entrant in the hill opposite the lodge; at the top I should find the 'grave'.

I carried on to Dunmoor, but that is another story. On my way back to Hartside I met, for the first time, Malcolm Elliot. Once again local knowledge, and the opportunity to gain some, was right in front of me. Malcolm was aware of the Hurricane on Meggrims Knowe, the Wellington on Dunmoor Hill and had, as a child, seen the remains of the Ju 88 on Linhope Rig. He said the same as Robbie: that the bits were in a sike, but without being there he couldn't say exactly where. This gave me two people who had seen bits in the last thirty years; a long shot I know, but nonetheless, witnesses. I took this opportunity to ask Malcolm for access through Hartside for when I started to search for the Wellington on Dunmoor Hill.

4 July 2008: The New Search Party

I had arranged to meet with Sarah and Basil at Sarah's farm, Ingram, for 9.15 a.m. There was no need for a very early start as Sarah had kindly offered the use of her Land Rover, which would reduce hours of walking time. This was to be the second of three sites, all of which Basil had attended as a child. They were a Beaufighter EL457 on Hedgehope Hill, a Junkers 88 on Linhope Rig and a Hawker Hurricane, N2522, on Meggrims Knowe. The sites of the Beaufighter and Hurricane are told in separate chapters.

Having already been guided to a search area for Bristol Beaufighter EL457 in Threestoneburn Wood on the slopes of Hedgehope Hill, we arrived at the hunting lodge near lunch time at the base of the re-entrant to the north of Linhope Rig. This was the sike that Robbie Cowens and Malcolm Elliot had described, and had advised as the quickest route to the hill.

We had our snack and discussed the route up the hill. Basil at the time of the crash was thirteen years old, and was a fit seventy-nine-year-old returning to the hills he had been born in, but we would take our time going to the proposed site. I guided Basil and Sarah to the 'Stone Age grave'; now the search would get interesting, as I had an eyewitness on site. Basil described to both Sarah and I that he brought his son to the site in the 1960s/70s, and they had found what looked like a door which had scratched onto it the name of a local lad: Colin Beveridge.

Basil asked where I had searched on my previous visit. I pointed to the area of the grid reference I had, approximately 300 metres to the east of where we standing. Basil explained that that was not the crash site, as the ground was too flat. He remembered the aircraft being slightly raised on a bank to its left hand side, leaning to the right, but in the upright position. Basil got his bearings and directed me towards a small hillock 200 metres to the west of us. As we walked to this, I noticed a slight depression in the heather 25 metres to the south of us.

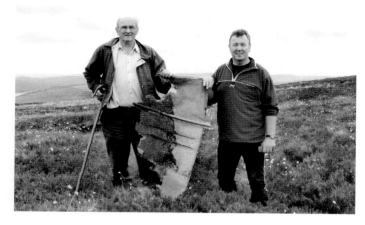

Basil Oliver and the author with a panel from the Ju 88. (Author)

I let Sarah and Basil know that I would meet them at the hillock as I recalled what Robbie Cowens and Malcolm Elliot had said about the pieces being in a small sike. As I followed the sike, I found a large alloy panel in a deep hole in the sike (local knowledge really does help). The panel, as Basil had said, had the name 'Colin Beveridge' scratched on it.

I caught up with Sarah and Basil at the small hillock. Basil was true to his word: there was even evidence on the hillock of where the left-hand engine of the aircraft had pushed the earth up over before the stricken aircraft had settled. We returned to the panel; as I brought it out of the sike, Basil said, 'That's the piece, you should find a name scratched into it, it is of local lad who had done it when they were kids …' Once again, on close inspection, there was the name. I later discovered that the panel was a gondola door, the access hatch into the aircraft.

Account of Ian 'Jock' Brown

Jock was fourteen at the time of this crash and lived with his parents at Low Bleakhope Farm, approximately a half a mile to the south-west of Linhope Rig. Jock told me that the two shepherds that found the aircraft were Henry Scott and George Taylor, and that they had told him some of the crew had been scattered across the hill.

Staying with the family at the time was a family friend, Mr McGuffy (Guffy), on leave from the Royal Navy. When news of a German bomber crashing on Linhope Rig reached Low Bleakhope, Guffy led a trip to the site. This was approximately one or two days after the crash; when they arrived at the site, the German crew's bodies had been removed. Jock recalls that Jimmy White was with them, and that the aircraft was in the upright position.

Led by Guffy, they entered the aircraft and Guffy retrieved the dinghy. They liberated the emergency rations from the dinghy, a small treasure trove of sweets and chocolate, including a Very pistol and flares. Also liberated were a few belts of machine gun ammunition. Jock can remember entering the aircraft to 'have a look around', then heading for home with their cache.

Some time later, Jock's father was resting one evening by the fireplace, with his feet up on a small mantle. The Very gun and ammunition had been securely stored, or so it seemed, in the peat cupboard next to the fireplace, the gun and ammunition being stored on the top shelf. Jock's mother was stoking the fire with 'peat cumb' (the dried dust at the bottom of the store). Minutes later, there was an explosion and a live round shot out of the fire and struck the back wall of the living room. It would appear that a live machine gun round had fallen from the shelf, into the peat cumb which had been put on the fire. Needless to say, this was the last time the objects retrieved from the German aircraft were ever stored there.

Official Documents

I firstly checked my reference books for any possibilities and came up with a Ju 88 fatality, this being Junkers Ju88 144354/3E+BH.

I had managed to obtain a copy of the Air Investigation Report from 1943; this gave valuable information as what was believed to have happened; the report contradicts itself: on one page it records that the aircraft is 'turned over on its back', and on another page it records the aircraft as 'disintegrating'. Note: Eyewitnesses have the aircraft being intact and in the upright position.

The Luftwaffe recorded the loss of 3E+BH officially on 27/05/1943.

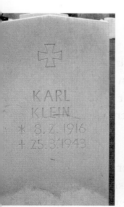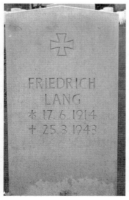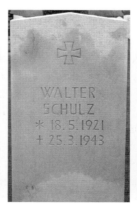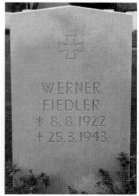

The graves of Karl Klein, Friedrich Lang, Walter Schulz and Werner Fielder. (Author)

I then contacted the Registrar Office at Morpeth to obtain the crew's death certificates; this revealed that a German crew had been killed at Linhope Rig.

With the help of Air Vice-Marshal Sandy Hunter, I was able to put questions to Oberst a. D. Wilhelm Goebel, Archivist *Gemeinschaft der Flieger Deutscher Streitkraefte*, therefore confirming the surname of the radio operator to be Klein.

A Brief Account of the Crash

The crew of Ju 88A-14 144354/3E+BH were part of an attack against Edinburgh on the night of 24/25 March 1943. Fifty-two aircraft were in the force that took off from their bases in Holland and France.

Ju88A-14 144354/3E+BH took off from its base in Beauvais, northern France, and was operated by I./KG 6 (Kampfgeschwader); it crashed at 00.45 hours, 25 March 1943, on Linhope Rig.

The AI1(g) investigators reported that the Junkers had hit the ground at a 'shallow angle', striking uphill and disintegrating. There was no record of a fire and there were no claims of 'fighter interception' in that area and no reports of gunfire reported by locals; the loss was put down to 'other causes'. The crash was discovered on the misty morning of 25 March by a local shepherd, Henry Scott, who was 'looking his ewes'; he left the site, returned to Linhope and reported his find.

The funerals of Obfw. Friedrich Lang, Obfw. Karl Klein, Uffz. Walter Schulz and Gefr. Werner Fiedler took place on Monday 29 March 1943, conducted by D. Cleasby, Chaplain, RAF Acklington, at Chevington Cemetery, Northumberland.

Oberfeldwebel K. Klein: Section H, Grave 27, Chevington Cemetery
Oberfeldwebel F. Lang: Section H, Grave 18, Chevington Cemetery
Unteroffizier W. Schulz: Section H, Grave 62, Chevington Cemetery
Gefrieter W. Fiedler: Section H, Grave 63, Chevington Cemetery

The crew are buried alongside thirteen other German airmen who died in the region during the Second World War.

The Site of the Crash

Junkers Ju 88A-14 3E+BH w/nr 44354
Pilot: 65112/98 Oberfeldwebel Friedrich Lang, age 29 +
Radio Operator: 65102/10 Oberfeldwebel Karl Klein, age 27 +
Navigator: 65124/2 Unteroffizier Walter Schulz, age 22 +
Air Gunner: 65124/124 Gefrieter Werner Fiedler, age 21 +

Squadron:	1./KG 6 Luftwaffe
Site:	Linhope Rig
Grid:	NT94121 16830
Map:	OS Outdoor Leisure 16
Note:	Fragments remain buried at the site. A memorial is planned at the site

Bibliography

Chorlton, Martyn, *Airfields of North-East England in the Second World War*

Clark, Peter, *Where the Hills Meet The Sky* (1st & 2nd edn), Glen Graphics 1997

Cooper, H. J., O. G. Thetford and D. A. Russell (eds), *Aircraft of the Fighting Powers* Vol. I, 1940.

Norman, Bill, *Broken Eagles 2, Luftwaffe Losses over Northumberland & Durham 1939–1945*

Walton, Derek, *Northumberland Aviation Diary 1790-1999*

Wilson, Sarah, *Reflections: The Breamish Valley and Ingram*

Reference

A.I. (K) report no. 147/1943

AIR 29/1025 – 83 Maintenance Unit ORB

Air Crew Remembrance Society www.aircrewrememberancesociety.com

Archivist Gemeinschaft der Flieger Deutscher Streitkraefte (Oberst a. D Wilhelm Goebel)

Basil Oliver

Commonwealth War Graves Commission

Ian 'Jock' Brown

Luftwaffe Loss Card

Malcolm Elliot

Ordnance Survey Maps

Penny

RAF Commands website www.RAFcommands.com

Registrar Office, Morpeth

Register of Burials (War Graves) Chevington Cemetery

Robbie Cowens

Sarah Wilson

HURRICANE N2522

Hawker Hurricane Mk I N2522
55 Operational Training Unit
RAF Ouston

Megrims Knowe
Ingram
25 April 1941

While preparing for my first visit to Linhope Rig to search for the site of the Ju 88A, described in Chapter III, I met with Malcolm Elliot at Hartside farm in early 2008. Malcolm informed me that previous tenants of Hartside had been the Oliver family and was able to point out three crash sites in the close proximity of his farm from tales he had been told by Basil's brother Ronnie, but could not pinpoint the exact locations.

4 July 2008

We met at Ingram Farm to look for three sites; Bristol Beaufighter EL457, Junkers 88A-14 and Hawker Hurricane N2522.

This account is of one of these sites: that of Hawker Hurricane N2522. Basil was very confident in locating this site, as the farm he lived in at the time (Hartside) overlooked Meggrims Knowe.

Hawker Hurricane Mk I. (Courtesy Iain Arnold, Hawker Hurricane Society)

Basil was near the age of eleven at the time of this crash and at the time of our first visit he was seventy-nine, recounting his father's recollection of the crash as he had seen it happen. This made it more personal as to where and what had happened at the time of the crash. Sarah, Basil and I were parked up in Sarah's Land Rover on the single-track road approximately halfway between Hartside Farm and the small hamlet of Linhope, overlooking Meggrims Knowe. Basil asked where I thought the aircraft had crashed; I was unsure, but presumed that it was high up the side of the hill, as the local reference books had not been able to pinpoint the site. I was surprised when Basil told me that he had been interviewed by a few authors, but no one had actually asked him where the crash site was on Meggrims. I jokingly said to Basil, 'Well, give it your best shot!' Basil directed me to two piles of boulders on the lower east side of Meggrims, then towards a large patch of nettles 100 metres to the west. 'That is where I think it is; we always used to say it was halfway between Alnhammoor Farm and Linhope.'

Off we moved in Sarah's Land Rover, following the private road which runs from Hartside past Alnhammoor Farm.

Whenever possible I have my trusted crash-site-hunting poodle Penny with me, and she sat alert on my knee in anticipation of our search. We stopped to request permission from Elspeth Bone, the wife of shepherd Steve Bone, at Alnhammoor for access to her field on Meggrims Knowe. Parking up just outside of the gate to Meggrims and armed with my metal detector and small Swiss entrenching spade, we walked to the second of the two piles of stones Basil had pointed out; approximately 3–400 metres, it took around five minutes. We then moved approximately 100 metres north, near to the large patch of nettles Basil had pointed out. Basil stopped us and said, 'Try here.' I switched on my metal detector, checked it was working on my entrenching tool then made one sweep left to right.

Basil Oliver, Penny and the author at the N2522 crash site. (Author)

It must be remembered that we were in the middle of a moor and the chances of finding anything are low, but anything metal has a high chance of being aircraft (as we had been guided to the site). I was amazed: I did not even move from the position where I tested the metal detector, and in that one sweep from left to right, approximately a six to eight feet arc, I got a very positive signal. At a depth of approximately 20 cm, I uncovered a piece of oxidised alloy frame (in conjunction with other aircraft parts I have unearthed at various sites) and we had only been on site one minute; unbelievable!

Basil was impressed with himself, but also with the machine I was using. Passing my metal detector to Basil and Sarah to take turns (I am the youngest – just, mind you – so I got the job of digging), we uncovered a small selection of aircraft fragments. We were soon joined by Elspeth Bone who, in turn, uncovered a few fragments as well. The comment of the day had to come from Basil, who rounded the day off with: 'I have had a great day, its amazing, I can hardly remember what I had for breakfast but found this site without hesitation, a grand day, a grand day.'

Alex Oliver's Recollections, as Told by his Son, Basil Oliver

At the exact time of the crash, Basil was attending Ingram school. When he got home, he was aware of what had happened. Alex first saw N2522 flying low from the direction of Linhope Rig, heading south-east towards the meadow beyond Alnhammoor Farm. The aircraft turned to the east, circling Hartside Hill, and turning to the north behind Greenside Farm and south, level with Hartside Farm. Alex was standing at a wicket gate to a small field opposite Hartside Farm. The aircraft was flying at about the height Alex was standing at and the pilot tipped a wave to him, which he returned; this was probably the last human contact the pilot had. Moments later the aircraft turned south over the meadow, then returned north back over the top of Alnhammoor, just clearing the chimney pots when it spun into the ground on Meggrims Knowe. The aircraft exploded and bullets were firing off everywhere, making rescue impossible.

Basil explained that his father was a strong man and he was very disturbed by the thought that he may have been the pilot's last human contact. His father was very quiet at supper that night and Basil has no doubt that his father may have shed a tear.

Official Documents

I firstly checked my reference books for any possibilities and came up with a 55 OTU fatality, this being Hawker Hurricane Mk I N2522.

I next contacted the National Archives for copies of the 55 OTU Operational Records Book (ORB); this came under AIR 27/2006 for April 1941. A single

P/O Martin Walter Rivers. (Simon Colverson)

line entry records the loss of this pilot: 'P/O M. W. Rivers killed in accident to Hurricane N2522 at Linhope.'

My next move was to contact the RAF Museum Hendon for the F1180 (Loss Card) for this aircraft. What I needed to know was, as near as possible, where the crash had occurred. This revealed that the aircraft had crashed at Linhope near Amble (some 30 miles west of where I was looking). However, Linhope is next to Hartside Farm.

I then contacted the Registrar Office at Morpeth to obtain the pilot's death certificate; this revealed that 62015 P/O Martin Walter Rivers had been killed in a flying accident at Meggrims Knowe. (This is the hill opposite Hartside Farm.)

A Brief Account of the Crash

On 25 April 1941, at approximately 11.00 a.m., Hawker Hurricane N2522 of 55 Operational Training Unit (OTU), RAF Usworth, was piloted by 62015 Pilot Officer Martin Walter Rivers. He was on a solo training flight completing authorised aerobatics. Flying in the Breamish Valley area, at approximately 12.00 p.m., N2522, during a steep 90-degree right turn, stalled and spun into the ground on the lower east side of Meggrims Knowe, killing the pilot. It would appear from police observation at the time that when N2522 came back over Alnhammoor Farm, a small gust of wind tipped the aircraft over; there was nothing the pilot could do to save himself or the aircraft.

The body of P/O Martin Rivers was brought down from the hill to Hartside by Alex Oliver and George Taylor, one of the Ingram Valley shepherds.

P/O M. W. Rivers: Panel 7, Newcastle-upon-Tyne (West Road) Crematorium

The memorial post at the crash site of N2522. (Author)

16 March 2009

After several visits to the site and discovering a lot more fragments of N2522, Sarah, Basil and I decided to erect a memorial in the style of the direction marker posts used in the Cheviots. It was to be a simple ceremony, with the three of us unveiling a small plaque at the site.

I had to ensure all details were correct: name, rank, number, age, aircraft, unit and date. All was going well, except that my reference books gave two different dates for the crash and the Commonwealth War Graves Commission (CWGC) gave a third date. So my problem was to find the right date, either 23, 24 or 25 April 1941. The CWGC gave the 25, but errors can and have been made.

I decided on a long shot from a forum where amateur and professional researchers share information regarding RAF history. On 28 October 2008, I requested information regarding P/O M. W. Rivers. On 23 November 2008 I was contacted by Simon Colverson, nephew of P/O M. W. Rivers, who confirmed the date of the crash.

I explained to Simon what we intended to do at the site and he asked if he and his family could attend. This threw a spanner in the works, as it now became complicated with family attending. I do like a challenge!

The date was agreed so as not to interfere with the lambing in the valley, allowing all those involved to attend. I had arranged for representation from the RAF at RAF Boulmer (led by Squadron Leader M. Vickery, 202 Squadron), and for Simon Colverson and family, his cousin Naomi Kenny and husband and Edward Kent Ryder (for the Last Post) to attend. Sarah arranged for the

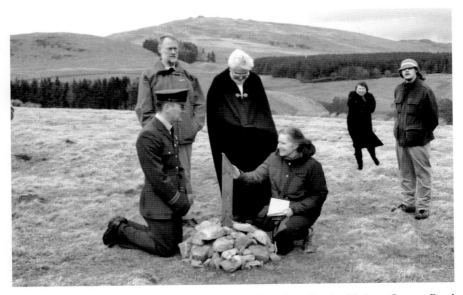

From left to right around the memorial post are: Squadron Leader Vickery, Simon, Revd Burston, Naomi. Note, the rocky hill in the background is the crash site of Wellington R1535. (Author)

locals, husband Johnnie, Lord James (land owner), Reverend Bob Burston (for a service) and the local farmers, to attend. In all, nearly forty people came to the service on this wind-swept hill. To top it all, the RAF flew Sea King Helicopter Mk II No. 598 over the site, flying the RAF Ensign below the aircraft.

The service was reported in the local papers *The Journal*, *Northumberland Gazette*, and *Berwick Advertiser*.

12 November 2008

While searching for the site of a Wellington bomber, I asked Malcolm Elliot if I could pass through the farm he shepherded (Hartside), as it would take nearly 4 miles off my round trip. I also asked him if he could remember a sack being left in the barn from the previous tenant, Ronnie Oliver, which contained bits of N2522. An hour later, I was in heavy rain and thick fog on Dunmoor hill when I heard the sound of a quad bike. Out of the fog came Malcolm, shouting he had something that might interest me ... In the tray on the back of his quad was a Hawker Hurricane wheel, which he found under the stone staircase of his barn, that had been there since 1941 ... even Basil did not recall it at the farm.

It is with great sorrow and regret that Malcolm Elliot passed away, 14 July 2009.

The Site of the Crash

Hawker Hurricane Mk I N2522 55 OTU RAF

Pilot:	62015 P/O Martin Walter Rivers RAF, age 24 +
Squadron:	55 OTU RAF
Site:	Meggrims Knowe, Breamish Valley
Grid:	NT96810 15836
Map:	OS Outdoor Leisure 16
Note:	Fragments remain buried at the site

Bibliography

Chorlton, Martyn, *Airfields of North-East England in the Second World War*
Clark, Peter, *Where the Hills Meet The Sky* (2nd edn), Glen Graphics 1997
Walton, Derek, *Northumberland Aviation Diary 1790–1999*
Wilson, Sarah, *Reflections: The Breamish Valley and Ingram*

Reference

AIR 29/682 – RAF Station Usworth ORB
AIR 28/624 – RAF Station Ouston ORB
Basil Oliver
Commonwealth War Graves Commission
Cybil Telford
Dennis Gray
Edward Kent Ryder
Falon Nameplates www.falonnameplates.com
F1180 – Loss Card
Iain Arnold – Hawker Hurricane Society
Lynne Waterhouse
Malcolm Elliot
Mrs Joan Rose, Northumberland and Durham Family History Society
Naomi Kenny
Ordnance Survey Maps
Penny
RAF Commands website www.RAFcommands.com
Revd Canon Bob Burston
Ronnie Oliver
Sarah Wilson
Simon Colverson

HURRICANES L2066 & L1734

Hawker Hurricanes Mk I L2066 and L1734 FT-G
43 Squadron
RAF Acklington

Red Row
18 January 1940

A colleague, David Dunn, was aware that I had started researching air crash sites in Northumberland (I think I may have mentioned it to him once or twice) and recalled a tale his father had told him about a collision between two aircraft over Red Row during the Second World War. David's father, Eddy Dunn, suffered difficulties with his memory due to MS; however, he could recall two crashes at Red Row due to their close proximity, although they were two years apart.

I managed to borrow a very faded picture of the RAF Acklington gate guardian, Supermarine Spitfire Mk XVIE TB252, from Ethel Elliott, who has provided one of the eyewitness accounts here. I copied the picture for David; it now hangs proudly in his area of work.

L1734 in pre-war markings. (Iain Arnold Hawker Hurricane Society)

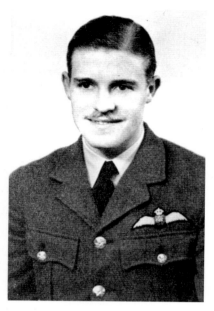

Sergeant Henry John Steeley. (Karen Hunt, *née* Steeley)

The Collision as Relayed by Eddy Dunn

All I could be told was that two unidentified aircraft had collided above the village of Red Row on a cold, crisp winter's day. He recalled that one of the aircraft crashed in what was known as Jobson's Field; this is the field behind what was Pettica's Garage. This aircraft had lost its tail, which landed on the 'Stinky Burn' to the east of Jobson's field (Stinky Burn was the outlet of water from the local pit).

Eyewitness Ethel Elliott

Whilst researching another crash (Spitfire K9935), I was introduced to Ethel Elliott, who lived at Whitefield Farm, Red Row. She had lived there all of her life and was also a member of the local history group.

Ethel recalled being fourteen at the time and attended Red Row Senior School, which backed onto Jobson's Field. While crossing the schoolyard with a bowl of rice pudding freshly made for the teacher's lunch, an almighty bang happened above her. Two aircraft had collided, and one had lost its wing. She felt as if the aircraft was going to fall onto her. Ethel could not recall what type of aircraft, but that it was a cold, crisp winter's day. Ethel had walked along to the crash at Joe Hakin's Field and picked up a fragment of L2066 from the road leading to Chevington Drift; she kept it for many years in her shed, but it has been lost over time.

Eyewitness Gordon Black

Through Ethel Elliott, I was introduced to Gordon Black, who lived in The Willows, near the entrance to the Welfare Field, Red Row; this was the road from Red Row to Chevington Drift. Gordon was six or seven years old at the time and can recall seeing the site of one of the aircraft. Gordon only saw the one aircraft, which he recalls spluttered, turned over the village and looked like it was turning to go out to sea. It dived into the ground approximately 100 metres to the east of the Welfare Field, in what was known as Joe Hakin's Field, some 500 metres from the first aircraft. Only the tail was visible out of the ground. Gordon took me to the route he had taken within minutes of the aircraft crashing. Gordon was unaware that the aircraft he had seen had been involved in a collision.

Eyewitness Eric Wood

Eric Wood was ten years old at the time of this crash and attended North Broomhill School. He also recalls that on a crisp, cold sunny winter's day early in the Second World War, a collision took place over Red Row. Eric took me to the site in Jobson's Field and pointed out the site where the detached tail had landed, formerly known as the Stinky Burn, now the site of a sheltered accommodation bungalow. Eric also guided me to where the main fuselage had landed; we walked to the spot and he provided valuable recollections of the sites which I later could match with other accounts and, more positively, with official records as to which aircraft had crashed into Jobson's Field.

18 April 2010

I was introduced to Jim and Monica Wilson by Basil Oliver, as Jim was originally from Red Row and Monica was originally from Rothbury. Both would provide accounts of five accidents researched in this book, these being the collision of Hawker Hurricanes L2066 and L1734, Hampden L4072, Hawker Hurricane V6868, Whitley Z6869 and Spitfire NH700.

Account of Jim Wilson

In January 1940, Jim Wilson lived at 74 Hedgehope Terrace, Chevington Drift, and attended Red Row Senior School. He can remember that in his class a young girl called Evelyn Edwards, who had been naughty, had been sent to

'stand in the corner' as punishment for disrupting the class. The young girl let out a scream: she had seen two aircraft collide over Jobson's Field. One of the aircraft had had its tail cut off by the other. Jim recalls the tail landing over by the Stinky Burn and the body of the aircraft crashing into Jobson's Field. The other aircraft crashed next to the road into Chevington Drift, in Joe Hakin's Field. The engine of this aircraft was lying next to the bend in the road just after the Welfare Field in Red Row (this is the exact site where Gordon Black took me to and the area where Ethel Elliott had picked up a fragment). Bits of the aircraft were scattered on the road. The pupils were held back at school that day until the wreckage could be cleared.

Account of Jack Scott

A colleague, Linda Furtak, suggested I contact her mother, Margaret Furtak, *née* Scott, as she was born and bred in the Red Row area. Margaret put me in touch with her cousin, a Chevington Drift man who now lives in Hexham, Jack Scott. At the time of this collision, Jack was eight years old and lived at 15 Hartside, Chevington Drift and as he said, 'must have bunked off school'. Jack recalls helping his father to fill the coal bucket from the coal shed in the back yard when he heard two aircraft overhead. They were flying from opposite directions, but he did not know if they were Hurricanes or Spitfires. He looked up as they approached each other and saw them collide, with one of the aircraft looking like it was going to crash near Chevington Drift. Jack said he 'took off with deaf ears', ignoring his father's shouts to come back. He ran to the back of Hedgehope Terrace, through the allotments to a place known as the Green Seat, at the top of the 'Drift'. He can recall seeing the torso of the pilot on the ground; a local man from the Drift placed his top coat over the body, an admirable act of decency, as most people had only one top coat.

Jack's description of the location of the site matches with that of Ethel Elliott, Gordon Black and Jim Wilson, this being Joe Hakin's Field, on the north side of the road leading to Chevington Drift.

Account of Bruce Jobson

Bruce Jobson is the son of Willy Jobson, who grazed livestock in the field where one of the aircraft had crashed. Bruce relayed the tale his father had told him about the collision.

Willy had been breaking ice in the water trough between Liddle's Field and the Parish Hall Field on a cold winter's morning at around 10.30 a.m. He saw two aircraft coming from the east when they collided. The one aircraft lost its

tail (which landed in the Stinky Burn) and crashed to the ground approximately 30 metres from him. Willy recalled that the machine guns were firing as the aircraft hit the ground. Willy was first on scene; the aircraft was in the ground, but the cockpit was clear. He saw that the pilot's tunic was covering his head and pulled it down for signs of life, but he found that the pilot was dead.

This account of the happenings matched with the timings in the Squadron ORB and F1180. All locals in Red Row know this field as Jobson's Field, Pettica's Field or the Show Field, but to most it is Jobson's Field. Bruce informed me that his father never owned the field; he just rented it from a chap called Liddle, and it really should be recorded as 'Liddles Field'.

Official Documents

At first, I could not find any trace of a collision over Red Row/South Broomhill; the book I was using for reference had the nearest collision as being Longhoughton on 18 Jan 1940. I decided to review this collision as the pilots were named in the book, and sent for their death certificates (rather macabre, I know). On receipt of these it became obvious that there was an anomaly in my reference book; the death certificates were of Sgt Edwin Gilbert Peter Mullinger and Sgt Henry John Steeley, both of 43 Squadron, RAF, and they were recorded as Red Row, not Longhoughton, which is some 14 miles to the north of Red Row.

I contacted Andy Saunders, who wrote a history of 43 'Fighting Cocks' Squadron, as he had mentioned this collision in his book as happening 'near Broomhill'. Unfortunately, he had no further information.

I next contacted the National Archives for copies of the 43 Squadron Operational Records Book (ORB). This came under AIR 27/441 for 18 Jan 1940. This confirmed the collision over Red Row.

I now had confirmation of two crash sites, but could not ascertain which was which.

My next move was to contact the RAF Museum, Hendon, for the F1180s (Loss Cards) for these two aircraft. What I needed to know was which aircraft had lost its tail, and I could then allocate the correct aircraft to the sites. This document was not available.

The Broomhill Police Occurrence Book for 18 January 1940 records that 'one plane landed behind the police station and the other in a field east of Chevington Welfare Field'.

Contacting the Air Historical Branch brought the final part of my search together. I had confirmation of the two sites: I needed to resolve which site was which. All I needed to know was which of the two aircraft had lost their tail. This was provided, which meant I could positively identify each site, as the AHB hold a copy of the F1180, but data protection prevents issue.

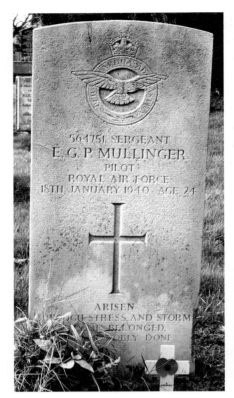
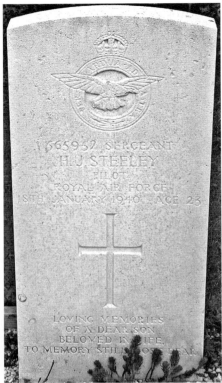

Above left: Gravestone of Sergeant Edwin G. P. Mullinger. (Author)

Above right: Gravestone of Sergeant Henry J. Steeley. (Steve Rogers, The War Graves Photographic Project)

From a contact in Australia, I was put in touch with Karen Hunt, *née* Steeley. Karen is the great-niece of Sgt H. J. Steeley. While researching her family, Karen had gathered that her great-uncle had died at Longhoughton. Producing the evidence I had discovered for Karen it has brought closure to the Steeley family which in turn has helped Sgt H. J. Steeley's brother (Karen's grandfather) to open his brother's flying log, something he was unable to do since the loss of his brother in 1940.

My research complete, I could then join the local stories with factual evidence.

A Brief Account of the Crash

At 10.30 a.m. on 18 January 1940, a flight of three Hawker Hurricanes of 43 Squadron RAF took off from RAF Acklington for air firing practice. They were

L2066 (pilot: Sgt H. J. Steeley), L1734 FT-G (pilot: Sgt E. G. P. Mullinger) and L1849 (pilot: F/O W. C. Wilkinson). At 10.45 a.m., flying at 800 feet, L2066 and L1734 collided, causing L1734 to lose its tail and both aircraft crashed. Sgt Mullinger crashed in Liddle's Field and, minutes later, Sgt Steeley crashed in Joe Hakin's Field. At 10.55 a.m., L1849 landed at RAF Acklington. As the crash sites were within easy access of the airfield, the large wreckage was removed with Bedford trucks which were equipped with Coleman cranes.

The funeral of Sgt John Henry Steeley took place on Wednesday 24 January 1940, conducted by Revd C. H. S. Matthews, at Kenilworth Cemetery, Warwickshire.

The funeral of Sgt Edwin Gilbert Peter Mullinger took place on Monday 22 January 1940, conducted by Revd J. M. Fray, at Chevington Cemetery, Red Row, Northumberland.

Sergeant J. H. Seeley: Plot 1, Section B, Grave 192, Kenilworth Cemetery
Sergeant E. G. P. Mullinger: Section BB, Grave 148, Chevington Cemetery

The Sites of the Crashes

Hawker Hurricane Mk I L2066 FT-
Pilot: 565952 Sgt Henry John Steeley, age 23 +
Squadron: 43, RAF Acklington
Site: Joe Hakin's Field, Red Row
Grid: NZ25196 99722
Map: O/S Explorer 325

Hawker Hurricane Mk I L1734 FT-G
Pilot: 564751 Sgt Edwin Gilbert Peter Mullinger, age 24 +
Squadron: 43, RAF Acklington
Site: Liddles field, Red Row (known locally as Jobson's Field)
Grid: NZ25301 99517
Map: O/S Explorer 325
Note: No wreckage remains at either site

Sergeants Steeley and Mullinger are remembered on the memorial to twenty-nine aircrew and thirteen aircraft in the former RAF Acklington church, St John the Divine, Red Row, unveiled on 7 May 2011.

Sadly, Eddy Dunn passed away on 30 July 2010. Had it not been for this man's experiences and recollections, I would never have started researching and resolving the Red Row, Broomhill and Acklington crash sites.

Bibliography

Chorlton, Martyn, *Airfields of North-East England in the Second World War*
Franks, Norman R., *Fighter Command Losses* Vol. 1
Saunders, Andy, *No. 43 'Fighting Cocks' Squadron*
Stewart, Elizabeth, *RAF Acklington*
Walton, Derek, *Northumberland Aviation Diary 1790–1999*

Reference

AIR 27/441 - 43 Sqn ORB
AIR 28/17 – RAF Station Acklington ORB
Basil Oliver
Broomhill Station Police Occurrence Book
Bruce Jobson
Commonwealth War Graves Commission
David Dunn
Dennis Gray
Eddy Dunn
Eric Wood
Ethel Elliott
Falon Nameplates www.falonnameplates.com
F1180 – Loss Card
Gordon Black
Iain Arnold – Hawker Hurricane Society
Jim Wilson
Karen Hunt, *née* Steeley
Mike Hatch – AHB
Mrs Joan Rose, Northumberland and Durham Family History Society
Ordnance Survey Maps
RAF Commands web site – www.rafcommands.com
Register of Burials (War Graves) Chevington Cemetery
Register of Burials (War Graves) Kenilworth Cemetery
The Aviation forum – www.keypublishing.com
War Graves Photographic Project

HURRICANE AM282

Hawker Hurricane Mk IIb AM282
539 Squadron RAF Acklington

Parish Hall Field
Red Row
4 November 1942

Eddy Dunn recalled an aircraft crashing in what is now Druridge Bay Middle School Field during the Second World War. This was to be the second site I was to be directed to from memories of Dave's father Eddy. He could recall the crash at Red Row Parish Hall Field as it was very close to the Hawker Hurricane collision crash sites in January 1940, but he could not recall the type of aircraft. Once researched, it emerged that the site of Hawker Hurricane AM282 is within 150 metres of that of Hawker Hurricane L1734 from 18 January 1940 described in Chapter 5.

Druridge Bay Middle School Field

The site of this school is in what was known as 'Parish Hall Field', which is still called this by the older generation of the village to this day.

I contacted the history teacher at Druridge Bay Middle School to see if the school had any records or stories of an aircraft crashing in its field. Tales were known, but no specific dates or aircraft type. There were tales of a German bomber, but no facts were known.

Account of Ethel Elliott

While researching other crash sites (Spitfire K9935, Hurricanes L1734 and L2066), I was introduced to Ethel Elliott, who once again would prove to be excellent in her recollections from this period.

An example of a Hawker Hurricane Mk IIb. (Roger Syratt)

Crash site of Hurricane AM282. (Author)

Ethel recalled being sixteen at the time and 'used to help out' at the Parish Hall which backed onto Jobson's Field, serving tea and refreshments. Ethel could not recall the type of aircraft but remembered seeing a crashed aircraft in the Parish Hall Field (now Druridge Bay Middle School field), although she could not identify the aircraft type.

Account of Eric Wood

Through David Dunn I was introduced to Eric Wood, who lived on the border of South Broomhill and Red Row. Eric Wood was eleven years old at the time of this crash and was attending North Broomhill School. He recalls that the day after the crash, he was aware that it had happened. He and a few friends attended the site after school the next day. The site was guarded by the army, but he saw lots of .303 ammunition on the ground and Browning machine guns, buckled and bent, sticking out of the ground. A girl was in the group visiting the site and while crossing the field she picked up a gauntlet ... it still had a hand inside.

Eric could not be sure if the aircraft was a Hurricane, Beaufighter, Defiant or a Lysander, but knew that all these types of aircraft flew from RAF Acklington.

However, Eric walked me into the school field, describing where the field entrance used to be and that the school boundaries were the original Parish Hall Field boundaries. He walked to a position in the field, stating that this was where aircraft had crashed; he was very positive about the location but after landscaping for the building of the school, the field may have been raised in depth.

Account of Willy Jobson (Retold by his Son Bruce Jobson)

Bruce Jobson is the son of Willy Jobson, who grazed livestock in the field where Hurricane L1734 had crashed; this field is next to the Parish Hall Field. Bruce relayed the tale his father had told him about the crash.

Willy, as well as owning his own farm, also owned a house which was on Red Row Front Street and backed onto the 'Parish Hall Field', and an aircraft had crashed directly behind his father's house.

Bruce asked what I knew of the crash. I explained that it had happened at night and that a witness to the wreckage, Eric Wood, had walked me to a spot in the school field. I pointed out the location; Bruce confirmed this as the spot his father said the aircraft had crashed on an evening. This final piece of the story matched with the timings in the Squadron Operational Records Book and the F1180 Loss Card.

Official Documents

I firstly checked my reference book for any possibilities and came up with a 539 Squadron fatality, this being Hawker Hurricane Mk IIb AM282.

I contacted Andy Saunders, who wrote a history of No. 43 'Fighting Cocks' Squadron, as 539 Squadron were a Turbinlite unit and 43 Squadron had started Turbinlite operations with 1460 Flight (Havocs) at RAF Acklington in 1941.

I next contacted the National Archives for copies of the 539 Squadron Operational Records Book (ORB). This came under AIR 27/2006 for November 1942. This confirmed the crash of Hawker Hurricane AM282 at Red Row. Also, AIR 28/17 RAF Acklington Station ORB confirmed the crash.

My next move was to contact the RAF Museum Hendon for the F1180 (Loss Card) for this aircraft. What I needed to know was, as near as possible, where in Red Row this aircraft had crashed. This revealed that the aircraft had stalled and crashed two miles east of RAF Acklington at 19.40 hours, on approach to the airfield. Drawing a straight line on the map 2 miles east of the airfield (in line with the one of the runways) led to Druridge Bay Middle School Field, this being the Parish Hall Field of the 1940s.

I then contacted the Registrar Office at Morpeth, to obtain the pilot's death certificate; this revealed that 1332525 Sgt Dennis Charles Bryant had been killed in a flying accident at Red Row.

A Brief Account of the Crash

On 4 November 1942, Hawker Hurricane AM282 of 539 Squadron RAF took off from RAF Acklington for a Turbinlite patrol with 1460 Flight (Havocs) at 18.20 hours. The pilot was 1332525 Sgt Dennis Charles Bryant. After flying for one hour twenty minutes the weather closed in and flying was finished for the night. On approach from the east to the north-west runway, AM282 stalled and crashed to the ground at the Parish Hall Field, Red Row, bursting into flames and killing the pilot. A member of the local fire brigade was charged with stealing a reflecting mirror from the aircraft to the value of 2s 6d.

As the crash sites were within easy access of the airfield, the large wreckage was removed with Bedford trucks equipped with Coleman cranes.

Sergeant D. C. Bryant: Square 111, Grave 7424, Camberwell New Cemetery

Note: Sergeant Bryant is remembered on the memorial to twenty-nine aircrew and thirteen aircraft in the former RAF Acklington church, St John the Divine, Red Row, unveiled on 7 May 2011.

The Site of the Crash

Hawker Hurricane Mk IIb AM282 539 Squadron RAF

Pilot:	1332525 Sgt Dennis Charles Bryant RAFVR, age unknown +
Squadron:	539 Squadron, RAF Acklington
Site:	Parish Hall Field, Red Row (now Druridge Bay Middle School Field)
Grid:	NZ25676 99233
Map:	OS Explorer 325
Note:	Nothing remains at the site

Bibliography

Chorlton, Martyn, *Airfields of North-East England in the Second World War*
Saunders, Andy, *No. 43 'Fighting Cocks' Squadron*
Stewart, Elizabeth, *RAF Acklington*
Walton, Derek, *Northumberland Aviation Diary 1790–1999*

Reference

AIR 27/2006 – 539 Sqn ORB
AIR 28/17 – RAF Station Acklington ORB
Broomhill Station Police Occurrence Book
Bruce Jobson
Commonwealth War Graves Commission
David Dunn
Dennis Gray
Eddy Dunn
Eric Wood
Ethel Elliott
F1180 – Loss Card
Falon Nameplates www.falonnameplates.com
Mrs Joan Rose, Northumberland and Durham Family History Society
Ordnance Survey Maps
War Graves Photographic Project

SPITFIRE NH700

Supermarine Spitfire Mk XIV NH700 VP-L
322 (Nederlands) Squadron
RAF Acklington

Dove Crag, Tosson Hill, Simonside
Rothbury
11 April 1944

27 January 2008

I had consulted my reference books and to my surprise a six-figure grid reference had been quoted, that being NZ041 988. Using the Ordnance Survey Map Outdoor Leisure 42 (OL42) and armed with my newly purchased handheld Global Positioning System (GPS), this was to be an easy nut to crack. The six-figure grid reference, once plotted in my GPS, should, with any luck, place me to within 100 metres of my location. I had tried and tested my device a few weeks earlier and found that if I stopped when the GPS marked 'you are here', then I would search in a 100 metre circle very similar to a spoked wheel. This method had proved very effective on my trials and I saw no reason for it to fail today. I set off from the Lordenshaw car park at 8 a.m., full of energy, ready to tick this site off my list. The hill was heavy going as it was foggy and pouring with rain. Clearing the crest of the hill, I was within 200 metres according to my GPS. I had also gathered information which suggested that once I had crested the hill, I

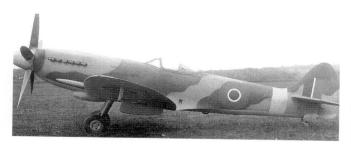

Spitfire Mk.XIV.
(RAF Museum
Hendon)

would see the corner where two fences joined in a V-shape to the north and that if I drew an imaginary line from this point, the site was 100 metres from there. Well, I saw the V-shape in the fence and drew the imaginary line, looking for a depression that had different foliage to most of the hill.

Now, I have the most vivid imagination, but I must admit it must have shut down as I could see three or four depressions in my 100 metre circle, which was located near enough 100 metres from the V in the two adjoining fences. All the depressions had similar foliage, but all were over 50 metres apart. I trudged through the bracken to each depression to see which was the correct site. All looked the same and none were convincing, so I decided to leave the hill and talk to the locals.

Account of Colin Pringle

Colin Pringle has lived in the Rothbury area all of his life, and has helped various researchers in the quest to find crash sites. I rang Colin to see if he had any information with regards to this site. Colin could recall that at school in the late 1960s, he had been taken on a field trip up the Simonside Hills to the Dove Crag area. The trees at this time were only around 2.5 metres in height and features on the hill were easy to see. He recalled being taken down a track and seeing pieces of aircraft fuselage 'the size of bin lids', about 5 to 10 metres into the trees. The school group had a bit of an investigation around the area and uncovered live 20 mm cannon shells. This caused a bit of a stink, and the local police were called to remove the live ammunition. Over the years Colin has walked the Simonside Hills but since the forest has grown, he has been unable to locate the site.

Account of Tom Snaith

After leaving the hill, I set off for Great Tosson Farm, Rothbury. At the time of this crash, Tom was ten years old and was going on a shopping trip to Rothbury with his mother. Tom could recall that the aircraft came out of the cloud at speed and crashed just below the summit of Dove Crag, on Tosson Hill, above their farm. Tom remembers a large explosion and a plume of black smoke. In 1944 Tossen Hill was a clear hill, so the crash site was visible from certain angles. Now the hill has a pine forest planted on its slopes, making navigation to the site from the farm difficult as no features are visible: it is all covered by trees. Tom explained that the grid reference I had was as near as he could remember.

Initial finds from the wreckage of NH700. (Author)

Account of Jim Wilson

At the age of sixteen, Jim Wilson was working at Whitton Glebe Farm, Rothbury. On 11 April 1944, he had been harrowing in the west field. His day was nearly at an end and he was removing the halter from the horse to pack up for the day. Jim had noticed a Spitfire diving in and out of the cloud cover over Simonside Hill. Jim saw the Spitfire dive out of the cloud at speed, and he realised that the aircraft was not going to recover from the dive. He saw the aircraft slam into the side of Simonside Hill and explode. Near the cemetery in Rothbury was a prisoner of war camp, which held both Italian and German prisoners. An army sergeant ran from the camp, passing Jim; Jim advised him there was no point running up the hill as the aircraft had disintegrated and there would probably be little or no chance of the pilot surviving.

Account of Steve Mills

I called at the nearest farm, Lordenshaw. I had two reasons for this visit; for NH700 but also for the site of Hawker Hurricane V6868, which had reportedly crashed at Lordenshaw, although no one could confirm as the F1180 (RAF Loss Card) for V6868 only stated Rothbury.

Steve, a gamekeeper on the Duke of Northumberland's estate, was aware of the crash on Dove Crag, but was unaware of its location. He also confirmed my doubts that the location of V6868 was Lordenshaw. He impressed on me that there were no air crashes on the Lordenshaw land.

However, what Steve did tell me was the story of how Lordenshaw was bombed in 1941. Foresters had been working in the area, and had been burning the off-cuts of their felling work. At the end of the day's work the fires had not gone out, and the practice was to cover the fires with sods of earth to smother them. All fires covered, the foresters left for the night. That night, a German bomber dropped its bombs over Lordenshaw. Bombs landed in the woods surrounding the farm, but one landed at the back of the farm house, blowing the back wall of the house down and collapsing the bedroom floor. Steve's grandparents were sleeping in the back bedroom and when the wall blew out. Still in their bed, they slid into the rubble in the yard, unhurt. It is believed that the embers of the buried fires had burned through the soil and were visible from the air, hence the bomber having a target. Even today the bomb craters are visible in the surrounding woods.

Steve suggested I contact Jim Mather, who was a forestry worker when Tosson Hill was planted and had worked as a gamekeeper in the area for most of his life.

Account of Jim Mather

Finding Jim proved difficult at first, but I eventually tracked him down. Jim could remember that in the 1950s, when the planting of the hill with pine trees started, he could recall seeing bits of aircraft (hydraulic pipes, etc.) on the hill. I showed Jim on the map the area the grid reference had taken me to. Jim totally disagreed with where I showed him and pointed to another area, some 600 metres west of where I had been searching. He described the route from the Lordenshaw car park to the site and what land features I should see; I would be travelling in a westerly direction. From the Lordenshaw car park, start to climb the hill, the track splits, take the right hand route until you come to what is now known as Beacon Hill and in front of you there is a fence; this is the 'Duke's fence', as it marks the border of his land. Turn right at the fence and walk until you see a step stile (for gamekeepers); cross the fence at the stile and follow a small foot path. On your left you will see boulders, then the path joins the forestry track. To your left is a track to Dove Crag; do not turn here but keep moving forward for approximately 100 metres; just as you crest the this part of the hill, the crash site is either side of the track. His next bit of advice was to visit Bill Cairns at Longframlington.

Account of Bill Cairns

I arranged to meet Bill the same day; Longframlington was only 4 miles from Jim Mather's. Bill was the subcontracted bulldozer driver for the Forestry Commission on the Simonside Hills and Harwood Forest areas of Rothbury in

the 1950s. Bill could also recall aircraft remains on Dove Crag. Bill's job was to make the forestry tracks for the easy access of forestry vehicles during planting and to enable easy management of the forest in the future. Bill was driving an ex-military bulldozer which had served on the beaches of Normandy. His description was the route from the west travelling east. Bill explained that he had to complete a track, but had to turn south to create a 'vista' (fire break) so as to ensure a view of Dove Crag. He said the reason why the track could go no further was because of large boulders. From this vista he told me to move back approximately 150 metres, to a crest in the hill; here is the crash site. Bill was positive he did not drive over any wreckage; it was either side of him.

7 February 2008

I asked a colleague from the ACIA, Russ Gray, if he would like to come to this site as I had three accounts of wreckage and two were pinpointing a very likely site. Russ also had a metal detector (I was still saving up for mine). I requested access to use a metal detector from the Rothbury Forestry Office, which was granted. We set off from the Lordenshaw car park on yet another damp and foggy day, over Beacon Hill to the 'Duke's fence'; as Jim Mather had said, we turned right, following the fence until we came across a step stile. Climbing over, we followed the small single-tracked footpath; very soon, boulders appeared to our left and the path joined the forestry track. These must have been the boulders that Bill Cairns said prevented him from going any further with his bulldozer. In front of us was the brow of a small hill. Both Jim and Bill's descriptions were proving to be true; the only difference was that the trees were now some 60 to 70 feet in height. Where the path met the track was our start point, Russ with his metal detector and me armed with my Swiss Army entrenching tool, ready to dig at the first bleep of the machine! The track had no signs of any debris, matching Bill's recollection that he did not bulldoze over the top of the site. Five metres to the right of the track in the tree line, we found fragments of hydraulic piping and oxidised alloy, atypical of other sites we had explored. The area was alive with tiny fragments of oxidised alloy. This also matched with Colin Pringle's recollections that the wreckage was indeed in the tree line.

6 April 2008

This was to be my first outing with my own metal detector and Russ was unable to make the trip. My rucksack loaded with my detector sticking proudly out of the top, Swiss Army entrenching tool clipped to my belt, I must have looked the most promising nerd ever as I revisited the site! This day had a great change ... it was

 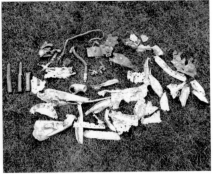

Above left: First positive fragments identified of NH700. (Author)

Above right: Fragments from NH700 after having been cleaned. (Author)

sunny and I had my trusted aircraft hunter with me, Penny my poodle at the grand age of fourteen. Arriving on site, I started to try my new machine. Before long I was finding lots of fragments on both sides of the track, just as Bill and Jim had said. They were buried under forty years of pine needle debris at a depth of up to 50 cm.

The fragments, although small, were plentiful and possibly there is more to find.

Official Documents

I firstly checked my reference books for any possibilities, and this 322 Squadron fatality was recorded. This crash became more of an interest to me as it was from RAF Acklington, this being Supermarine Spitfire NH700.

I next contacted the National Archives for copies of the 322 Squadron Operational Records Book (ORB). This came under AIR 27/1716 for April 1944. This confirmed the crash of Supermarine Spitfire NH700, but not the site.

My next move was to contact the RAF Museum Hendon for the F1180 (Loss Card) for this aircraft. What I needed to know was where, or as near as possible, it had crashed. This revealed that the aircraft had crashed at Rothbury.

I then contacted the Registrar Office at Morpeth, to obtain the pilot's death certificate, which revealed that 132085 Flying Officer Jacob Wilhelm van Hamel had been killed in a flying accident 4 miles south-west of Rothbury.

A Brief Account of the Crash

On 11 April 1944, F/O Jacob 'Jaap' Wilhelm van Hamel took off from RAF Acklington at 15.50 hours on an altitude test. At 16.05 hours, the aircraft was

Grave of F/O 'Jaap' van Hamel.
(Author)

seen to crash on a hillside to the south-west of Rothbury. It is noted in the 322 Squadron ORB that 'difficulties' were being experienced in converting to the new mark of Spitfire. One of the faults was the Coffman starter of the Griffon engine and another was a fault with the oxygen system. It is understood that oxygen failure, causing the pilot to 'black out', was the cause of the crash.

The aircraft was seen to come out of cloud in an inverted dive, struck the hill side of Dove Crag south of Great Tosson Farm and disintegrated in a ball of flame. It is noted in the 322 Squadron ORB: 'This is a blow for the Squadron P/O Van Hamel was a pilot with experience and we will all miss him deeply.'

The funeral of F/O Jacob 'Jaap' Wilhelm van Hamel took place at 14.00 hours on 15 April 1944, at Chevington Cemetery, Red Row, Northumberland.

Flying Officer Jacob Wilhelm van Hamel: Section H, Grave 249, Chevington Cemetery

Jacob Wilhelm van Hamel was a courageous man who had, on the night of 20–21 June 1941, along with 'Rudi' van Daalen Wetters, escaped the Gestapo by canoeing across the North Sea. The canoe had a small outboard motor, but this had failed and they threw it overboard. After four days at sea they were picked up by an Australian destroyer, HMS *Eglinton*, and transported to Britain (the full story of this epic journey can be found in *Where the Hills meet the Sky* by Peter Clark).

The Site of the Crash

Supermarine Spitfire Mk XIV NH700 322 (Nederlands) Squadron RAF
Pilot: 132085 F/O Jacob Wilhelm van Hamel RAF, age 23 +
Squadron: 322 Squadron RAF
Site: Dove Crag, Tossen Hill, Simonside, Rothbury
Grid: NT03458 98801
Map: OS Outdoor Leisure 42
Note: Fragments remain buried at the site

Bibliography

Chorlton, Martyn, *Airfields of North-East England in the Second World War*
Clark, Peter, *Where the Hills Meet The Sky* (1st and 2nd edn), Glen Graphics 1997
Clark, Peter, *Their Corner of a Foreign Field*
Morgan, E. B. and E. Shacklady, *Spitfire: The History*
Walton, Derek, *Northumberland Aviation Diary 1790–1999*

Reference

AIR 29/1716 – 322 Squadron ORB
AIR 28/17 – RAF Station Acklington ORB
Bill Cairns
Colin Pringle
Commonwealth War Graves Commission
Dennis Gray
F1180 – Loss Card
Jim Mather
Jim Wilson
Mrs Joan Rose, Northumberland and Durham Family History Society
Ordnance Survey Maps
RAF Commands web Site www.RAFcommands.com
Register of Burials (War Graves) Chevington Cemetery
Russ Gray
Steve Mills
Tom Snaith

WELLINGTON R1535

Armstrong Vickers Wellington Mk IV R1535 GR-G
301 (Pomeranian) Squadron
RAF Hemswell

The Rumblings, Dunmoor Hill
Breamish Valley
9 January 1943

Having walked past Hartside farm on many a good hike (this is a well-known area to park your car prior to heading into open hills and moorland), I had spoken to the then-shepherd, Malcolm Elliot. He had relayed the tales told to him by Ronnie Oliver (brother of Basil Oliver) about the crash of a Wellington bomber on the hill behind Hartside farm. I had already asked Malcolm for access to the hill to conduct my search; this would provide a useful shortcut on future visits.

10 April 2008

I set off to search for two sites: the Ju 88 on Linhope Rig and the Wellington on Dunmoor Hill. With my trusted air-crash-hunting poodle Penny, we were in for, if nothing else, a good day on the hills. The initial search for the Ju 88 drew

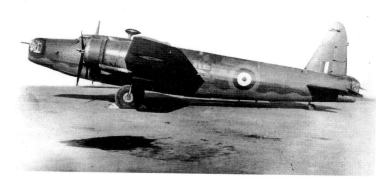

Armstrong Vickers Wellington Mk IV. (RAF Museum Hendon)

a blank, but I had a search area to return to (this would be a success on 4 July 2008). Today's search was hard and gruelling as Penny had given up the chase and was, by 1 p.m., neatly sitting comfortably in my rucksack providing as much dead weight as she possibly could on this steep hill. The day drew a blank, and we returned to my car and headed for home.

I returned to Dunmoor Hill on 5 June 2008, calling in at Hartside. I asked Malcolm Elliot if I could take a shortcut through his farm, so as to shave four miles of the round trip hike to the search area (Penny does get heavy). Again I drew a blank; it was time to draw in the big guns: someone who was there. Only one chap sprang to mind … Basil Oliver.

On 4 July 2008, while preparing to search for Hawker Hurricane N2522 on Megrims Knowe, Basil had pointed out the area on Dunmoor Hill where he remembered the bomber crashing. Because we were searching for three sites on that day, the Wellington site was put to one side for a later date; this was to be arranged.

Basil Oliver's Recollections

At the time of the crash, Basil was attending Ingram school. On the night of the crash, Basil recalls that the aircraft burst into flames when it hit the hill side, lighting up the whole valley. The sole survivor was the rear gunner, Sgt Marian Korczyński, who made his way down Dunmoor Hill to Hartside Farm for help. He had told Basil's father Alex that it was pointless to send a search party to the site to rescue the crew as the crew had all been killed. Sgt Korczyński was taken to Linhope by Alex Oliver, who telephoned the local authorities. Once Sgt Korczyński was bedded down at Linhope, Alex and a few others made their way to the crash site. They reached the site at 2.30 a.m., confirming that the rest of the crew had been killed. The next day, Alex, along with Walter Brown from Greenside Farm, P.C. Jack Inchmore and Sgt Korczyński, set off for the site. It was noted that Sgt Korczyński was a fit man, as he reached the site long before the others. The site was guarded by the Scottish Rifles, the Cameronians, but due to the bad weather instead of being on site in their tents, they were billeted in the upstairs granary space of Hartside Farm.

From the wall at the back of Hartside Farm, facing Dunmoor Hill, Basil informed me that you could only see the tail of the bomber, pointing into the sky; this view was from halfway down the wall towards Greenside Hill Farm, looking northwards.

When the wreckage was removed from the site, the wood and fabric from R1535 were placed onto a large fire at the site; the RAF personnel used the oxygen bottles from the aircraft to assist in lighting the fire. One of the main undercarriage wheels was 'set away' down the hill; it gathered momentum, and eventually came to rest against a wall at the back of Greenside. The rear gunner's

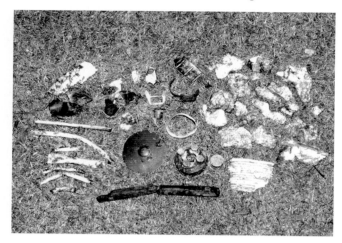

Fragments from
the wreckage of
Wellington R1535
GR-G. (Author)

turret lay out the back of Hartside for some months; Basil and his brothers used to play in it, placing sticks where the machine guns had once been.

25 August 2008

Meeting at Ingram Farm to look for this site, the team was myself, Sarah Wilson, Basil Oliver, and Penny.

Basil was near the age of thirteen at the time of this crash, and at the time of our first visit he was seventy-nine. His recollection of the crash was encouraging as he had met the sole survivor, the rear gunner. This made it more personal as to where and what had happened at the time of the crash.

After seeking permission from Malcolm at Hartside Farm, we took the previously agreed shortcut through the farm and headed for the saddle between Dunmoor Hill and Cunyan Crags. This area was the proposed search area. It was a warm, sunny day, so we took our time climbing the quad track which led up to some old peat diggings near the saddle.

Running north to south along the top of Dunmoor Hill is a fence. Basil directed us to an area where this joins a fence towards Hedgehope Hill, 100 metres south along the fence then 200 metres east onto the side of the hill. After two hours there was not a sign of anything, but the rocks on Dunmoor are very magnetic so I had lots of false readings. I did notice, however, that Basil kept going back to one spot; this provided him with a reverse view of Hartside from the crash site. I searched all around Basil in a 100-metre circle, but found no trace. After marking the proposed search area, we decided to leave the hill and head for home. Basil was most upset as we had found nothing, believing he had wasted our time by as he said, 'bringing you to the wrong place'! I had to explain that our previous trip on 4

July 2008 was an exceptional day, in that (a) we located three sites and (b) we had found evidence at two of the sites. This site would take possibly a few more visits.

12 November 2008

I returned to Dunmoor Hill with my trusted pooch, Penny. Checking with Malcolm Elliot at Hartside Farm for access through the farm, I reminded him of a tale from Basil that when his brother had ploughed Megrims Knowe in the 1970s, he had unearthed fragments of Hurricane N2522 and had stored them in a sack in the barn at Hartside. Malcolm was aware of the tale, but did not remember seeing anything when he had took the farm over; he said he would look around for me. An hour later, I was in heavy rain and thick fog on Dunmoor hill when I heard the sound of a quad bike. Out of the fog came Malcolm, shouting he had something that might interest me … In the tray on the back of his quad was a Hawker Hurricane wheel which he had found under the stone staircase of his barn; it had been there since 1941 … Even Basil did not recall it at the farm.

I found no trace of the bomber, but I did have a wheel from N2522, so the day was not as bad as coming away empty-handed, so to speak.

That night, I contacted Sarah Wilson to gloat about the Hurricane wheel, but also to report back of my negative findings of the Wellington bomber. Sarah suggested that she would speak to Ronnie Oliver (Basil's brother), who was nine years old at the time of the crash, to see if he could remember anything.

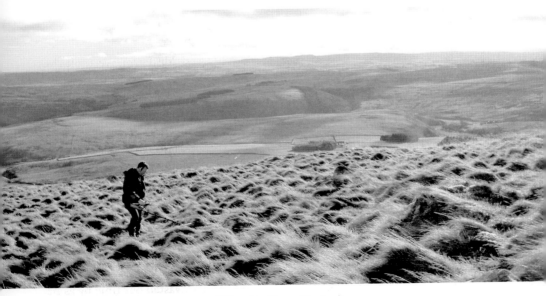

The R1535 crash site, with a view of Hartside Farm. (Author)

Ronnie told Sarah that you can see some loose rocks on Dunmoor Hill, known as 'The Rumblings', which are not marked by name on the OS map. He put the crash as nearer here. His description used the same fence, but 500 metres south (Basil was 100 metres south) to 300 metres east (Basil was 200 metres east).

19 November 2008

I decided to 'split the difference' between the two advised possible locations and marked a position on my map 300 metres south and 150 metres east. It was a bright, sunny, crisp day. I did not have Penny with me, as she had just been clipped at the parlour and Mrs Davies would have lynched me since Penny had just been groomed. I arrived at my chosen location, climbing slightly higher as my thought was, 'It's easier to move down hill than up'. I had been on site ten minutes, and at 10 a.m. I found fragments of oxidized alloy, alloy pipes, burnt wood and molten (heat-damaged) engine alloy. This was positive proof of the site of Wellington R1535 GR-G. I contacted Sarah on my mobile phone; I barely had a signal and left a garbled, excited message on her answer phone.

Since I now had a positive search area, I left my rucksack and metal detector and walked to the original search area I had marked when I came with Sarah and Basil on 25 August. I walk on average 115 paces to 100 metres. From the marked spot back to the crash site was 260 paces, approximately 225 metres, and on the same contour line; I had not moved up or down the hill in height

Author at launch site of Basil and daughter. (Author)

from the original search area. Amazingly, the view of Hartside appeared to be the same; Basil and Ronnie were both close in their recollections of where R1535 had crashed, but without any big artefacts to easily find covering a 200-metre-wide circle, it is difficult to locate on an open moorland hill. Sarah sent the pictures off to Basil to show the location and Basil could not believe it: a week or so after he had climbed Dunmoor with Sarah and I he had gone up with his daughter see if he could find any trace. They had stopped for lunch at the very spot where I had found the fragmented remains of the aircraft.

Official Documents

Firstly, checking my reference books for any possibilities, I came up with a 301 Squadron crash, this being Vickers Wellington Mk IV R1535 GR-G.

I next contacted the National Archives for copies of the 301 Squadron Operational Records Book (ORB), which came under AIR 27/1660 for January 1943. This confirmed the crash of Vickers Wellington R1535.

My next move was to contact the APC Polish Historical disclosures, at the Air Historical Branch. They helped confirm the correct names of the crew.

No F1180 (Loss Card) or Bomber Command loss card for this aircraft exists (P. Clark, *Where the Hills Meet the Sky*).

I checked on the 301 Squadron website and got in touch with its author, Wojciech Zmyślony. On this site also was an account by Andrzej Sokoliński (son of the navigator, kpt. Sokoliński) of his father's life. I was also introduced to Wilhelm Ratuszyński, who provided the Polish ranks and the initial contact with Frances Gates in Australia, who was able to contact relatives of the crew for me, most importantly Marta Slaska, great-niece of Por. Pil. Tadeusz Jan Tylara. Marta also translated documents from the Polish Institue and Sikorski Museum.

I had success with the Polish Institute and Sikorski Museum, which provided photographs of the crew and the statement provided by the sole survivor of R1535, the rear gunner, Kpr.strz. Marian Korczyński.

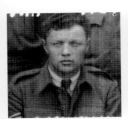 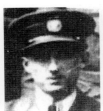

From left to right: Sgt Marian Korczyński, Por pil Tadeusz Tyrala, Por obs Tadeusz Sokoliński, Kpr rtlg Jozef Pasierski, Kpr strz Ernest Tabaczyński. (Polish Institute and Sikorski Museum)

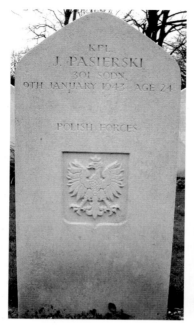
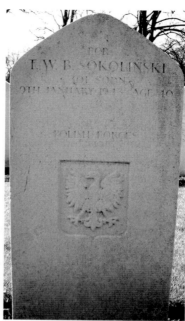

Above left: Gravestone of Kpr r/op Jozef Pasierski. (TWGPP)

Above right: Gravestone of Por obs Tadeusz Sokoliński. (TWGPP)

Below left: Gravestone of Kpr strz. Ernest Tabaczyński. (TWGPP)

Below right: Gravestone of Por pil Tadeusz Tyrala. (TWGPP)

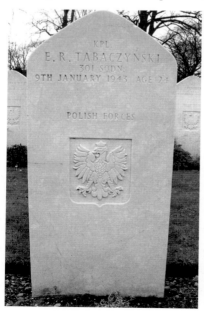
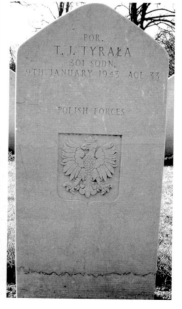

A Brief Account of the Crash

R1535 GR-G of 301 Pomeranian Squadron had taken off from RAF Hemswell, Lincolnshire, at 17.59 hours, along with three other aircraft from this squadron. They formed part of a force of thirty-seven Wellingtons laying mines in the sea around Langeoog, in the Frisian Islands. R1535 reached its target area and dropped its mines. On leaving the area to head for home, it was attacked by two Luftwaffe night fighters; the first night fighter was warded off by the rear gunner, but the second aircraft managed to hit R1535 during its attack. This resulted in the fuel and oil systems in the starboard engine being badly damaged. The aircraft became lost and they believed they were within ten minutes of landing. Fifteen minutes later, R1535 flew into a snow blizzard; it was a long way north of its base at RAF Hemswell and at 22.30 hours it crashed into the south east side of Dunmoor Hill, killing all on board but the rear gunner. Kpr. Korczyński was knocked unconscious. When he came to, he found himself still in his rear turret approximately 80 yards from the main body of the aircraft. He managed to get himself free and drag Por. Sokoliński and Kpr. Tabaczyński free from the wreck; Kpr. Tabaczyński was barely alive. Kpr. Korczyński made his way off Dunmoor Hill to seek help, arriving at Hartside Farm.

Note: Kpr. Marion Korczyński was awarded the *Krzyż Walecznych* (Cross of Valour) on 23 February 1943. He survived the war, reaching the rank of *Chorazy* (Warrant Officer).

Also worthy of note is that all British records have Pasierski, Tabaczyński and Korczyński holding the rank of sergeant, while their graves and Polish records have them as *kapral* (corporal).

Por/pil. T. Tyrala, Kpt./ObsTWB. Sokoliński, Kpr.r/op. J. Pasierski, Kpr.strz. E. R. Tabaczyński are all interned in The Polish War Cemetery, Newark. They are also commemorated on the War Memorial to Polish Airmen, Warsaw.

Memorial

Similar to the site of Hawker Hurricane N2522, we planned to place a memorial plaque on a 1-metre post at the site. The names that had been provided by at least four different sources had put the rear gunner as a Sgt Jan A. Korczyński; British ranks were provided for the crew. I submitted the draft for moulding and received it a few weeks later; all seemed well. I forwarded this to my new contact Frances Gates, who spotted a spelling error in the navigator's name. The engravers accepted the error as theirs and agreed to replace the plaque. I asked if they could wait as I would like to use the Polish ranks; they agreed. Now this is where it began to fall apart. The various sources I had used (about five in all,

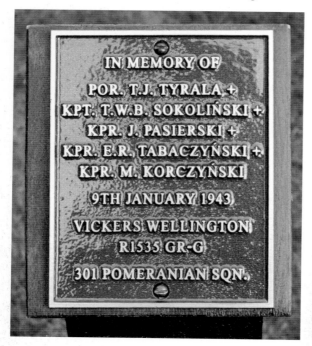

The memorial plaque to the crew of R1535. (Author)

all claiming to be authentic!) had the rear gunner as Sgt Jan A Korczyński, but two new sources had the rear gunner as Sgt Marian Korczyński! I sent off to the APC Polish Historical disclosures and the Sikorski Museum for confirmation of the crew. While I was waiting for a reply, I contacted Basil Oliver and asked if the name 'Marian' meant anything to him; he said yes! They had found it strange as youngsters that a man would have, by British standards, a woman's name!

Also the navigator, Por. T. Sokoliński, had been promoted posthumously to *kapitan*; this meant that some sources record him as a flying officer/navigator (*porucznik/nawigator*). This has now been rectified.

7 May 2010

Plans had been made with Sarah Wilson to erect a memorial at the crash site of R1535 GR-G. I obtained permission from the tenant farmer, Roly Telford, and, for ease of access to the site via a short-cut through Hartside Farm, Alan Hutchins; all was agreed after careful explanations and the date of 7 May was set.

The difficulty would be in carrying the equipment needed to complete the work; the site is at a height of 1,800 feet (504 metres). My initial plan was very basic: I would carry 25 kilos of concrete post mix, the memorial post itself, spade, saw, spirit level and fragments of the aircraft up Dunmoor Hill. Sarah was unable to make the

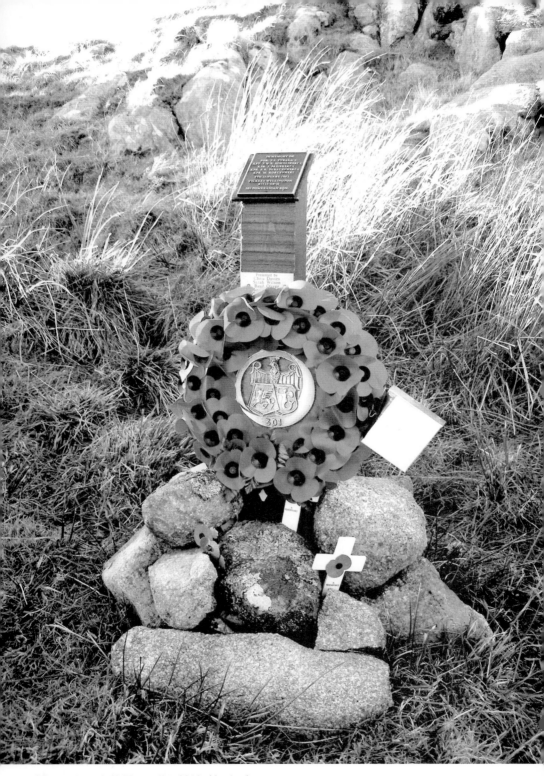

The memorial, 13 November 2010. (Author)

trip due to commitments with lambing, but kindly volunteered her husband Johnnie to assist me in carrying the equipment to the site. Johnnie saved the day by providing his Rhino 4x4 'all-terrain buggy', so what I had planned as a two-hour hike carrying some serious weight was a 30 minute trip taking us to within 800 feet (250 metres) of the proposed site. Penny was sat on my knee, loving the easy route up the hill. We arrived on site at 2.30 p.m., unloaded and prepared the post. Once in position, we stood for a moment in silence, remembering what had happened to these men on a cold, stormy winter's night sixty-seven years previous.

7 June 2010

I received an e-mail from Adam Pasierski, a relation of Kpr Józef Pasierski, requesting to attend the small service to be held on the site on 13 November 2010. Adam lives in Słowackiego 2B/4, Poland. I had made contact some six months ago through Wojciech Zmyślony of the 301 Squadron website. Adam was keen to attend, but didn't answer subsequent e-mails. I was surprised after such a long time that contact had been lost. I passed Adam's details onto Marta Slaska, to help with the language difficulties, to arrange the ceremony.

13 November 2010

The service arrangements grew once I had located family members of the crew. The plan was simple but effective.

Plan A was to have the service 'on site', so to speak; this gave the first headache, as some of those attending would be in their eighties. Sarah would speak to the head gamekeeper of Linhope Estates and ask if he could provide their Hagland and Argocat vehicles to ferry the group up the hill. All things running to a tight schedule, we should have in attendance representatives from RAF Boulmer, a vicar, eyewitnesses, relatives of Malcolm Elliot, a bugler and, most importantly, Marta Slaska and her family.

The week leading up to the memorial service was a nail-biting nightmare. The weather all week had been severe gales and heavy rain, with a forecast for the 13th to be no different. We were then notified that John Queen had been injured in a shooting accident on the 6th (fortunately it wasn't too serious, but serious enough to put him out of action for a few days). On the 10th I received news that the Hagland off-road truck had broken down, and the weather was going to get worse. I had a long chat with Sarah and struck up Plan B.

If all the arrangements went 'pear-shaped' due to the weather and transport, we would hold the service at the back of Hartside Farm, with Dunmoor Hill in the background. Once the service was finished, I would take Marta and her family up to the memorial on foot. I had to consider at all times the safety of everybody

present, and there were those in the group who were a lot older than me, and it is an hour's walk from Hartside to the site, even for an experienced hill walker like me. Plan B was not the best, but it was the safest if it all went wrong.

On Friday the 12th at 7 p.m., I was informed that the Hagland had been repaired and would be available, so Plan A was looking better. I woke up on Saturday the 13th to brilliant sunshine (yes, I had stayed in bed a little longer), there was no wind and no rain, just clear blue skies. Plan A was looking good.

I had arranged to meet at Hedgley Services, Powburn, before moving into the Ingram valley. Sgt Mick Stringfellow was my contact with the RAF; he was to bring Group Captain Jeff Portlock (Officer Commanding RAF Boulmer), along with Flt Lt Bruce McGrath, Sgt John Lewis and Anne Russell (Media Communications Officer). We would meet Marta, Marcin and Natalia Slaska, Lynne and Cheryl Waterhouse (Cheryl is the bugler) for 12.45 p.m. We moved onto Hartside Farm in Ingram Valley, where we met up with Basil and Ronnie Oliver, Betty Elliot (Malcolm's mother) and Sarah. As we arrived, I told Cheryl that there was no pressure, but the BBC Television Look North team were present.

Everybody was loaded into the Hagland, which holds fifteen people; the Argocat had another six. The RAF lads followed to the base of the hill, and the

From left to right: Basil Oliver, Marcin Slaska, Marta Slaska, Sgt Mick Stringfellow, Ronnie Oliver, F/Lt Bruce McGrath, G/Cptn Jeff Portlock, Sgt John Lewis, the author and Penny. (OGL, (C) UK MOD Crown Copyright 2010, RAF Boulmer)

Argocat was sent back down for them. Although it was fine and sunny, there was a wind chill and I felt for the RAF representatives, as we were all wrapped up and they were in their No. 1 dress uniforms – it was a sight seeing them arrive in the Argocat. We were due to start at 2 p.m.

When I got out of the Hagland, there were people already waiting at the drop-off spot. In total, over forty people were in attendance. The proceedings were delayed by ten minutes, so we rearranged the Order of Service as 202 Squadron were to complete a flyover at 2.20 p.m. and could not change their flight plan.

Sarah opened the proceedings. From the south-east, the 202 Squadron Sea King Helicopter was seen to start its approach. With the RAF Ensign flying beneath the helicopter, there was barely a dry eye in the house. I presented the history of the site before 202 Squadron made their second approach, which was directly over the memorial. Marta was invited to unveil the memorial plaque. The Reverend Canon Bob Burston conducted a very moving service, followed by Group Captain Jeff Portlock reading 'The Royal Air Forces Association Dedication'. A one-minute silence was held, followed by 'The Last Post' expertly performed by Cheryl Waterhouse. The service was completed by Marta Slaska reading the 'Kohima Epitaph'.

The afternoon was extremely emotional for all who attended, but more so for Marta, Basil and Ronnie.

I spoke to Basil a few days after the service. He summed the day up in a simple but quite effective statement: 'Please pass on my thoughts and good wishes to Marta and her family, it was emotional to meet members of one of the crew's family, sixty-seven years after what we saw as children. I was glad there was a slight breeze, it masked the few tears I was struggling to hold back. Chris, you can walk tall with your chest puffed out for what you did on Saturday, it will stay alive with me for as long as I live.'

The Site of the Crash

Vickers Wellington R1535 GR-G 301 Pomeranian Squadron RAF

Pilot:	F/O (*por./pil.*) Tadeusz Jan Tyrała, PAF, age 33 +
Navigator:	F/O (*kpt.*) Tadeusz Włodzimierz Bronisław Sokoliński, PAF, age 40 +
	W/Op + A/G – Sgt (*kpr. r/op.*) Józef Pasierski, PAF, age 24 +
	B/A +F/G – Sgt (*kpr. strz.*) Ernest Ryszard Tabaczyński, PAF, 24 +
	R/G – Sgt (*kpr. strz.*) Marian Korczyński, PAF, age unknown (survived)
Squadron:	301 Pomeranian Squadron, RAF Hemswell
Site:	The Rumblings, Dunmoor Hill, Breamish Valley
Grid:	NT97154 17885
Map:	OS Outdoor Leisure 16
Note:	Small fragments remain buried at the site

Bibliography

Chorley, W. R., *Bomber Command Losses*, Vol. 4
Chorlton, Martyn, *Airfields of North-East England in the Second World War*
Clark, Peter, *Where the Hills Meet The Sky* (2nd edn), Glen Graphics 1997
Cynk, Jerzy B., *Polish Air Force in World War 2*
Walton, Derek, *Northumberland Aviation Diary 1790–1999*
Wilson, Sarah, *Reflections: The Breamish Valley and Ingram*

Reference

Adam Pasierski
AIR 29/1660 – 301 Squadron ORB
Alan Hutchin
Andrzej Sokoliński
Basil Oliver
Commonwealth War Graves Commission
Dennis Gray
F1180 – Loss Card (missing)
Falon Nameplates www.falonnameplates.com
Frances Gates
Johnnie Wilson
Lord James Percy – Linhope Estates
Malcolm Elliot
Marta Slaska
Mrs Joan Rose, Northumberland and Durham Family History Society
Ordnance Survey Maps
Penny
Roly Telford
Ronnie Oliver
Sarah Wilson
Steve Rogers, The War Graves Photographic Project
The Polish Institute and Sikorski Museum
Wilhelm Ratuszyński
www.polishairforce.pl
www.RAFcommands.com

HURRICANE V6868

Hawker Hurricane Mk I V6868
55 Operational Training Unit
RAF Usworth

Hostel Field, Mount Healey
Wagtail Farm
Rothbury
1 July 1941

Since my reference books have this aircraft as crashing in the Lordenshaw area of Rothbury, my first port of call was to speak to Steve Mills, a gamekeeper on the Duke of Northumberland's estate at Lordenshaw Farm. This was 27 January 2008, as I have explained in the search for Spitfire NH700. Steve was positive that no aircraft had crashed on the Lordenshaw land.

Since my initial contact with Steve Mills was with regards to the site of Spitfire NH700, it was not to be until late May 2008 that I started to focus my research on the site of Hurricane V6868.

I was given the contact details of Ken Wilson. He came from Tynemouth prior to the Second World War, but was evacuated to Rothbury on 6 September 1939. The crash he talked about was a Spitfire, and happened *c.* 1941 (he was ten). A flight of three Spitfires (Hurricanes; as Ken put it, 'all aircraft seen by young boys appeared to be Spitfires') flying in a V-formation came from the south-east of the Rothbury area. The left aircraft dipped its wing, dived into the ground and exploded. Ken had witnessed this crash from the Thropton road, to the west of Rothbury. He was on his bicycle with his friend and when they saw the crash, they peddled as fast as they could to the site; it took approximately twenty minutes to get there.

There was little left of the aircraft, and no crater. He remembers there being a tail wheel on the surface, along with some Perspex, and it seemed the aircraft had gone straight in to the ground!

One very large piece of Perspex was taken into school and carved into a horse. (This has now been lost.)

The site as Ken Wilson described it:

Leave Rothbury over bridge (Scots Gap road).

Road starts to climb a hill.

Road turns.

When you see new houses on the left, take a small road to the right.

Continue along the road until you come to a stile.

The crash site is in the field over the stile.

My Search for the Site

This aircraft has had no known location as the F1180 (Loss Card) records the site as 'Rothbury'. It was believed to have crashed at Lordenshaw area of Rothbury, however; nothing was positive, but looking for evidence in the Lordenshaw vicinity was advised.

When I looked at Ken Wilson's description and cross-referenced it with a local map of the area, the search area was easily identifiable.

After seeking permission from the land owner of the field, John Foggon of Tosson Tower Farm, the first search was conducted on 11 June 2008. Here, along with my father-in-law Jim Lynch and trusted air-crash-searching poodle Penny, we followed the directions provided by Ken Wilson. The description by Ken was to the letter; when I spoke to him, he explained that where he stood on top of the hill as a child in 1941 there were exposed rocks (not standing proud, but visible as if being scuffed). At the top of the hill (three to four minutes walk from the stile) his description was perfect, the only difference being that a stone wall had been erected from north-west to south-east in place of a fence that had stood in the 1940s (this fence is marked on maps of *c*. 1935–47). Arriving on site with this sort of detail helps produce a positive

Sgt Maurice Fieldhouse. (Belinda Wormesley)

feeling to your search, however, after three extensive searches, nothing was found except the remains of a very old discarded sheep pen buried over the years. This proved at the time to be disheartening. My next step was to gain access to the field to the east. I could have jumped over the wall and started searching (after all, it seemed like a fallow field), but this was private land and I needed to return several times.

Account of Jack Carr (Retold by his Daughter June Taylor)

Having only partial access to the land on this hill (at the time, the OS map did not give it a name), I contacted another farm, this being Wagtail Farm. Here, I spoke to Ms Jessica Taylor and Mrs June Taylor. June recalled her father attending a crash on the hill above their farm; she explained that he saw the crash and was 'first on scene', and when the fire died down he helped remove the pilot's body from the aircraft. I was pointed towards the side of the hill closest to Wagtail Farm and near the bottom; this field is next to where the original Rothbury Golf Course was located.

24 April 2009

I started to search the bottom field, which proved to be fruitless, although I had found enough bits of farming implements to make my own hay turner. I requested permission to move into the next field (Hostel Field) on my next visit. I remembered Ken Wilson's account, mentioning he could see little of the aircraft (when I spoke to him he believed the aircraft had gone into the ground): this next field had a depression in it which obscured the top of the hill.

7 May 2009

I moved into the next field up the hill. From here, I could see where Ken had stood as a child back in 1941. Adding together that he could not see much wreckage and that Jack Carr was first on scene and helped recover the pilot, this meant that the aircraft did not dive into the ground. I started to look for a dip or blind spot in this field; approximately 100 metres from the road, halfway up the hill, is a blind spot which obscures the top of the hill.

I returned to Wagtail Farm after speaking to Jessica Taylor (who explained her grandmother thought that the bottom field was the wrong field) and was met by Mrs Carr, grandmother to Jessica. She explained her late husband, Jack Carr, was working in the bottom field when the aircraft came down; she also explained that the aircraft came down in the field known as 'Hostel Field', and that the aircraft had indeed crashed at the spot I was in (the dip or blind spot) in the second field.

I later checked on a 1940 Home Guard-issue map, and the hill is called Mount Healey and the field at one time did have a hospital located in it. This small refuge was for children suffering from tuberculosis (I did find a stone medicine bottle near the site of the old hospital).

Account of Monica Wilson, *née* Foster

Monica Wilson (*née* Foster) had just turned eleven years old in the June of 1941. She lived with her parents at Whitton Glebe Farm in Rothbury. Monica did not see the crash of V6868, but was well aware of its location as it had crashed in the field which bordered Whitton Glebe's land.

On the day of the crash, and not long after it had happened, Monica went up to the top of Mount Healy hill to try and see what had happened, but being a child she was kept back (Monica took the same route up the hill to the same spot that Ken Wilson had described).

Monica knew that there was an isolation hospital on the other side of the hill, towards the old golf course, and that the crash had happened in the same field. Monica said one of the first on scene was the 'road man' for the isolation hospital, a Mr Jobson. Monica believed he had been awarded a medal for his actions in trying to rescue the pilot.

Above: Brave Conduct badge awarded to Charles Jobling. (Jim Jobling)

Right: Citation for Brave Conduct awarded to Charles Jobling. (Jim Jobling)

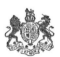

By the KING'S Order the name of
Charles Jobling.
Foreman Roadman, Rothbury, Northumberland,

was published in the London Gazette on
10 April, 1942.
as commended for brave conduct.
I am charged to record His Majesty's
high appreciation of the service rendered.

Prime Minister and First Lord
of the Treasury

I tried every angle of enquiry with the *London Gazette*, changing the name from Jobson to Johnson to Johnston, etc., but I could find no trace of an award to a Rothbury man for this period.

4–5 October 2010

Through Ronnie Oliver, I had been introduced to Air Vice-Marshal Sandy Hunter. I had asked Sandy if he would write the foreword for this book, and Sandy had agreed. I had been tipped off that Sandy was interested in local history as well as RAF history. Knowing that he was from the Rothbury area, I still required the positive identification of the 'road man' and to see if he had been awarded a citation or medal. During our telephone conversation, I asked if Sandy had any idea or knew anyone in the village who may be able to resolve this final part of the background of V6868. Sandy believed he may have a contact, and said to leave it with him.

5 October was to be an eventful day, as replies from sources for other chapters would snowball. Returning home from work, I opened my e-mails; one that jumped out was from Sandy, with the title 'BINGO'; attached was a copy of the citation awarded to Charles Jobling, and a picture of the silver lapel badge, 'For Brave Conduct'. Monica Wilson had been right; the man from the isolation hospital had been the foreman/roadman at the isolation hospital located at Mount Healey.

Account of Jack Jobling, Elder Half-Brother of Jim Jobling

Jim Jobing explained that his father had died when Jim was twelve years old and had never spoken to him about the crash.

Jim's elder half-brother, Jack, had lived at the isolation hospital as a child with his parents (not as a patient). Jack told Jim what he could recall of the crash. It was around tea time when Jack and his father Charles heard an aeroplane spluttering in the distance; it came down very close to the hospital and burst into flames. Jack ran out of the house in his bare feet with his father towards the wreckage; he was sent back by his father because of exploding ammunition. Jack Jobling saw his father pull the pilot from the wreckage; his father Charles was awarded a citation and clasp for his actions on that day.

Jim told me that the isolation hospital later became an outward bounds centre, and was demolished in the mid-1960s.

Probably due to the demolition of the old hospital and landscaping of 'Hostel Field', this might explain why no trace of the aircraft remains on site.

Official Documents

My reference books guided me to Hawker Hurricane V6868 and the loss of pilot Sgt Maurice Fieldhouse; all mention Rothbury, but not where.

The 55 OTU ORB only has one line with regards to the loss of this pilot: '01 July 1941. Flying accident to Hurricane V6868 at Rothbury, Pilot No. R54312 Sgt Fieldhouse, Killed'.

The F1180 (Loss Card) only reports the crash site as 'Rothbury'.

Registrar Office, Morpeth, confirmed Sgt Fieldhouse's death as Rothbury.

Citation for Brave Conduct awarded to Charles Jobling.

A Brief Account of the Crash

On 1 July 1941, a flight of three Hawker Hurricanes of 55 Operational Training Unit (OTU) took off from RAF Usworth, Sunderland, on a 'Cross Country - Low Level training exercise'. One was Hurricane V6868, with Sgt Maurice Fieldhouse at the controls. At 17.20, while flying towards Rothbury in the region of Rothbury Golf Course, the left-hand aircraft, V6868, dipped to the left, stalled and spun into the ground at Hostel Field (nearly two miles from Lordenshaw), near to Rothbury Golf Course (this is not the site of the present golf course). The aircraft crashed and burst into flames. The first on scene was Jack Carr, followed closely by Charles Jobling, who were at first unable to get the pilot free due to the ferocity of the fire. Charles Jobling managed to free Sgt Fieldhouse from the wreckage; it is believed that Sgt Fieldhouse died instantly from multiple injuries, including a fractured skull, broken legs and severe burns to the face and hands. For his actions in the recovery of Sgt Fieldhouse, Charles Jobling was awarded the 'Brave Conduct' badge and citation.

The funeral of Sgt Maurice Fieldhouse took place on Saturday 5 July 1941 at Farsley Baptist burial ground, Calverley, Pudsey, Bradford.

Sergeant M. Fieldhouse: Section D, Grave 840, Farsley Baptist Burial Ground, Pudsey

The Site of the Crash

Hawker Hurricane V6868 Mk I 55 OTU RAF

Pilot:	R54312 Sgt Maurice Fieldhouse RCAF, age 26 +
Squadron:	55 OTU, RAF Usworth
Site:	Hospital Field, Mount Healey, Wagtail Farm, Rothbury
Grid ref:	NU06614 00825
Map:	OS Outdoor leisure 42
Note:	No wreckage or signs of the crash remain

Biblography

Chorlton, Martyn, *Airfields of North-East England in the Second World War*
Gray, Larry, *Fathers Brothers and Sons*
Saunders, Andy, *No. 43 'Fighting Cocks' Squadron*
Walton, Derek, *Northumberland Aviation Diary 1790–1999*

Reference

AIR 27/682 – 55 OTU ORB
AIR 29/682 – RAF Station Usworth ORB
AIR 28/624 – RAF Station Ouston ORB
AVM Sandy Hunter
Commonwealth War Graves Commission
Dennis Gray
F1180 – Loss Card
Jim Jobling
John Foggon
June & Jessica Taylor
Ken Wilson
Monica Wilson, *née* Foster
Mrs Carr
Mrs Joan Rose, Northumberland and Durham Family History Society
Ordnance Survey Maps
Steve Mills
War Graves Photographic Project

STARFIGHTER D-8337

Lockheed F104-G Starfighter D-8337 'Dusty'
312 Squadron (Volkel)
Royal Netherlands Air Force

Dykemans Edge, Otterburn
12 April 1983

While researching subject matter for his book *Air Crash Northumberland*, Jim Corbett asked if on my travels I could find where the Dykemans Edge area of Otterburn was, as that was the site of a 1983 Starfighter crash. Having been introduced to Dave Rutherford on 10 November 2007 with regards to Bristol Beaufort DX118, Dave was able to confirm that Dykemans Edge was on the land his brother Jim Rutherford farmed back towards Alwinton. Contact established, I arranged to meet Jim. He advised the best time to visit the site was when the Otterburn Ranges were closed for a two- to three-week period over the Christmas and New Year holidays. This was to be of an advantage as I was on night shift over this period, which meant I could get to his farm early straight after a shift. Arrangements made, all I had to do was wait for Jim to call.

20 December 2007

On my way to work at about 7 p.m. on 19 December 2007, I got a call from Jim Rutherford to say tomorrow was a good day as the range had just closed. I arrived at Quickening Cote for 8.30 a.m. on the 20th. We had only spoken on the telephone but Jim's brother Dave had verified who I was. Instead of walking to the site, Jim cut a lot of time off the search by taking me to the area on his quad bike … this was going to be a fun trip. Jim pointed out the site of the crash on my map, I loaded an approximate grid reference into my GPS and off we went. It was bright and sunny, but the wind chill on the back of the bike bit in; I now understood why whenever I had seen farmers in winter or summer on quad bikes, they were always wrapped in layers of clothing!

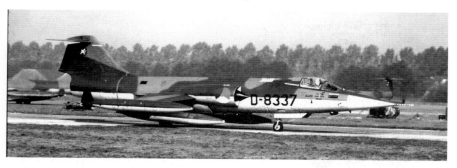

F104-G D-8337 prior to its final flight from RAF Coningsby. (Dutch Air Force)

Nearing the foot of the hill next to the now-disused farm of Old Quickening Cote (Jim's father had farmed this site), Jim told me we would turn left up the hill; I passed the GPS to Jim and it showed the direction of the site to our left. Impressed with my bit of kit, Jim told me to hang on tight as we went up his track on to Dykemans Edge. As we came to a halt at a fence which separated his normal grazing ground and a very wet boggy area next to the Otterburn Impact area, Range B, Jim pointed out the wreckage of D-8337, approximately 200 metres from where we stood. This is an impressive site, with over half of the aircraft still on the site.

During my morning with Jim Rutherford, I happened to mention that I had met a few of his family at various farms throughout the Coquet Valley; Jim's reply did make me smile: 'You kna Chris, we're not aal interbred!' I had not suggested that they were by any means interbred, but before I could get into a chorus of 'Duelling Banjos' from the movie *Deliverance*, Jim had, with a smile, crushed any suggestion of it.

We checked the site, which has a lot of big sections of the aircraft with easily identifiable parts, e.g. the wings, tail section, cockpit, and intake nacelle. To the north of the main site lies the engine, which travelled a further 1 km after the aircraft impacted with the ground. There is plenty of wreckage to see spread over a 300-metre radius on very wet, boggy ground.

While on site, I asked Jim if he was aware of another crash 1 km to the south of this site, a German Tornado. He was unaware, and as time was pushing on we arranged for another day to check this site out.

27 December 2007

Since positively identifying the crash site of D-8337 and sending pictures to members of the ACIA, the group became excited with the amount of wreckage that was on the site. I guided a group of five members of ACIA to the site after seeking permission (only right and proper) for access from Jim Rutherford. The

The tail section of D-8337. (Author)

group, once on site, firmly believed the site of D-8337 could possibly have the largest amount of wreckage at any site in Northumberland.

Contact was made with the son of the pilot of D-8337 (2nd/Lt M. S. Harkema), who lives in Canada. He passed on various documents to Jim Corbett of the aircraft and pilot, including the aircraft's service log and pictures taken at the time of recovery by the Dutch Air Force in 1983.

Official Documents

Checking my reference books for any possibilities, I came up with a F104-G fatality, this being Lockheed Starfighter D-8337, which in turn matched with what I had been asked to locate by Jim Corbett.

Further proof was not required for identification of the site, as the remaining wreckage still had the 312 Squadron markings on the tail fin and the aircraft serial number on the remaining cockpit section, as well as still being on the left hand side of the tail fin. Further evidence was the Dutch RAF roundel on the intake nacelle.

I then contacted the Morpeth Registrar office, to obtain confirmation of the pilot's death; this revealed that 2nd/Lt Martin Sasbrink Harkema, RNAF, had been killed in a flying accident at Dykemans Edge, Otterburn.

Further information supplied by the Dutch Air Force and Martin Harkema's son, Ash Harkema, via Jim Corbett confirmed the details of the aircraft and the

Above: 2nd/Lt Martin Sasbrink Harkema. (Ash Harkema)

Left: Grave of 2nd/Lt M. S. Harkema. (Ash Harkema)

crash site location, including a copy of the Crash Investigation Report. Kimay Harkema, Martin's daughter, confirmed the location of Martin's grave and approved my account of my search.

A Brief Account of the Crash

During the 1980s, the RAF organised NATO training exercises over the Otterburn Training area. These were known as 'Mallet Blow' and would be held four times a year using the 'Charlie' range, which was a mock airfield defended by Surface to Air Missile (SAM) sites, and the 'Bravo' range where aircraft could attack a Bailey bridge and vehicles; very realistic practise as the aircraft would be firing live ammunition on the attacks in the 'Bravo' range.

On 12 April 1983, 2nd/Lt Martin Sasbrink Harkema RNAF was part of a flight of two Lockheed Starfighters, D-8337 and D-8061, attacking the 'Bravo' range; 2nd/Lt Harkema was the pilot of D-8337, 'Dusty'. The two aircraft formed up over the North Sea, setting course for a low-level attack on the Bailey bridge. At 11 a.m., D-8061 was the lead aircraft with D-8337 flying on the port wing. Once the attack had commenced, D-8337 was to change to the starboard wing for a better view of the target and to prevent being caught in the slipstream of D-8061. While homing in on their target, D-8337 got caught in the slipstream of D-8061 and dived into the ground at Dykemans Edge, spreading wreckage over 1.5 km. 2nd/Lt Harkema did not have time or enough height to eject from his aircraft and died in the crash.

2nd/Lt Martin Sasbrink Harkema: Grave No. U064, Municipal Cemetery, Bronkhorst Singel, Uden, The Netherlands

The Site of the Crash

Lockheed F104-G Starfighter 312 (Volkel) Royal Netherlands Air Force

Pilot: 2nd/Lt Martien Sasbrink Harkema RNAF, age 26 +
Squadron: 312 (Volkel) Royal Netherlands Air Force
Site: Dykemans Edge, Otterburn training area
Grid: Restricted (Military impact area)
Map: OS Outdoor Leisure 16
Note: Large remnants of this aircraft remain on site

On 25 April 2011, I was visiting the site of Panavia Tornado 44+47 to take a picture of the Bailey bridge. To get to the bridge I passed the wreckage of D-8337 'Dusty' and noticed that each section of the wreckage was marked by a small taped post. This was in preparation for removal by the Dutch Air Force, which I understand is due to begin in May. The family of 2nd/Lt Martien Sasbrink Harkema were invited to the site prior to the wreckage being removed. It is understood that the wreckage of 'Dusty' will be displayed in Holland.

Bibliography

Corbett, Jim, *Air Crash Northumberland*
Walton, Derek, *Northumberland Aviation Diary 1790–1999*

Reference

Ash Harkema
Dave Rutherford
Dennis Gray
Jim Corbett
Jim Rutherford
Kimay Harkema
Members of ACIA
Mrs Joan Rose, Northumberland and Durham Family History Society
Ordnance Survey Maps
RAF Commands web Site www.RAFcommands.com

BEAUFORT DX118

Bristol Beaufort Mk I DX118
No. 16 Ferry Pilots Pool
Air Transport Auxiliary
RAF Edzell

Brownhart Law
Makendon
23 February 1943

Having assisted in the updating of the Air Crash Investigation and Archaeology group's (ACIA) records by extending my hiking to searching for and locating already recorded sites then providing up-to-date GPS (Global Positioning System) grid references and photographs, I was asked by Jim Corbett if I had any contacts in the Cheviots area with regards to crash sites. At this point in 2007 I had met farmers, etc., but had not really searched for undiscovered remnants. Jim asked if I could do some research on my travels in the hills to see if any positive search area could be found for a Bristol Beaufort DX118 in the Mackendon Farm area of the Coquet Valley. Always eager to learn, I set off to find out as much information as I could for this site.

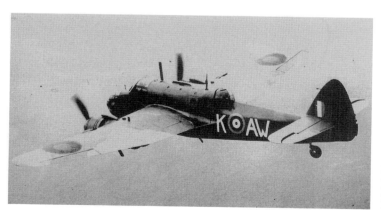

Bristol Beaufort Mk I. (RAF Museum Hendon)

10 November 2007

Setting off for the Coquet Valley at 7 a.m., I arrived at the hamlet of Alwinton, 9 miles from Makendon Farm and the start of my search. As I left the hamlet, heading up the valley approximately half a mile from Alwinton, I saw a shepherd on a trail motorbike coming down from Lords Seat Hill. This would be my first port of call, and he might have knowledge of people further up the valley who could lead me to the site.

This meeting showed great promise, as the chap I had just met had lived at Makendon Farm until a few years earlier. Unfortunately, he had not heard of any aircraft crashing near Makendon. While we were talking, a 4x4 pulled up with Ian Tait, who lived at Barrowburn Farm further up the valley. Ian recalled tales of an uncle of his, who, as a child, had lived at Uswayford during the war. He and a friend had lifted a machine gun from one of the crashed aircraft in the Cheviots, took it home and slaughtered the ducks on the farm. The boy's father buried the gun in a peat bog, not telling anyone where he had buried it. As to which aircraft it had come from, Ian did not know, but within hiking distance of Uswayford there were three possible aircraft which had crashed with weapons on board. Although no positive identification of a site, tales of air crashes from the war years were encouraging.

Ian Tait suggested that we meet up with a cousin of his, Dave Rutherford at Bygate Hall, about a mile before Barrowburn. I followed Ian to Bygate Hall and was introduced to Dave Rutherford. Dave was aware of a crash at Brownhart Law; Dave fixed the site as half a mile west of Makendon Farm, adding that his uncle, Willy Rutherford, and cousin, Jimmy Cowens, had attended the crash as young lads; one of them, Willy, had lived at Fulhope Farm at the time of the crash and had visited the site while the wreckage was still smouldering. He was between twenty-three and twenty-four years old at the time. Dave was also aware of a collision between two Hawker Harrier GR3 fighters on the land he farmed within the Otterburn Training area, and a Lockheed F104-G Starfighter on the land his brother farmed within the Otterburn training area. These sites would be researched at a later date.

The eyewitness who lived nearest to Dave was Jimmy Cowens, who lived at Shillmoor Farm, which I had passed to meet Dave Rutherford. Dave contacted Jimmy Cowens to let him know I was on my way to meet him. Jimmy was seventy-seven and had been thirteen at the time of the crash; he could recall the crash, but could not give a positive site as 'it was a long time ago', but directed me towards the area Dave had mentioned to the west of Makendon Farm, towards Chew Green but not up to the Border Fence (across the top of Brownhart Law is a fence running north-east to south-east, which is the recognised border between England and Scotland, known as the Border Fence or the Border Ridge).

Leaving Jimmy Cowens, I then headed for Rothbury, to where Willy Rutherford now lived. Willy was now eighty-seven years old. Willy confirmed to me that he

Brownhart Law. (Author)

had lived at Fulhope Farm, which is one mile east of Makendon. Back in 1944 Willy had gone up to the site the day after DX118 had crashed on Brownhart Law. When he got there, the wreckage was still smouldering and the pilot's body was still in the burnt-out wreckage. He recalled that the aircraft had bounced once before finally sliding to a halt on Brownhart Law. Willy was positive in his directions from Makendon. I was to leave the farm, and walk up a field at the back of the farm; this would lead me to a 'sike' (a stream of sorts), and this would split into a Y shape, take the left hand 'Sike' and it was up there! He also mentioned that to the south below where the aircraft was, there was a cart track which he now believed was a road. This proved to be the road which leads from the 'dry training' area of the Otterburn ranges to the 'live firing' area. He suggested that the site would be approximately half a mile from the farm, but not past the border fence.

The recovery team were billeted at Makendon for two weeks and dragged the wreckage down to Makendon with a tracked vehicle, where it was placed on a Queen Mary trailer and removed from the valley.

I did have a brief walk to the area as a suggested grid reference, NT79500 09300 had been given to me from Jim Corbett; the grid reference was based on half a mile west of Makendon, which allowed a survey of the hill with regards to plotting a search area for a future visit.

6 June 2008

I decided to wait for the winter months to pass fully as Brownhart Law is a very open and unsheltered hill and this area can be very inaccessible. My day planned, I arrived at the search area with my air-crash-hunting poodle Penny

Revd William B. E. Milton. (Jim Corbett)

and my wife Sue (a famous first for her). The weather was glorious, so with luck we could stay on site for a good while.

I soon discovered that Brownhart Law is part of the dry training area; evidence of this was provided by the uncovering of spent blank ammunition from three generations of military small arms: .303 in. Lee Enfield, 7.62 mm SLR, 5.56 mm SA80 rifles, with a few belt-fed 7.62 mm GPMG for good show. This was proving difficult. I had covered the area described to me when the heavens broke with an almighty downpour of rain; I wanted to keep going but Sue and Penny were soaked through and I retired under the guidance of Sue.

9 July 2009

Between 6 June 2008 and 9 July 2009, I had returned to the area on a further three occasions. I had found no sign of aircraft remains but was gathering a large collection of buried army 24-hour ration pack tins. I had by now covered an area of 1 square km, with no trace of fragmented remains. Everything was there: the Y-shaped Sike, the track below the hill, even the Border Fence over the hill, but nothing was found. It could be that the crew which removed the wreckage were just very thorough, but this is unlikely.

I went back to see Dave Rutherford to see if there was any way we could get Jimmy Cowens or Willy Rutherford up to the area, but their ailing health would not allow this. Dave suggested taking a few pictures of the hill and seeing if Jimmy and Willy could pinpoint the site from the photographs. This seemed easier said than done! Only when you get up onto Brownhart Law do you fully realise its extent. The Law is basically three separate spurs covering a 1 square km area. Since the time of the Romans, this hilled area which is part of the

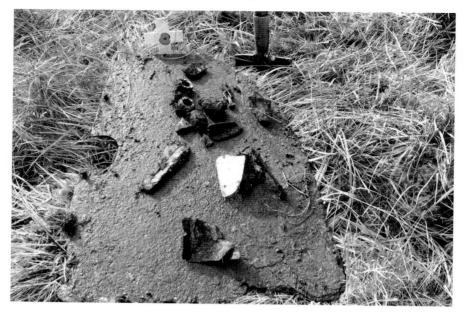

The remains of DX118 found on 6 October 2010. (Author)

MOD Otterburn training area (blank firing only) has been a training ground for troops.

6 October 2010

After having successful, albeit minimal finds of Spitfire P8360 at Eshott on 5 October (see chapter 11), I moved back to Brownhart Law to try once again to locate the exact site of DX118. The weather was foul, with heavy rain, all too familiar for this area. I arrived at 7.45 a.m. and decided to wait out the rain. I could see in the distance, over the Border Ridge, that the sky was clearing so I sat tight. At 8 a.m. the skies cleared, and I set off towards my objective. Since I had completed thorough searches of the two outer spurs on my previous visits, I had planned to start higher up on the centre spur, moving towards Makendon. This spur, like the other two, is still a large area to cover and very wet. I kept in my mind that Willy Rutherford had told me it was up on the top of the Law. Starting my systematic search at 8.30, I moved across and down towards Makendon. Surprisingly, there were minimal signs of army debris on this part of Brownhart Law. At 10.38 a.m. I picked up a positive reading. With anticipation, I checked and re-checked the signal before digging. At last, oxidized alloy; after nearly three years of revisiting Brownhart Law, I had found positive evidence of the crash site. The fragments were typical of aircraft debris I have found at other sites and stretched in a line west to east for approximately 100 metres. The site is located 210 metres south-

west of the original presumed grid reference. I was unable to build a small cairn at the site as the whole area is peat and no stones or rock were in the area. I did, however, place a small cross at the site, next to the fragments I had found.

Official Documents

Strangely, three accounts are mentioned in the reference books of Northumberland air crashes. The F1180 Loss Card records this crash as Brownhart Law, Makendon, while the Registrar Office at Morpeth records this as Entry 436 at Makendon.

RAF Edzell was first established to the east of the village of Edzell, near Brechin on the east coast of Scotland during the First World War. It was closed in 1919. During the 1930s it was reopened and operated as a civilian airfield, but the outbreak of the Second World War saw its return to service in 1940 as RAF Edzell. The airfield served as an aircraft maintenance facility, and by the end of the war held some 800 aircraft in reserve.

A Brief Account of the Crash

Before the outbreak of hostilities between Japan and America, when on 7 December 1941 Japan attacked the US naval base of Pearl Harbor, launching the USA into the Second World War, brothers Marshall M. Milton and William B. L. Milton were both clergymen; both enlisted as Air Transport Auxiliary Pilots. Revd W. B. L. Milton graduated from the Virginia Military Institute in the class of 1929. Ferry pilots were usually instructed to fly by sight. Most of the aircraft were not fitted with wireless sets and destinations were found by compass bearings and landmarks. It was a very hazardous job, as in the case of this type of aircraft, there would have been a crew of four for operational duties.

First Officer William Byrd Lee Milton was stationed at No. 16 Ferry Pilots' Pool (FPP) at Kirkbride, Cumbria. He was sent up to RAF Edzell to receive his orders to ferry Bristol Beaufort DX118 from RAF Edzell, Strathmore, Scotland, to 5 Operational Training Unit (OTU), RAF Long Kesh, Maze, Lisburn, Northern Ireland.

Bristol Beaufort DX118 took off from RAF Edzell at 12.18 p.m. While crossing the border region on 23 February 1943, the starboard engine of DX118 failed. It was noted in the crash report that First Officer Milton trimmed the aircraft for single-engine flying but crashed on Brownhart Law at a height of 1,350 feet, to the west of Makendon at approximately 1 p.m. It is believed that First Officer Milton encountered bad weather as he was crossing the border between Scotland and England, crashing on the English side of the border.

At the request of his family he was cremated and his ashes repatriated to the USA.

First Officer W. B. L. Milton: Family Plot 133 West, Ware Episcopal Church Cemetery, Gloucester County, Virginia. The grave is marked with the words 'He That Believeth in Me Hath Everlasting Life'.

The Site of the Crash

Bristol Beaufort Mk I DX118 44 Maintenance Unit

Pilot:	First Officer William Byrd Lee Milton, ATA, age 36 +
Squadron:	No. 16 Ferry Pilots Pool, Air Transport Auxilary.
Site:	Brownhart Law, Makendon, Coquet Valley
Grid:	NT79360 09148
Map:	O/S Outdoor Leisure 16
Note:	Fragments of the aircraft remain at the site

Bibliography

Clark, Peter, *Border too High*
Earl, David W., *Hell on High Ground* Vol. 2
Walton, Derek, *Northumberland Aviation Diary 1790–1999*

Reference

Air Ministry F1180 – Loss Card
AVIA 5/22 – Air Investigation Branch Precis No. W1474
Commonwealth War Graves Commission
Dave Rutherford
David Earl
Dennis Gray
Ian Tait
Jim Corbett
Jim Cowens
Mrs Joan Rose, Northumberland and Durham Family History Society
Ordnance Survey Maps
Penny
RAF Commands web Site www.RAFcommands.com
Richmond Times-Dispatch, 3 November 1940
Sue Davies
Willy Rutherford

HARRIERS XZ136 & XV790

Hawker Harrier GR3s XZ136-O and XV790-AP
3 Squadron
RAF Gutersloh, Germany

Ridlees Hope and Ridlees
Otterburn
2 November 1987

In the month between 15 April and 15 May annually (the dates do vary by the odd day or two), the Otterburn Ranges are closed during the lambing season. It is during this period that the public has access to the ranges, but on the tracks only. It must be remembered that this is a military live-firing range which has thousands of tons of unexploded ordnance scattered across its valleys. It is always sensible to stick to the tracks. This is a dangerous area to be messing around in: take note of the danger signs; they are there for a reason.

During my conversations with Dave Rutherford regarding searching for the exact location of the crash site of Bristol Beaufort DX118 on Brownhart Law in the Coquet Valley, Dave brought my attention to a collision between two Hawker Harrier jets which collided in the valley behind Bygate Hall, in the area where, in the lambing season, Dave is permitted to graze his sheep.

Dave was positive he could lead me to the two sites with little difficulty, so a date was set for 22 December 2007, two days after his brother Jim had taken me to the Lockheed F104-G Starfighter site. Being on night shift was having its bonuses for me this week.

Harrier GR3
XV790-AP.
(Andrew
Wylie)

Harrier GR3 XZ136-O. (Andrew Wylie)

27 December 2007

The arrangement was simple, with the ranges being closed for live firing; I would meet up with Dave at a T-junction of a metalled road and a gravel track a few miles up the valley from Quickening Cote. Dave would come cross-country on his quad bike; killing two birds with one stone so to speak, he would be checking part of his flock on the way to meet me. I, in turn, after visiting these sites would meet up with members of ACIA and take them to the Lockheed F104-G Starfighter site.

It was cold, misty and very damp when we met; Dave had a small trailer on the back, and this was to be my ride to the first site where XV790 had crashed. We arrived not long after at the bombarded remains of a smallholding formerly known as Ridlees. Dave could remember the farmhouse that once stood here, but now only the foundations seemed to remain and what looked like a mock Taliban encampment with defensive positions surrounding it. Not far from here, we dismounted from the quad and Dave directed me to a large piece of metal, possibly off a tank target that had been blown to bits over the years. From here, he pointed out where this GR3, XV790, had exploded and had spread over the hill and carried on up a sike. All that remained at the site was an area in which the foliage was a different colour and texture. Dave explained that this was where the main body of the wreckage had landed. But no visible remains seemed present, and this was not an area where I would consider a metal detector (live impact area and unexploded ordnance; I shiver at the thought).

Moving on, we returned to the quad bike and carried on towards Ridlees Hope. Here, we crossed a drain known as the Cement Ford; as we approached the site, Dave asked me where I thought this aircraft, XZ136, had crashed. I directed Dave to a corner in the track and pointed to the north-west, explaining that I thought it would be approximately 150 metres in that direction. Dave confirmed my belief, parking up his quad bike where he had himself seen the recovery crews park their vehicles in 1987. Moving slightly away from the quad

bike (150 metres north-west), after a brief search we found fragmented remains of XZ136, small but remains none the less. These were of alloy construction, but I could not identify what part of the aircraft they had come off.

Dave explained that he had been told that during a major military exercise, the main strike aircraft were being followed by radar as they approached the range; the two GR3 Harriers came in from a different angle to create confusion in the attack, and collided into balls of flame; the two pilots, he believed, stood no chance.

2 January 2008

Since fragments had been found at the site of XZ136, it seemed logical that some fragments should remain at the XV790 site. Along with an ACIA colleague, Russ Gray, I was revisiting the site (I was now on my days off after night shift); I first took him to the site of the Lockheed F104-G Starfighter, as Russ had been unable to attend when the rest of ACIA had visited on 27 December 2007 and I was a more than willing escort.

Shortly after the F104-G site, we moved along to the T-junction of the metalled road and gravel track where I had met up with Dave on the 27th. Here we left the car, and were to head towards the site of XV790. Our first obstacle was the rain, as this had swollen the Ridlees burn at the ford crossing to Ridlees; the burn was wider, faster and deeper. To get to the site we had to cross it. Russ asked how we were to cross, as there was no bridge and no easy place to take a run and jump; I advised Russ that the only way across was the number one method! Before Russ had time to let this sink in, I took off at great speed, taking high and long steps straight through and over the ford. Russ was left bemused on the other side of the burn and I was only slightly wet. Russ took off with the same pace, nearly floundering halfway, but made it in much the same state as myself.

Above left: A section of hydraulic pipe from the wreckage of XV790. (Author)

Above right: A fragment of wreckage from XZ136. (Author)

I guided Russ to the area where Dave Rutherford had taken me and showed him the difference in foliage from where the main part of XV790 had burnt out. Explaining where the aircraft had disintegrated up the sike to the north, we started looking carefully. Nothing was visible, and it appeared the recovery crew had done an exceptional job. We turned to head back to the car (still searching) when I came across a hydraulic pipe with fixing wires attached to the nuts and bolts. Generally, fixing wires are fitted to aircraft to prevent vibration and loosening of vital nuts.

The hydraulic piping I took to a colleague at work, Mark Henderson, who had worked as an airframe fitter on Jaguar and Tornado jets. Mark confirmed this hydraulic piping was off an aircraft. With this find being in the trail where the aircraft had gone, it was feasible to assume that it was part of XV790.

Account of Keith Wardrope, ex-Sgt, RAF

At the time, I was a sergeant telecommunications controller (formerly telegraphist) on Tactical Communications Wing at RAF Brize Norton. I was tasked to supply the communications and basic navigational aids for this NATO exercise. These being the days before mobile telephones, I supplied all the management radios. This enabled people on the ground to talk to each other within line of sight. I also supplied radio to monitor and provide a safety net with the aircraft, a low-level radio beacon for the aircraft to home in on and a high-frequency radio link back to Strike Command Headquarters at RAF High Wycombe via the Royal Air Force world-wide Flight Watch, who would give us a dedicated link to the operations for the sole purpose of passing on statistics of the aircraft's performance (bomb scores). We had given out all the radios, set up the beacon and had our radio link set up behind the statisticians who were monitoring the aircraft's performance and filming them also. They would pass the scores and we would send them on to Headquarters, who would disseminate them to the various nations and squadrons. The area was a valley with aircraft frames and vehicles placed in it and a replica airfield cut out of the grass. We were high above it, in a good position to see all the aircraft approaching and going down the valley. We

Crash site XZ136, 1987. (Jim Corbett)

had witnessed various NATO aircraft practicing bombing this airfield. In particular, I remembered the American F111 high above; I had not particularly found this exciting. Then, in the early afternoon, I heard the sound of the Harrier GR3s. They were flying very low, and one would fly straight down the valley, with the other coming at a 90 degree angle over the far hill, which was quite dramatic. This could have easily been them in the Falkland Islands using a tactic to limit any damage from ground fire. As my men were doing all the work, I had a good position on the hill behind them; watching this, I looked beyond the valley and saw a GR3 coming towards the valley. I watched it come down the valley, and saw another coming over at 90 degrees; I turned my head for just a few seconds back down the valley, and when I looked back in the valley all I could see was a large ball of flame. At this point, I looked at one of the statisticians, about to ask if they were dropping some live ammunition, and saw a face of disbelief. At this point, I realised there was a problem. It appears the aircraft had clipped their wings, and this was enough for the aircraft to go out of control and crash in the immediate area. Both pilots died as they did not have time to eject. One was a Flight Lieutenant Sunderland, and the other was an American exchange pilot called Lieutenant Carver, I think. Our part in this exercise was immediately called off. Within 10 minutes, two RAF Search and Rescue helicopters arrived on the scene. These particular Harriers had flown from Gutersloh in Germany and refuelled at Lossiemouth, then come for their bombing practice. These were regular exercises; the RAF would have their own called OSEX and the NATO ones were called Mallet Blow, which had previously been called Hammer Blow.

Account of Andrew Wylie, ex-SAC

I had received notification once again via the Rootschat forum on 17 February; it was to lead to the account of, probably, the last person to have human contact with F/Lt David Sunderland.

Hi Chris, let's try and remember what went on that sad November day.

I'm Andrew Wylie (E8211511); at the time I was a Flight Line Mechanic working on Harrier GR3s with No. 3 (Fighter) Squadron at Gutersloh in West Germany. I joined the Squadron in Nov. 84 and left in Nov. 87. Whilst Gutersloh was our home base, we spent a great deal of time deployed in other locations around Europe - Sardinia, Cyprus, Portugal etc. Not to mention our NATO war-role in the forests of northern Germany. However, when this crash took place we were operating from the Jaguar Operational Conversion Unit line, at RAF Lossiemouth, in Morayshire.

Lossiemouth was a base that I had previously visited on two other occasions with 3 Squadron. We deployed at virtually full squadron strength, of twelve to fourteen aircraft and about ninety ground crew, for a two-week period. The

coast of Scotland was/is (??) full of bombing ranges, so the deployments were very worthwhile for our aircrew to hone their skills.

Another reason for deploying in late '87 was to practice bombing runs with the use of ground-based Forward Air Controllers. I was led to believe these were newly recruited Special Forces guys who were being trained for the role in a 'real-time' situation using our Harriers. Their mission was to get deep inside enemy territory and 'call in' air strikes on tactical targets, utilizing laser guidance equipment. Rather them than me!!

If I remember rightly, we were at the end of the detachment and had half an eye on packing and getting back to Germany. A few nights prior to the crashes, we had a big squadron all-ranks booze-up in the Rugby Club at Lossiemouth and, as was traditional, we all did a few comedy sketches on the stage. Mainly taking the mickey out of the hierarchy, who, as always, took it in the good spirits it was meant to be. I've no idea what our 'Panto' was (our, as in the 'Lineys', as we were known), but I was wearing a large cowboy hat and trying to pull off a very poor impersonation of John Carver; he took it well.

The next day we were up and on the flight line at 7 a.m., prepping the jets for the day's operations. This is where it gets sketchy; normally, as a liney, we had an aircraft each for the whole deployment. On this occasion we had more aircraft than lineies, so we swapped around between each sortie. At some stage of the day (lunchtime), I ended up with Dave Sunderland's jet (either XV790 or XZ136 ?); I carried out the normal turnaround routine of refuel, oils, tyres and airframe checks, cockpit tidy, etc., while the Squadron armourers 'tooled it up' for the next sortie. Nothing special, nothing out of the ordinary, just a normal day on the flightline. F/Lt Sunderland was one of the more popular pilots amongst the ground crew - others not so. Probably as he was a lot younger than most of the other pilots and didn't take himself quite as seriously as some.

As we finished our servicing and signed the paperwork, the aircrew were already to sign for and take the aircraft from us for the next sorties. I was pleased to see that I had Dave Sunderland in my jet. Prior to take-off, the pilot will do a walk around, visual inspection prior to jumping in the cockpit. This went without a hitch; I assisted in strapping Dave into the ejection seat, we exchanged a bit of banter, engines started and off he went with the rest of the sortie - including John Carver.

Thirty to forty minutes later, our Squadron Warrant Officer, Derek Morris, came down to the flight line and issued instructions to impound the oils and fuels used on the above mentioned aircraft. We all looked at each other, knowing instantly why this was needed. I'd had a hand in a previous crash - XW933 in 1985 – so I knew the drill. Still, nothing prepares you for it, and I'm haunted by it to this day.

I believe the Board of Inquiry said that instead of the aircraft being called to the target in sequence by the FAC, Sunderland and Carver appeared on the

bombing run at precisely the same time from opposite directions. I can't recall if an ejection was attempted.

F/Lt Sunderland's funeral was in Bangor Cathedral a few weeks later. A Hercules was laid on for us and virtually the whole squadron travelled to RAF Valley and back for the day. Carver's funeral was held in the US and was attended by the Squadron Commander, Wing Commander Syd Morris, only.

Regards

Andrew Wylie

Official Documents

Checking my reference books for any possibilities, I came up with a collision between two RAF Harrier GR3s within the Otterburn ranges. This, in turn, matched with what I had been asked to locate by Jim Corbett.

I next contacted the Air Historical Branch of the RAF; they confirmed the accident and its place as the Otterburn training area.

I then contacted the Registrar Office at Morpeth, to obtain the pilot's death certificate; this revealed that Lt John Carver and F/Lt David Robin Sunderland had died in a collision at Riddlees on the Otterburn training area.

Searching the Armed Forces Memorial Trust provided the age and home town of F/Lt D. R. Sunderland.

The genealogy web site Rootschat provided me with details of contacts in Wisconsin, USA, for Lt J. Carver and Andrew Wylie.

The Anglesey Record Office provided a copy of the story which ran in the *Bangor Chronicle*, 5 November 1987.

I contacted the North Wales News Media and the *Milwaukee Journal* for permission to use the photographs published of F/Lt Sunderland and Lt Carver.

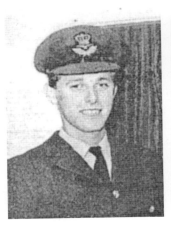

Right: F/Lt David Sunderland. (*Bangor Chronicle* 5 November 1987, courtesy NWN Media)

Far Right: Lt John Carver. (*The Milwaukee Journal*)

A Brief Account of the Crash

In the 1980s, Operation Mallet Blow was a NATO exercise conducted by the RAF up to four times a year on the Otterburn training area.

On 2 November 1987, XZ136-O, piloted by F/Lt David Robin Sutherland, and XV790-AP, piloted by Lt John Robert Carver, United States Navy, of 3 Squadron RAF, took off from RAF Gutersloh in Germany to take part in 'Mallet Blow'. They had been on one sortie over the ranges, landed at RAF Lossiemouth, refuelled and were preparing to attack the SAM 'C' range in the valley between Brown Law and Scald Law.

They were briefed as numbers three and four of a formation of six Harriers. The formation planned to carry out a co-ordinated attack on the Otterburn range. From an initial reference point, even numbered aircraft were to follow a track almost direct to the target while odd numbered aircraft would take a slightly longer 'offset' route, to achieve a sequenced separation of aircraft over the target area (a safety net). The order of aircraft in the attack was: Two, One, Four, Three, Six, Five.

Their planned attack was a diversionary tactic where one aircraft would draw the radar onto them, while the other came in from another direction and take the SAMs by surprise, a method of attack that was a recognised strategy.

The first formation arrived on the target area as planned; Two attacked over the target first and One some eight seconds later. After a delay of sixteen seconds, it was the turn of XV790 (Three) and XZ136 (Four) to attack. Unfortunately, their approach was mistimed by a fraction of a second and the two aircraft collided directly over the target area.

One pilot made no attempt to eject and the other managed to eject from his stricken aircraft shortly before impact, but it was too late for the ejector seat to complete its sequence. Lieutenant John Carver (US Navy) and Flight Lieutenant David Robin Sunderland (RAF) were both killed in the collision.

Flight Lieutenant David Robin Sunderland was cremated in his home town of Bangor, Gwynedd, Wales, Friday 6 November 1987. His ashes were interred at Bangor New Cemetery; plot CR440 on Friday 29 April 1988.
Lieutenant John Carver was cremated in his home town of Shorewood, Milwaukee, Wisconsin, on Tuesday 10 November 1987.

The Sites of the Crashes

Hawker Harrier GR3 XZ136-O RAF
Pilot: 5203264D F/Lt David Robin Sunderland, age 27 +
Squadron: No. 3 (F) Squadron, RAF Gutersloh

Site:　　　　Riddlees Hope, Otterburn
Grid:　　　　Restricted (MOD impact area)
Map:　　　　O/S Outdoor Leisure 16

Hawker Harrier GR3 XV790-AP RAF
Pilot:　　　　53217 Lt John Robert Carver, age 31 +
Squadron:　　No. 3 (F) Squadron, RAF Gutersloh (US Navy exchange)
Site:　　　　Riddlees, Otterburn
Grid:　　　　Restricted (MOD impact area)
Map:　　　　OS Outdoor Leisure 16

Bibliography

Air Britain, *Royal Air Force Aircraft XA100 to XZ999*
Flight Global
UK Serials
Walton, Derek, *Northumberland Aviation Diary 1790–1999*

Reference

Andrew Wylie
Anglesey Record Office
Armed Forces Memorial Trust
Commonwealth War Graves Commission
Dave Rutherford
Dennis Gray
Emlyn Roberts, North Wales Media
Jim Corbett
Jim Rutherford
Keith Wardrope
Kiki Schwitz, Freerick Funeral Home USA
John Cadmore, Cyngor Gwynedd Council, Bangor Crematorium
Mark Henderson
Mrs Joan Rose, Northumberland and Durham Family History Society
Ordnance Survey Maps
RAF Commands web Site www.RAFcommands.com
www.RootsChat.com/forum/

TORNADO 44+47

Panavia Tornado 4147 44+47
Jagdbombergeschwader (JBG) 31

Dykemans Edge
Otterburn Training area
21 October 1986

20 December 2007

I was being escorted on the back of a quad bike to the site of a Royal Netherlands
Air Force Lockheed F104-G Starfighter by Jim Rutherford, who farmed this
area. Once on the Starfighter site, talking to Jim, I asked if he knew anything
about a German Tornado which I believed had crashed approximately 1 km to
the south of where we were standing. Jim was unaware of the crash, but offered
immediately to escort me to the proposed site of the Tornado.

Climbing onto the back of the quad, Jim told me to hang on tight as the track
only went halfway to where I wanted to go and it might be a bit bumpy! This I
soon found out to be an understatement, as the ground was boggy as well as being
very bumpy. My confidence was high because of the expert way in which Jim had
handled the quad so far, but revenge for a comment about my having met a few

Panavia Tornado 44+47 of JBG 31 at RAF Honington, 1986. (Courtesy *Military Aviation Review*)

Above left: Main wreckage of 44+47. (Jim Corbett)

Above right: Engine of 44+47 from 1986. (Jim Corbett)

of his family at various farms throughout the Coquet valley, and that everybody in the valley seemed related was to silence my cheek. Jim had just passed a warning that we were to cross a 'steep bit', but this was a touch too late; the next thing I knew was that my feet had locked under Jim's armpits and I was hanging off the back, arms flailing and preparing to go head first into what looked like a very deep bomb crater full to the top with sludgy water and gunk. Jim stopped the quad in time for me to drag myself ungracefully back into position on the back.

A Bailey bridge came into view, approximately 400 metres to the south of us; here we dismounted as the ground was too rough for two to be travelling on a single-seated quad. I pointed out to Jim that the Tornado had come down to the south-west of the bridge. As we walked towards the bridge, Jim pointed out what appeared to be a very large unexploded bomb; with a glint in his eye, he tapped the bomb with his boot explaining, 'We should not touch that'! My heart was thumping good style, but then I realised it was a concrete bomb used for training exercises, allowing aircrew to fly an aircraft at full armament weight but without live ammunition. We carried on to the proposed search area, but couldn't see anything as we only had a short time at the site.

Account of Sgt John Snaddon, Army Air Corps

I was a sergeant pilot for 3 Flight Army Air Corps, based at Topcliffe, North Yorkshire, at the time. On 22 October 1986, along with Captain Bradshaw, also of 3 Flight (he was our 2 i/c), I took a Gazelle up to Otterburn to ferry the German pathologist with the Tornado's black box back to a Luftwaffe flight at Newcastle, so that he could return to Germany. I had been stationed Berlin for a couple of years prior to the tour I was on. This was one of my last flights, as I left the Army in November 1986, and I haven't flown in uniform since.

I had been to a couple of crashes before, but this one hung with me for a long time because the two crew looked so peaceful. I remember having a bit of an unprofessional

44+47 crash site, to the right and behind the bridge. (Author)

strop with my boss when I got back to Topcliffe, because in my mind, the bodies should have been covered out of respect, even if it was only a parachute or a tent.

It was twenty-four years ago now, but if I remember correctly, when we got to Otterburn we had to land in the camp before being called forward to the crash site. While in the camp, we were fed and watered in the control room. While there, we got a chance to see the range camera footage of the crash. I thought then that the crew were so unlucky that their flight had ended the way it did; they'd come over a crest of a hill very low, as if they had just pushed the nose down a bit to come down the reverse slope and the slope wasn't as steep as expected. The aircraft ran along the ground, shedding bits and slowing down; there was a ditch about 90 degrees across their path, and when the aircraft hit the ditch, it broke up and tumbled.

When we moved up to the crash site, I remember thinking that the engines hadn't gone very far (strange, I know, but the previous crash sites I had seen had been high-energy ones at fairly high attack angles, so there was usually a crater and a small debris field). I had expected them to have carried energy and gone further. Of the crew, one was on the ditch side next to where the aircraft had impacted, the other about 30 yards to the left, in the direction of travel. Neither was attached to their seat. I don't remember if they ejected, but I don't think so, as the impression I got was they just came out when the nose broke up.

That's about as much as I can remember, and time does things to memories. What I remember might be right or wrong, but it is how I remember it. I know you might find this a bit soft, but I remember just going down on one knee, at the feet of the crewman that was away from the aircraft, and saying a short prayer, as we were all doing a similar job and they were just unlucky and he looked so peaceful.

My Last Flight ever in uniform was on 31 October 1986.

John Snaddon provided me with the details from his 'Notam' (Notice to Airmen) for 21 October 1986; it is timed at 211515 (3.15 p.m., 21 October).

(a) From Scottish Control Zone, (b) with immediate effect, (c) until further notice, (e) a restricted area, 10 nautical miles radius from location 'Restricted'

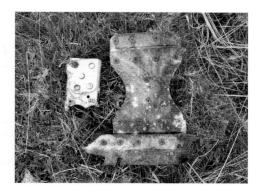

A fragmented piece of fuselage from Tornado 4147 44+47. (Author)

(the Crash Site), up to 2000 feet, has been set up. No one is to go into this area without permission, as search and rescue helicopters will be operating.

14 May 2008

The day before the range reopened for military training, I had one last chance to pinpoint the exact location of the crash. The next available window would be one day in August, then December.

Being on foot this time, I took a more direct route past the D-8337 site described in Chapter 10 and down to the Bailey bridge. I had a little bonus with me this time, as I had been passed on some photographs of the crash; this would be a great help. On my way to the Bailey bridge, I noticed that my first search here had been too close to the bridge and a little too far to the east. I had a photograph facing the bridge taken from the south, and one from the north of the bridge facing south.

Still expecting to find a large amount of wreckage similar to D-8337, I spotted a tangled, large metal object to the south of the bridge; I couldn't tell what it was at first, but as I got nearer it became obvious that it was the tangled remains of a target vehicle. As I left the vehicle, I moved slightly to the west, to a small hillock where one of the original crash photographs had been taken from (south of the bridge). I came across the remains of two tail fins from dummy or practice bombs in Luftwaffe colours (green, as opposed to RAF grey/blue); this colour scheme was also the same as the Luftwaffe Panavia Tornado remains I had seen at Rottenmoss, Stannersburn, near Kielder.

I was right in the middle of where 44+47 had crashed. Nearby, there were small, fragmented remains of aircraft fuselage; this was identifiable by the type of fixtures they had on them (very similar to the fixings of the D-8337 fuselage). My search complete, I was satisfied I was on the exact site; I left the area, not touching the tail fins or removing any part of the fragmented remains.

Official Documents

I firstly checked my reference books for any possibilities and came up with a JBG 31 Fatality, this being Panavia Tornado 4147 44+47 of JBG 31, Luftwaffe.

My next move was to contact the Bundeswehr for any official information from the Luftwaffe.

I then contacted the Registrar Office at Morpeth, to obtain the crews' death certificates. This was recorded as: Tornado crashed on 21 October 1986 near Harbottle, Rothbury, Register RO 7A. Both crew were listed as officers in the German Air Force, base Headquarters Strike Command, RAF High Wycombe, Buckinghamshire, Werner Schreiber (24/09/1953, entry 91) and Walter Keilhauer (20/03/1959, entry 92).

Sgt John Snaddon's log book and Notice to Airmen did have the longitude and latitudes of the site within its contents. When cross-referenced with my own personal knowledge of the site, they matched the area where I had found fragmented remains of the aircraft.

With the help of Air Vice-Marshal Sandy Hunter, I was able to put questions to Oberst a. D. Wilhelm Goebel, Archivist *Gemeinschaft der Flieger Deutscher Streitkraefte*, confirming the timings and the crew's mission purpose.

A Brief Account of the Crash

Panavia Tornado 4147 44+47 of Jagbomergeschwader 31 (JGB 31), Luftwaffe, piloted by Captain Werner Schriber and his radar/weapons operator Oberleutnant Walter Keilhauer, was participating in the NATO exercise Mallet Blow, attacking the Bravo range; these exercises were held up to four times a year.

A flight of two Tornados were to participate from Nörvenich, Germany; however, the No. 2 aircraft aborted. No. 1 took off, serial no. 4147, tactical markings 44+47, flew onto the Otterburn range and landed at RAF Honington, Suffolk, to refuel and to launch a second sortie.

On 21 October 1986, the planned attack route was to attack Bravo range, approaching from the north, and strike a Bailey bridge (the same bridge as D-8837 had in 1983). 44+47 would be flying over the site of D-8837 striking the Bailey bridge; 44+47 had made one previous sortie on the bridge that day. The airplane configuration was two wing tanks, one under-fuselage tank, one CBLS (rack for carrying practice bombs) with a DM 18 practice bomb, two chaff dispensers and wings at 45 degrees.

The target at Otterburn was a small Bailey bridge, difficult to see, with no contrast to the surrounding ground. Captain Werner Schriber and Oberleutnant Walter Keilhauer took off at 1.47 p.m. from RAF Honington, flying low-level to the target area, with a minimum altitude of 250 feet. They didn't hit the target

flying a phase 1 attack (using the aircraft's electronic sensors; a 'blind' attack). The crew re-attacked, this time via visual. At 2.32 pm, approaching the Bravo range after clearing Dykeman's Edge, 44+47 struck the ground 200 metres to the south-west of the target area (Bailey bridge) and exploded. Both crew members had no time to eject and were killed in the explosion.

Only in the last fraction of a second did the pilot try to eject the crew, but the impact prevented the bail-out.

Both Captain Werner Schriber and Oberleutnant Walter Keilhauer were killed.

The Site of the Crash

Panavia Tornado 4147 44+47 of Jagdbombergeschwader 31
Pilot: Hauptman Werner Schreiber, Luftwaffe, age 33 +
Radar/Weapons: Oberleutnant Walter Keilhauer, Luftwaffe, age 27 +
Squadron: Jagdbombergeschwader 31
Site: Dykemans Edge, Otterburn training area
Grid: Restricted (Military impact area)
Map: OS Outdoor Leisure 416

Bibliography

Bundeswehr, Bundesarchiv – Personal correspondence
Walton, Derek, *Northumberland Aviation Diary 1790–1999*

Reference

Air Vice-Marshal Sandy Hunter
Dave Rutherford
Jim Corbett
Jim Rutherford
Lieutenant Colonel Thomas Schmitz, Bundeswehr, Bundesarchiv
Military Aviation Review (MAR)
Mrs Joan Rose, Northumberland and Durham Family History Society
Oberst a. D Wilhelm Goebel, Archivist Gemeinschaft der Flieger Deutscher Streitkraefte
Ordnance Survey Maps
RAF Commands web Site www.RAFcommands.com
Sergeant John Snaddon, ex-AAC

BLENHEIM V6445

Bristol Blenheim Mk IV V6445 UX-E
82 Squadron
RAF Bodney

Long Nanny
Newton Links House Farm
High Newton by the Sea
20 August 1941

While researching aircraft which had crashed in and around RAF Acklington for a memorial to the lost airmen, to be placed in the former RAF Acklington church, St John the Divine at Red Row, I had come across a document in my notes of a Bristol Blenheim which had 'force-landed' in a field 'near Acklington aerodrome'. This was V6445; the member of the crew who had died was Sergeant Eric Laurence Cash, who had died of his injuries the day after the crash.

I was having no luck in my usual records for a location; I could get a good search area from a death certificate but as Laurie Cash had died in hospital, what was recorded on his death certificate was his place of death, Alnwick Infirmary, not the place of the forced landing.

I had a contact but I had misunderstood what information they had passed on to me, misinterpreting it as Embleton Hall, which is at Longframlington in Northumberland, a small village which I have passed through on my many hiking trips in the Cheviot Hills.

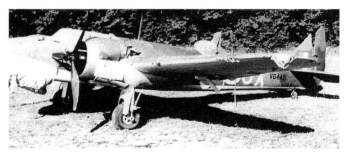

Bristol Blenheim V6445 UX-E damage to left wing after raid on 12 August 1941. (RAF Museum Hendon)

26 January 2009

I posted a question on the Key Publishing Ltd Aviation Forum website with regards to this incident and its possible location. By 29 January, I had all the details of the crew but no location.

Believing the site was at Embleton Hall, Longframlington, I crossed this off my list of research for the memorial, as its possible location was too far away from the immediate area of RAF Acklington (some 7 miles as the crow flies). My search for this site was at an end and I had no requirement to revisit the forum with regards to this aircraft.

20 October 2009

I had been up into the Cheviots with Sarah Wilson, Basil Oliver and Penny, to try and plot a search area of a Spitfire which had crashed on 25 March 1943 on part of the Cheviot masiff known as Bellyside Hill. It was a good walking day, breezy and sunny, but we had no luck in finding any trace of the crash. On my way home I passed Embleton Hall and thought about where V6445 may have crashed. Once home, I decided to resurrect this crash as a possible future search.

Re-checking my previous findings, I noticed that I was correct in that this crash was out of the area of RAF Acklington but it was also not at Embleton Hall; it was near a village called Embleton, which is located nearly 25 miles up the coast from Acklington.

I revisited Google to see if I could find anything new to add to my findings. I noticed a link on the Key Publishing Ltd forum, which had my name attached to it. When I opened the link, I found that on 26 February 2009, a month after my original posting on the site, the wireless operator/air gunner of V6445, Stan Pascoe, had tried to contact me. Here I was, nine months later, preparing to contact a survivor of the crash of V6445 sixty-eight years after the crash. I was nervous about how I was to approach Stan with my reasons for looking (albeit only a short period) into his life. My reputed style in life is to jump in with both feet and to be open and honest.

I received this reply from Stan Pascoe on 21 October 2009:

Chris!!!!!!! Well, well, well.

I was so thrilled to receive your E-mail. I have finished my research on my wartime exploits and the exercise was long and at times so frustrating. However, I now have full details of all things relating to our unfortunate demise.

If you are interested in more details I will compile an E-mail with all the information you would like. It will be pretty long and I will start to write it up for you if I get your OK. It will include pilot log details and crash site detail.

Many thanks for replying to my entry in the Key Publishing site.

Stan Pascoe and Dennis Gibbs, 12 August 1941. (Stan Pascoe)

E-mail letter from Stan Pascoe (wireless operator/air gunner V6445), 22 October 2009:

Dear Chris,

I am presuming that your interest lies in the events which led up to our unfortunate forced landing on the 20th August 1941.

To fully understand the reason for the crash I will go back in time to the beginning of August 1941. You will be aware of the role the Blenheim squadrons of 2 Group played in daily low-level shipping strikes, off the north coast of the Friesian Islands. The ops became routine in their planning, bombing any enemy shipping we saw during our 3-minute beat along the coastline.

The first two weeks of August were different in as much as we carried out numerous low-level exercises over Norfolk and the Wash areas, which to us seemed curious as we were well experienced in low-level flying over water.

The briefing on August 12 made sense of our previous low-level flights over land. On that day, the celebrated attack on power stations near Cologne took place. Of the fifty-six Blenheims that took part in the raid, twelve did not return. Pilot skill and concentration was paramount in order to evade power lines and anything else with similar height. The formation was escorted by fighter aircraft only to the Dutch coast on the outward leg, and we were met by the escort on our return to the coast. My pilot Dennis Gibbs was only 20 at the time.

Two days later, we were back on routine shipping strikes. The 20th of August was a routine briefing for strikes on enemy shipping, taking off from RAF Bodney at 12.15 p.m. At the end of the patrol we saw a couple of freighters, not large and not what we had hoped for. One never brings back your bomb load, so Dennis commenced his bombing run, low down so as to virtually throw the bombs into the side of the ship. Dennis pulled up and Laurie released the bombs. At this moment, Dennis realised he was below the mast of the ship and attempted to rise above it; too late, as it turned out, and we struck the mast square on the nose

of the aircraft, where Laurie was stationed. The Perspex nose was shattered and Laurie received the full force of the impact, mortally wounding him. The aircraft was severely damaged; the top of the mast was firmly embedded in the shattered nose. The bottom of the aircraft was split open; my radio gear was put out of action, so no means of radioing base. Dennis got control of the aircraft again and as our intercom was still working, he called me up to render assistance to Laurie. Unfortunately, the hinged armoured flap behind the cockpit was jammed and I could not get through. Meanwhile, Dennis had big problems. The shattered nose allowed gale-force wind into the aircraft and he lost maps and charts, various instruments were out of action and he had to read the compass, Dennis had to virtually screw up his eyes to read it. In the end, he decided to fly due west and hope that we reached landfall somewhere. After about 3 hours, land was sighted but unfamiliar. Because we had no idea where we were, and with no airfield in sight, Dennis decided to put the aircraft down in the nearest suitable field.

By this time we had almost reached our flying duration; we had been in the air some 6 hours, 15 minutes, and we executed a wheels-up landing near a small town at approximately 6.30 p.m. Fortunately, a passing military or Home Guard stopped (he had seen the piece of mast and ropes on the front of the aircraft and assumed all was not what it should be). With his help, we got Laurie out of the chaos in the front of the aircraft and he was whisked off to Acklington RAF Hospital. Dennis and I were examined and cuts and bruises were attended to. Tranquillizers were given and we spent the night at Acklington. Sadly, Laurie passed away during the night. I have a photograph of his gravestone in a churchyard at Chevington.

Dennis and I were ferried back to base next day, and we were sent off on 7 days' leave. We crewed up with another navigator and continued our flying. Dennis was awarded the DSO, as recorded in the *London Gazette* of Tuesday 8 August 1944.

I have exchanged many E-mails with Dennis' son Jonathan, and he tells me that his father blames himself for Laurie's death. My theory is that the daily strain of operational flying, especially the trip to Cologne only 8 days previously, could have been a contributing factor for the error of judgment on his part. I, personally, enjoyed great confidence in Dennis' skill as a pilot during the time we flew together.

For your interest, Dennis suffered a brain haemorrhage in 1985 and died almost immediately. I'm just 91, health pretty good (fingers crossed).

Would love to correspond when you have time and thank you again for contacting me.

With regards, Stan

24 October Onwards 2009

I was having no joy in my further findings, except that I had all the details of the aircraft, crew and mission, but had no idea as to where. A posting on the RAF

Commands forum came up with a village: Newton Hall, Embleton (not Embleton Hall). Other than that, even the crash report had recorded 'near RAF Acklington'). I remembered that the family of one of my colleagues, Chris Jackson, originated from the Embleton area; I asked if he knew any people from his father's generation in the area and Chris put me in touch with a Willy Fletcher from Craster, whom he had worked with in his youth at the local brewery. Willy was unaware of any of the crashes in that area, but said he would ask around the village. In the meantime, since all was not progressing, I decided to Google villages around Embleton. This proved to be a success, as the BBC *WW2-The People's War – High Newton-By-The-Sea* link appeared. This mentioned the evacuation of children from the cities to the area, and of the building of RAF Brunton.

The strongest link was in paragraph twelve:

> Brunton Aerodrome was started in 1941. A Wellington bomber came down one Saturday before it was finished. The first aeroplane we saw crash was a Blenheim. It crashed across at the 'Long Nanny' a stream draining into Beadnell Bay, along 'Link House' way. Overnight it had been to Norway and had been so low that two to three feet of the mast from the beach was still embedded in the front of it. One man was badly injured. He lay a long time as no ambulance could be got. There was one at Embleton but it was only for civilian use. At last he was taken to Alnwick but he died the next day.

Account of Mary Wright

This one small paragraph matched with Stan Pascoe's account of the forced landing of V6445. Searching through the names of the sources that had contributed to this site, I managed to trace Mary Wright, aged eighty-seven, the surviving sister of a Hugh Wright; Hugh was one of the contributors. Mary identified exactly where the site was, as she had attended it as a seventeen- or eighteen-year-old girl.

Mary remembered an aircraft flying low over the village of High Newton-by-the-Sea, to the north of the village, nearly at roof-top height. It disappeared over a small hill at the north of the village, but she did not see or hear it crash as the small hill obscured what had happened. She had visited the site, and for many years had in her possession a piece of the ship's mast chain which V6445 had struck. Over the years, this has now been lost.

Her description of the route to the site was perfect; I cross-referenced it with my OS map and an aerial shot from Google Earth before visiting the site, which provided me with an image of the surrounding area before I got there. Mary had believed that all the crew had died, as it was a few days after when she had been to the site. Interest was high (as Mary put it) with the local girls when the RAF recovery team were in the area to remove the wreckage.

Access to the field where the crash happened was provided by Victor Thompson, who owns Newton Links House farm.

Official Documents

I firstly checked my reference books for any possibilities and came up with an 82 Squadron crash with no site location, this being Bristol Blenheim Mk IV V6445 UX-E.

I next contacted the National Archives for copies of the 82 Squadron Operational Records Book (ORB); this came under AIR 27/681 for August 1941. This confirmed the crash of V6445 and the loss of Sergeant Cash, but not the site.

My next move was to contact the RAF Museum Hendon for the F1180 (Loss Card) for this aircraft. What I needed to know was, as near as possible, where the aircraft had crashed. This revealed that the aircraft had crashed in a field near RAF Acklington.

I then contacted the Registrar Office at Morpeth to obtain the death certificate of Laurie Cash. This revealed that 916895 Sergeant Eric Laurence Cash had died in Alnwick Infirmary, 'Due to War Operations' (again no site, as Sergeant Cash had died in hospital). The funeral of Sergeant Eric Lawrence cash took place on 25 August 1941, conducted by J. Wright, RAF Chaplain, at Chevington Cemetery, Red Row.

At the time of writing, Stan Pascoe was living in Queensland, Australia, aged ninety-three. On 27 September, I had the privilege and honour of accompanying Stan Pascoe and his family to Chevington Cemetery, Red Row, to the grave of his bomb aimer and crewmate Laurie Cash. It was bound to be emotional; it was one month over seventy years since their crash. I had prepared a poppy wreath with the 49 Sqn Crest for Stan to lay on the grave. I stood back to allow Stan to have a few minutes private thoughts at the grave. As we left Stan touched Laurie's headstone and said, 'Seventy years mate'. That one statement reduced all to tears, bringing home the importance that these men and women should not be forgotten.

I received the following from Stan's family after the visit.

I would like to thank you personally for everything that you have done for Stan, he was absolutely thrilled for the effort that you had put into everything especially the wreath and visit to the cemetery and of course the conversation with regards to the history of his and other crashes. It was a real pleasure to meet you Chris and once again Many Many Thanks on behalf of Stan, Margaret, Emmie and myself Ray.

The Site of the Crash

Bristol Blenheim Mk IV V6445 UX-E of 82 Squadron, RAF Bodney
Pilot: 63471 F/Lt Dennis Raleigh Gibbs RAFVR, age 20 i/s
W/Op-A/G: 548419 Sgt Stanley Victor Pascoe RAF, age 22 i/s
Observer: 916895 Sgt Eric Laurence Cash, RAF, age 22 +
Squadron: 82 Squadron, RAF Bodney
Site: Long Nanny, Newton Links House Farm, High Newton by the Sea.
Grid: NU22827-26835
Map: OS Explorer 340
Note: No wreckage remains at the site

Bibliography

Chorlton, Martyn, *Airfields of North-East England in the Second World War*
Walton, Derek, *Northumberland Aviation Diary 1790–1999*

Reference

AIR 27/681 – 82 Sqn ORB Jan 1917 to Dec 1941
AIR 27/685 – 82 Sqn ORB appendices Sept 1939 to Sept 1943
Chris Jackson
Commonwealth War Graves Commission
Dennis Gray
F1180 – Loss Card
Key Publishing Ltd website www.keypublishing.com
Mary Wright
Mrs Joan Rose, Northumberland and Durham Family History Society
Ordnance Survey Maps
RAF Commands web Site www.RAFcomands.com
Register of Burials (War Graves) Chevington Cemetery
Stan Pascoe
Victor Thompson
www.bbc.co.uk › Archive List › Childhood and Evacuation
www.london-gazette.co.uk/issues/36649/supplements/3715

HAMPDEN L4072

Handley Page Hampden Mk I L4072 ZN
49 Squadron
RAF Scampton

Church of Christ
North Broomhill
21 December 1939

During my research of air crash accidents which happened in the villages surrounding RAF Acklington, I found this one to be well documented and talked about by local villagers as the aircraft totally destroyed the Church of Christ at North Broomhill. Dave Dunn reminded me of this crash while I was searching to identify a collision over Red Row in the January of 1940. As information for the collision was beginning to come together, I was introduced to Eric Wood, who had provided accounts of four crashes he had visited as a child; one of them was of Handley Page Hampden Mk I L4072 of 49 Squadron RAF Scampton.

Account of Eric Wood

Eric could recall the crash of the Hampden at the Church of Christ. He was unsure of the time, but can remember he was at North Broomhill County Primary

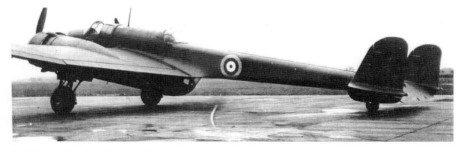

L4072 at Handley Page Radlett airfield, 11 January 1939. (RAF Museum Hendon)

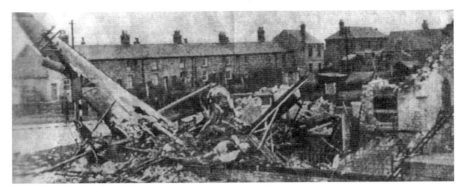

L4072 crash site. (Eric Wood)

School in the junior pupils' class, which had just finished their Christmas party and was being sent home to allow the senior pupils to have their party. Unsure of which direction the Hampden had come from, Eric could vaguely recall the flagpole in front of the church being broken. Eric provided me with a copy of a newspaper cutting from the date of the crash which clearly shows the stricken aircraft and the Church of Christ being totally demolished.

Account of Matty Smith

At the time of speaking to Matty, he was ninety-four years old and in good health. In 1939, Matty lived with his parents in a cottage belonging to North Broomhill Colliery. His father was the head horse keeper for the colliery and Matty, aged twenty-three, trained the ponies for underground work in the pit. On the day of the crash, Matty was training a pony in the field next to the colliery when he heard an aircraft approaching overhead. He saw that it was a bomber coming in to land. Seconds later, Matty saw the bomber hit the Church of Christ and explode into flames. Putting the pony back into the stable, he ran to the church to see if he could help. Matty remembers the Longstaff brothers being present, along with other men. With the aircraft being on fire, he recalls bullets exploding and them breaking windows in the surrounding houses. Matty returned to work for fear of a 'ticking off' for leaving the pit. He always has felt sorry for what happened to the crew, as they were nearly on the runway when they crashed.

Account of Stan Knox

Stan was a seven-year-old pupil at North Broomhill County Primary School in 1939. He was in the infants' class, and they had just had their Christmas party and were being sent home an hour early to allow the junior pupils to have their party.

Stan had been sent for some Christmas decorations at the local shop on Acklington Road. He recalls seeing the aircraft heading towards the Welfare Field at North Broomhill. He could see that the aircraft had a full Perspex front and could clearly see the pilot's knees, but not his face. Stan had not left the school grounds; he had only reached the school gates when he saw the aircraft collide with the flag pole in front of the Church of Christ. There was an explosion and the aircraft burst into flames, carrying on into the church, totally destroying the building. Stan never made it to the shop – he ran straight home to his mother. Stan was able to provide me with a transcript of the police report that had been published in the local church magazine many years after the crash.

Local rumour has that two women were cleaning in the church when the aircraft struck, escaping by climbing over the wings. I have been unable to verify this to date.

Account of Ernie Thornton (Jim Wilson's Uncle)

Ernie Thornton lived at his grandparents' house on Acklington Road North Broomhill, directly opposite the Church of Christ. Ernie was on shore leave from the Navy in December 1939. At the time the Hampden bomber struck the church, Ernie Thornton was at home. He ran out of the house to see what help he could offer in rescuing the crew. Ernie, producing a pocket knife, had helped in cutting the straps of the pilot's safety harness to get him free from the wreckage. This was done successfully with the aid of the pocket knife, thus saving the life of the pilot, Sgt H. Marshall.

Glyn Longstaff (Son of Robert Longstaff BEM)

On 21 December 1939, a Handley Page Hamden bomber was returning from a mission and it is thought that the pilot, realising that he wouldn't be able to make the airfield, made an attempt to land in the recreation ground at Togston at about 3 p.m., just as the children came out of the school, and probably seeing the children playing in the field, tried to turn the crippled aircraft round. In doing so a wing clipped the flagpole, which forced the aircraft into a tight turn, causing it to crash into the Church of Christ. At the same time, Bob Smailes of North Row, Togston, had just got off the local bus; he ran across the road and found the aircraft embedded in the church. He then noticed a pair of feet sticking out of the fuselage. He tried to pull the person free, but he was stuck fast. Just then, Robert Parks of Acklington Road and Robert Longstaff, the Togston garage proprietor, came to his aid and with the use of a pocket knife, they managed to cut free the pilot, a Sgt Edward Marshall, and lift him out of the wreckage. Sgt Marshall had severe facial injuries and a broken leg; unfortunately, the rest of the

crew had been killed. The aircraft then burst into flames and soon both aircraft and church were completely gutted.

For his actions in the rescue of Sgt E. Marshall from the wreckage of L4072, Robert Longstaff was awarded the British Empire Medal (BEM).

Account of Fleet Air Arm Observer Richard Phillimore

In September 2012 while researching the crash site of Typhoon Mk V NV759 at Ford, I was contacted by Rachel Phillimore. Rachel explained that her late father-in-law was in the Fleet Air Arm. In 1939 he was attached to the RAF as an Observer. He was in the aircraft behind L4072 on the approach to RAF Acklington.

> Two squadrons of Hampden aircraft from No. 4 Bomber group were ordered to take off at first light on 21 December 1939. I was to fly in the aircraft of the Wing Commander of the Scampton squadron. I was to identify the German battleship, *Deutschland*. After a meal, we were sent to our aircraft, the only occasion I had ever seen a Hampden. I found there was no seat for me and I had to kneel behind the pilot and shout in his ear. Kneeling on metal from before sunrise to after sunset, even on the shortest day of the year was very unpleasant. Reaching the northerly point of Denmark, without any difficulty, we saw a lot of merchant shipping there, but we were too high to see what nationality it was. We turned north and soon after, the weather deteriorated with low cloud and a westerly gale. I crawled down to the navigator's position and found that his map for the area was hopelessly inadequate and he had no idea where we were. The CO told his radio operator to get a bearing from England and was told he could get no reply. (In the subsequent investigation it was found that peacetime frequencies were being used in the aircraft.) The navigator chucked his hand in and urged that we should head west. We had to fly at a height of 1,000 ft due to low cloud, at a speed of 140 knots into a gale, we would have little fuel left when we reached the English Coast. The pilots were reporting that fuel was almost exhausted when we sighted Holy Island. At the same time we saw Hurricanes about to attack us. I was able to alert the CO to fire the appropriate two-star Very signal to identify ourselves just as one of the Hurricanes started to dive. Five minutes later we were preparing to land at RAF Acklington. While in the circuit preparing to land, one of our aircraft (L4072) indicated that they were out of fuel and could they go into land first. My aircraft was on the approach to the airfield. L4072 indicated that it was out of fuel and needed to go in straightaway. The CO let it go in just ahead of us, and as a result I was watching it immediately ahead of my own plane, as it just failed to make it down safely and crashed into a church; all on board I believe were killed. Ironically as we were taking off from Scampton, I had seen one airman running to his aircraft, which, however, took off

without him. This was the navigator of the aircraft that crashed into the church; he had gone to sleep after being called and missed the flight. He was subsequently court-martialled and reprimanded, but he was alive.

Official Documents

I firstly checked my reference books for any positive identification and matched this with a 49 Squadron fatality, this being Handley Page Hampden Mk I L4072 of 49 Squadron.

I next contacted the National Archives for copies of the 49 Squadron Operational Records Book (ORB); this came under AIR 27/2006 for December 1939. This confirmed the crash of Handley Page Hampden L4072 and the crash site.

Stan Knox provided me with a letter submitted to the church magazine which had a variation of the account from the Broomhill Police Section Occurrence Book.

My next move was to contact the RAF Museum Hendon for the F1180 (Loss Card) for this aircraft. What I needed to know was, as near as possible, where the aircraft crashed. This revealed that the aircraft had struck the Church of Christ at Broomhill.

The citation posted in the *London Gazette* for the award of the British Empire Medal to Robert Longstaff has the crash as happening on 27 December 1939. All other records have crash as 21 December 1939.

The Broomhill police occurrence log for 1939 does not mention who cut Sgt Marshall from the wreckage, but that 'he was thrown from the aircraft'. It also does not record the second pilot/navigator, P/O J. M. D. Irvine as being on the aircraft.

49 Squadron Association gave a full account of the last flight of L4072; the Squadron ORB also records second pilot/navigator P/O J. M. D. Irvine as being on the aircraft.

I then contacted the Registrar Office at Morpeth to obtain the crew's death certificates; this revealed that Sgt S. H. Potts and AC1 E. H. Humphrey were killed at North Broomhill.

Broomhill Police Section Occurrence Book

21 December 1939
Sgt 165 J. McAlister reports, a flying accident which occurred at about 3.30 p.m. on Thursday.

21 December 1939
It appears that a HAMPDEN twin engined bomber from Scampton Aerodrome, Lincolnshire, after having been in the air for some continuous hours, was about to

Left: Gravestone of Sgt S. H. Potts. (Author)

Above: Grave of AC1 E. H. Humphrey. (49 Sqn Association)

land at Acklington aerodrome when one of its engines stalled and the bomber lost height, and in doing so collided with a flagstaff and a tree in the Welfare Park.

The aircraft continued and then collided with the Church of Christ chapel. Through the collision, the chapel and the bomber caught fire. The pilot, Sergeant H. Marshall was thrown from his machine and sustained a fractured leg and bruises and cuts on the body. He was conveyed to Alnwick Infirmary. Sergeant Samuel Hainey Potts aged 24 years and AC1 Edward Harry Humphrey aged 20 years were burned to death. Robert Longstaff, 'Craig Y Don', Warkworth and George Longstaff, 'Prospect House', Radcliffe, attempted to remove the two airmen without success. Ashington Fire and Rescue Brigade arrived at the scene at 4.17 p.m. The chapel and the plane were completely destroyed.

Result of inquests: Fatal flying accident inquest held by H. J. Percy, HM Coroner on 22 December 1939 and adjourned.

Further inquest held 1 January 1940 at 11 a.m. at the aerodrome. Verdict of Coroner, H. J. Percy: 'That the deceased men were killed as a result of the accidental crashing of a Royal Air Force machine which the deceased were flying as passengers', and that the cause of death was, 'Multiple injuries in each case as a result of the said crash'.

Brief Account of the Crash (from *The Dog at War* by John Ward)

December, 1939: At 21.00 hours on 20 December the squadron received instructions to bomb the pocket battleship *Deutschland*, which had been reported in the vicinity of the Norwegian coast. They were then required to return to the Scottish base of Leuchars.

The following day, the 21st, twelve Hampdens of 49 Squadron took off from their Scampton base. Over Lincoln they met up with twelve Hampdens of 44

Squadron from Waddington and under the command of W/Cmdr Sheen, the formation headed towards the North Sea, passing over Skegness.

On reaching the Norwegian coast, they turned northwards and spread out in line abreast as they hunted for the *Deutschland*. But the search was in vain, and at the limit of their range the Hampdens turned and headed for Scotland.

Sleet and rain showers reduced visibility on the return flight and the two squadrons became separated. The Scampton flight made landfall in Northumberland, where it was intercepted and recognised as friendly by twelve fighters of 43 Squadron. By 15.47 hours, most of the formation was landing at nearby Acklington. Meanwhile, 44 Squadron had crossed the coast south of Dunbar. Spitfires of 72 Squadron intercepted them and informed control that they were Hampdens. No. 602 Squadron Spitfires from Drem (the same base as the Hurricanes) were also scrambled, and without at first recognising the aircraft, proceeded to shoot down two of the Hampdens.

At Acklington, one of 49 Squadron's aircraft was short of fuel, and was having problems. Piloted by Sgt Marshall, it crashed into a Chapel at Broomhill on the edge of the aerodrome. As a result, the pilot was seriously injured and sadly two members of the crew were killed. Also injured in the crash was the second pilot/navigator, P/O J. M. D. Irvine.

The funeral of Sgt Samuel Hainey Potts took place on 27 December 1939, conducted by Revd J. Newbould, at Chevington Cemetery, Red Row. Among those present were Sgt Potts' father and mother and representatives from his RAF station.

Sergeant S. H. Potts: Section B.B., Grave 95, Chevington Cemetery
AC1 E. H. Humphrey: Benfieldside Cemetery
39988 P/O James Melville Dundee Irvine was killed on 24 May 1940, aged 21. His aircraft, Hampden P1336 ZN of 106 Squadron, was on a training exercise when his aircraft flew into the Coventry balloon barrage at night. The aircraft crashed killing the three crewmen aboard.
P/O J. M. D. Irvine: Square 348, Grave 42, Coventry (London Road) Cemetery

The Site of the Crash

Handley Page Hampden Mk I L4072 ZN of 49 Squadron RAF Scampton
Pilot: (Service Number unknown) Sgt E. Marshall, RAF, age unknown.
2nd Pilot/Navigator: 39988 P/O James Melville Dundas, Irvine RAF, age 21 i
Observer: 580464 Sgt Samuel Hainey Potts, RAF, age 23 +
Wireless Operator: 539268 AC1 Edward Henry Humphrey, RAF, age 19 +

Squadron:	49 Squadron RAF
Site:	Church of Christ, North Broomhill
Grid:	NU22490 01529
Map:	OS Explorer 325
Note:	The crew of this aircraft are remembered on the memorial to twenty-nine aircrew and thirteen aircraft in the former RAF Acklington church, St John the Divine, Red Row, unveiled on 7 May 2011

Bibliography

Chorley, W. R., *Bomber Command Losses*, Vol. 1
Chorlton, Martyn, *Airfields of North-East England in the Second World War*
Eden, Paul, *Encyclopaedia of Aircraft of WWII*
Stewart, Elizabeth, *RAF Acklington*
Walton, Derek, *Northumberland Aviation Diary 1790–1999*

Reference

AIR 27/480 – 49 Sqn ORB
AIR 28/17 – RAF Station Acklington ORB
Broomhill Police Section Occurrence Book
Commonwealth War Graves Commission
Dave Dunn
Dennis Gray
Ed Norman, 49 Squadron Association
Eric Wood
F1180 – Loss Card
Falon Nameplates, www.falonnameplates.com
Glyn Longstaff
Jim Wilson
Margaret Weaver
Matty Smith
Mrs Joan Rose, Northumberland and Durham Family History Society
Northumberland Gazette
Ordnance Survey Maps
RAF Commands website, www.RAFcommands.com
Register of Burials, War Graves, Chevington Cemetery
Revd Wendy Aired, St John the Divine Church, Red Row
Stan Knox

HURRICANE V6989

Hawker Hurricane Mk I V6989
59 OTU
RAF Milfield

Till Bridge
Newton Grange
Chillingham
4 February 1943

Once again, my thanks to Basil Oliver for pointing me in the right direction for this aircraft. While searching for Hawker Hurricane N2522 at Megrims Knowe in the Breamish valley (known as Ingram Valley), Basil retold a story from his father-in-law Bob Davison with regards to a crash at the Till Bridge, near Chillingham Castle. Always one to take note of local knowledge, I listened and took note of what Basil told me. This matched up with a record of a Hurricane loss for which I had previously sent away to the RAF Museum Hendon for the F1180 Loss Card: that of V6989.

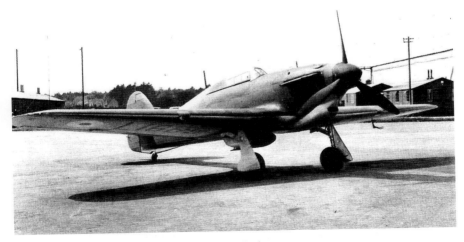

Hawker Hurricane Mk I. (RAF Museum Hendon)

Account of Robert (Bob) Davison (Retold by his Son-in-Law, Basil Oliver)

Bob was working in the Newton Grange area of Chillingham; he was approaching the Till Bridge, a small humpbacked bridge running north to south from Newtown Grange to Chillingham Castle. Sitting on the parapet of the south-west side of the bridge was a section of Home Guard. Bob asked them what was happening. He was told that an aeroplane had crashed into the ground in the small copse to the west of the bridge. When he asked where, he was told, 'You can't see it, it's gone straight into the ground', and that if he listened carefully, he would be able to hear the hissing of the engine. The aircraft had gone deep into soft ground and was as far down as the water table.

21 January 2009

Along with my trusted air-crash-hunting poodle, Penny, I set off to find this site. I had not been in the Chillingham Castle area for some twenty years and could not remember the Till Bridge. Checking my OS map, the bridge was to be easy to find. Sarah Wilson from Ingram informed me that the land belonged to Lilburn Estates. I contacted the estate manager, Ian Hall, for access to the small copse either side of the bridge (if I could not locate evidence in one, I would have to search the other).

Permission granted, I arrived at the Till Bridge ready to conduct a search of the copse to the west of the bridge. The Till Bridge was as Basil had described it, humpbacked with a short parapet leading to the bridge itself. I could imagine where the Home Guard had been sitting when Bob Davison had spoken to them on the night of 4 February 1943.

Breaking the copse into sections, I began my search pattern. As this site is very close to a road, I prepared myself to find a lot of cola, beer and lager tins which will have been cast out of many a car window over the years. At first, the finds were spread out and, to my surprise, minimal. As I moved to the west, away from the bridge, I found the remains of several Ely paper and brass shotgun cartridges (the paper had disintegrated). After an hour I was becoming bored with my finds. Recalling that the aircraft had buried deep into the ground, I started to look for a depression in the ground. Nearly 100 metres from where I was standing, I could see a reflection of water through the trees, not a pond, but a small area containing water.

As I moved towards it (the river was to the north and behind me), I kept on sweeping with the metal detector. At 10.25 a.m., I had a positive signal; I unearthed a small alloy tube, and moments later, fragments of fuselage; I was on site. Concentrating on these small finds, I started to move towards the water in

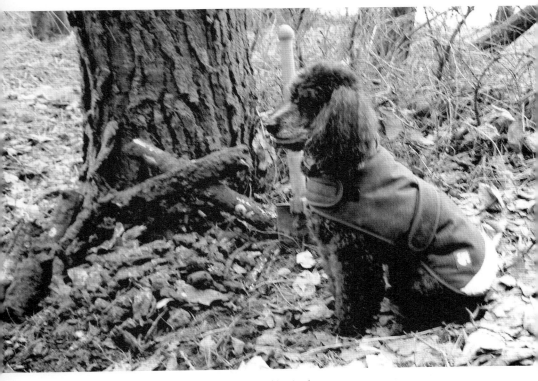

Penny guarding an undercarriage leg of V6869. (Author)

the trees. I noticed to my right (west) a large depression, with what appeared to be the shape of a tapered wing at one end of it. This depression was alive with signals, and after several small excavations I uncovered broken .303 ammunition, various alloy pipes and fragments of airframe. I had located the site of V6989.

28 February 2009

I returned to the site with my trusted Penny and started to make a thorough search of the depression, as the site was alive with signals on my metal detector. I also brought along a larger spade; my Swiss Army entrenching tool is good for scratching the surface, but not for opening up a larger area.

I had informed Sarah Wilson that I would be at the site today, and asked if she would like to come along for moral support and to see for herself that I had found the site that Basil had told me about. As Sarah arrived, I had, at a depth of 1 metre, uncovered a part of an undercarriage leg. I had cleared a trench 3 metres long and 1 metre deep; there were no further significant finds, but the site was showing strong signals at a greater depth on the eastern side of the depression, I was to need help!

The fuel impellor from V6989. (Author)

Engine components from the wreckage of V6989, found 1 April 2009. (Author)

1 April 2009

I had arranged with my friend and colleague from work Dave Gray to come along and participate in some light digging. Dave was of the impression that we would not uncover much. There was a bad start to the day, as Dave had forgotten it was his children's assembly at school and arrived two hours late! But he is my mate, so I forgave him. He had the full support of his wife, Julie, who considered us 'very sad'.

Once on site, we marked a trench 2 metres in circumference and set to work. The ground was very sandy and easy to move; at just above the 1-metre depth mark, the fragmented finds stopped, but the signal from the trench was loud and clear. We continued then suddenly began to unearth larger pieces; these were two engine pistons, a fuel impellor, the yellow tip from the propeller, and various pumps and cogs from the engine. We had also found what appeared to be the main engine block, but it was too large to move. Time was getting on and I had persuaded Dave that we must refill the site and go home. 'But we have found it,' he explained, but time was getting on and we must leave.

Note: I have since applied to the Ministry of Defence for a licence to officially excavate this site; prior to this, full authorisation of the landowners had to be agreed, in conjunction with the Northumberland County Archaeologist. There is an unexplained delay with the County Archaeologist, and the excavation has been postponed.

Official Documents

I firstly checked my reference books for any possibilities and came up with a 59 OTU fatality, this being Hawker Hurricane Mk II V6989.

I next contacted the National Archives for copies of the 59 OTU Operational Records Book (ORB); this came under AIR 27/684 for February 1943. This confirmed the crash of Hawker Hurricane V6989, but not the location.

My next move was to contact the RAF Museum Hendon for the F1180 (Loss Card) for this aircraft. What I needed to know was, as near as possible, where the aircraft crashed. This revealed that the aircraft had crashed at Newtown, Chillingham.

I then contacted the Registrar Office at Morpeth to obtain the pilot's death certificate; this revealed that R133535 Sergeant Murray Allen Dixon RCAF had been killed in a flying accident at Newtown, Chillingham.

The Wooler Police Occurrence Book records the crash being reported at 10.45 a.m., with the aircraft, Hurricane V6989, crashing near the Till Bridge, Chillingham Newtown.

The Reverend Canon Jeffery Smith and his wife Barbara assisted by searching the Burial Register (War Graves) for St Gregory, Kirknewton, for the date of Sergeant Dixon's funeral.

A Brief Account of the Crash

Sergeant M. A. Dixon took off from RAF Millfield on the morning of 4 February 1943 for a routine operational training flight. At a height of 10,500 feet, his aircraft was seen to go into a right spiral then continue into a vertical dive straight into the ground; this occurred at 10.20 a.m. The aircraft dived into the earth, and the engine was buried into the ground at a depth of about 15 feet. The whole machine disintegrated; parts were some 60 yards away, and in the tree-tops. The crash site was guarded by soldiers of the 7th Battalion, Seaforth Highlanders.

The investigation into the crash concluded that the pilot probably blacked out and failed to recover due to some physical weakness!

Sergeant M. A. Dixon: Grave 4, Kirknewton. (St Gregory) Churchyard.

Note

Records for Operational Training Units are very brief; 59 OTU's entry for 4 February 1943 basically records 'Fine. Hazy. Flying 0850–1725 Sgt Dickson [*sic*] killed in flying accident.'

The *Toronto Star* newspaper for 9 February 1943 reported that 'The family held a private ceremony in Carleton Place, Ontario' (near Ottawa).

The funeral of Sergeant Murray Allen Dixon RCAF took place on the Monday 8 February 1943. The service was conducted by W. H. P. Hills, Chaplain, RAF

Gravestone of Sgt M. A. Dixon. (Author)

Milfield, with two officiants in attendance from 59 OTU, Mr R. Trinton and Gordon V. Porter RCAF.

The Site of the Crash

Hawker Hurricane Mk I V6989 59 OTU RAF
Pilot: R133535 Sergeant Murray Allen Dixon RCAF, age 19 +
Squadron: 59 OTU RAF Milfield
Site: Till Bridge, Newtown Grange, Chillingham
Grid: NU04868 25189
Map: OS Explorer 340
Note: Large wreckage remains buried at the site

Bibliography

Chorlton, Martyn, *Airfields of North-East England in the Second World War*
Walton, Derek, *Northumberland Aviation Diary 1790–1999*

Reference

AIR 29/684 – 59 OTU ORB
Basil Oliver
Commonwealth War Graves Commission
Dave Gray
Dennis Gray
F1180 – Loss Card
Ian Hall, Lilburn Estates
Mike Hatch – AHB
Mrs Joan Rose, Northumberland and Durham Family History Society
Ordnance Survey Maps
RAF Commands website www.RAFcommands.com
Register of Burials (War Graves) Kirknewton (St Gregory) Churchyard
Revd Canon Jeffery and Barbara Smith – St Gregory, Kirknewton
Sarah Wilson
Toronto Star Newspaper
Wooler Police Occurrence Book

WHITLEY Z6869

Armstrong Whitworth Whitley Mk V Z6869 GE-T
58 Squadron
RAF Linton-on-Ouse

Turnbull's Farm
North Broomhill
3 September 1941

While researching the collision of Hawker Hurricanes L2066 and L1734 on 18 January 1940, I had a small piece of information given to me via Dave Dunn, from Eric Wood of South Broomhill. This was regarding a Whitley bomber which had crashed in the Red Row/Broomhill area.

Intrigued, I started looking for anything in my reference books with regards to a Whitley bomber crashing in the area. It was noted that an Armstrong Whitworth Whitley Mk V, Z6869 GE-T, had crashed at Turnbull's Farm.

This one should be easy to locate, I thought, as I worked in the area and knew many people from Broomhill. Since my search for air crash sites in the villages around the former RAF Acklington had started from a tale from Davey Dunn's father, Eddy Dunn, Davey would know where the farm was. Davey could not help; as I soon discovered many others of Davey's generation from Red Row/ Broomhill did not know where the farm was located or had been located. However, all could tell me where Turnbull's buildings were: next to The Trap pub, in between it and the primary school. This was all before I could meet up properly with Eric Wood and discuss what, where and when!

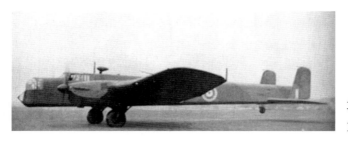

Armstrong
Whitworth Whitley
Mk V.

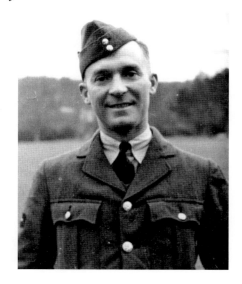

Sgt Charles Steggall, W/Op. (John Hardy)

Account of Eric Wood

Eric had kindly jotted down for me various air crash incidents he could remember that he had seen or was aware of in his home area of Broomhill. At the time of this crash, Eric was a nine-year-old boy, living what was then the end house on Cross Row, South Broomhill (the border of South Broomhill and Red Row). He could remember a Whitley bomber crashing in the fields over the main road (which passes through Red Row/South Broomhill) at Turnbull's Farm; this was at least a positive location for the farm.

Eric could recall the aircraft was stood on its nose with the tail in the air, clearly visible from his home. He could clearly remember the twin tail fins sticking up in the air above the tree line. The site he pointed out was in the field, behind a hedge, on the horizon line from where he used to live. He was aware that the rear gunner had survived the crash.

Account of Jim Wilson

At the age of thirteen, Jim Wilson attended Red Row Senior School; he did not see this crash or attend it, but was aware of what had happened. Jim said he had been 'tettie pickin' (potato picking) during the first week of September 1941. He and other youngsters from the local villages were earning extra pocket money 'tettie picking'. Jim explained that the crash had happened on a Thursday, as on the Friday they were not allowed into the field at Turnbull's Farm to pick potatoes; it was cordoned off because of the crash. Jim was aware that the tail gunner had survived.

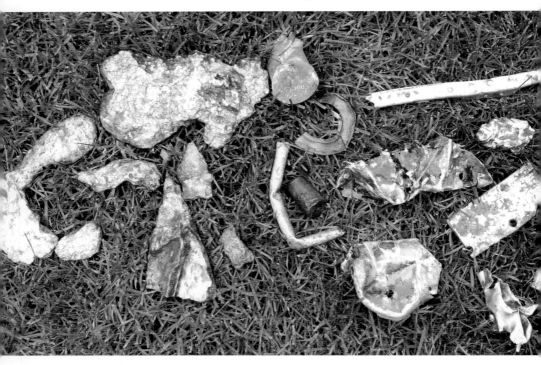

Fragments from the wreckage of Z6869 GE-T. (Author)

9 September 2008

I had arranged for Eric to escort myself and colleague Russ Gray to the field where he remembered the crash had happened.

We met at 10 a.m. and drove to Turnbull's Farm. This is now known as Broomhill Farm, and for the generation of Davey Dunn, it was known as Gray's Farm, but the important thing was that it was Turnbull's Farm. Armed with metal detectors and spades, I had already approached Chris Anderson, the manager of Broomhill Farm for access to the field; this was granted as the crop had not long been harvested and nothing could be damaged. We were to enter field number twelve. We arrived on site at approximately 10.15 a.m. in pouring rain. Eric explained that he thought the aircraft had collided with the tree line on the eastern edge of the field and hit the ground 80 to 100 metres into the field. There was evidence of damage to the tree line, as a large tree was missing from the tree line in a straight line to where Eric believed the aircraft had crashed. He also believed that the stricken bomber was approaching the north-west runway of RAF Acklington. Marking the area to search, we started from the broken tree and moved west into the field; at first, all finds were, as expected from a lowland site that has been farmed for over 100 years, many bits from farm machinery. At

about 11 a.m., we started to locate a concentrated area near enough to the 100-metre mark, as Eric has suggested. We began to uncover fragments of molten alloy, fuselage, cockpit frame and a cockpit light fitting (the light fitting was easy to identify: it was clearly marked 'Air Ministry Cockpit Lamp Mk 2'). We were definitely on site and Eric's memory was once again correct. That night after I returned home, I found my copy of the RAF Acklington station map (an ex-British Coal plan used prior to opencast mining) which had Broomhill and Acklington marked on it. This map I unrolled only as far Broomhill Farm (Turnbull's Farm). I marked on the map where we had found the fragments, then unrolled the map of the station fully. The site was 1 mile from, and in a direct line to, the north-west runway.

Chris Pickering, Field House Farm

I had met with Chris Pickering a few months earlier, while locating the abandoned wreckage of a De Havilland Vampire jet, XD592, which had crashed at Newton on the Moor in 1961; its wreckage had been brought to RAF Acklington for investigation, then placed on the station's dump (at the end of the north-east to south-west runway). Chris had kindly loaned me his copy of the British Coal map of Acklington. He also provided me with the draft notes of a book, of which only five copies were ever printed: *An Anecdotal and Statistical History of RAF Acklington*. Flicking through the notes I came across a reference to this crash submitted by a Thomas Law, who was the brother of the pilot of Z6869 P/O Andrew A. Law.

Thomas Law (Brother of P/O Andrew A. Law)

Reading the draft notes for *An Anecdotal and Statistical History of RAF Acklington*, Thomas Law had put his home as 'Plaistow, New Hampshire, USA'. I contacted the American Legion for the Plaistow region, the Carl Davis branch, and linked up with David Meaney; through David, I managed to trace the address and telephone number of Thomas Law; they also confirmed that this chap was the brother of P/O Andrew Law. I contacted Thomas by telephone on 12 December 2008. Although I was nervous at what to say at first, compounded by being very unsure of the time difference between England and America, Thomas was of great help. At the time of our conversation he was eighty-seven years old. He told me that he himself was a trained fighter pilot and joined 152 (Hyderabad) Squadron in Burma, flying Supermarine Spitfire Mk VIIIs. 152 Squadron had been formed at RAF Acklington on 2 October 1939, the station where his brother had died trying to land in the September of 1941.

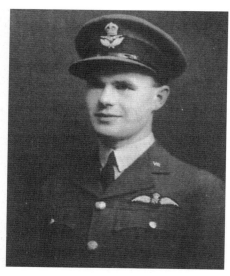

P/Off Andrew A. Law. (Thomas Law)

Official Documents

I firstly checked my reference books for any possibilities and came up with a 58 Squadron crash, this being Armstrong Whitworth Whitley Mk V Z6869 GE-T.

I next contacted the National Archives for copies of the 58 Squadron Operational Records Book (ORB), which came under AIR 27/544 and AIR 27/549 for 3 September 1941. This confirmed the crash of Whitley Z6869 GE-T.

My next move was to contact the RAF Museum Hendon for the F1180 (Loss Card) for this aircraft. This gave the area as Turnbull's Farm, South Broomhill.

I then contacted the Registrar Office at Morpeth to obtain the crew's death certificates; this revealed that 87053 P/O Andrew Allison Law, RAFVR, R69644 F/Sgt Wallace Howard Trewin, RCAF, R56104 Sgt Robert Lawrence Ward, RCAF and 755408 Sgt Charles Oliver Steggall, RAFVR had been killed in a flying accident at Turnbull's Farm, North Broomhill.

The Broomhill Police Occurrence Book for 4 September 1941 recorded the crash at Broomhill Farm, map reference 734205 (British Cassini Grid), and as happening at 11.50 p.m., with the fire brigade arriving at 11.49 p.m., one minute before the crash!

A Brief Account of the Crash

The Z6869 GT-E crew were: P/O A. A. Law, Sgt W. H. Trewin, Sgt R. L. Ward, Sgt C. O. Steggall and P/O E. D. Comber-Higgs. They took off from RAF

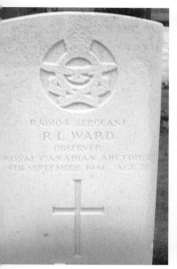
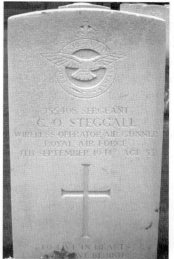
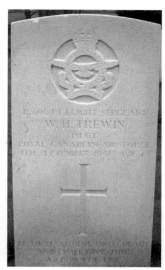

Left: Gravestone of Sgt Robert L. Ward, Obs. (Author)

Middle: Sgt Charles O. Steggall WOp. (Author)

Right: P/O William H. Trewin 2nd pilot. (Author)

Linton-on-Ouse at 19.21 for an operational sortie to Brest, which consisted of 2nd 140 aircraft (85 Wellingtons, 30 Hampdens, 19 Whitleys. 4 Stirlings and 2 Manchesters). Their targets were the German battlecruisers *Scharnhorst* and *Gneisenau* and the light cruiser *Prinz Eugen*. This was to be P/O A. A. Law's twenty-ninth operational sortie.

Due to worsening weather conditions, the aircraft received a signal at 20.30 and was ordered to return and divert to RAF Acklington airfield. Fifty-three aircraft out of the eighty-five reached the estimated positions of the German warships through a smoke screen.

Meanwhile, fog had moved in over the east coast of England and the returning aircraft had to contend with fog conditions. Approaching RAF Acklington from the south-east, 1 mile short of the runway at 23.45, Z6869 GE-T collided with trees at Turnbull's Farm, North Broomhill, bursting into flames, killing four of the five crew aboard.

The fire brigade and ambulance arrived at 23.49, East Chevington auxiliary fire brigade arrived 00.03 a.m.

The sole survivor was the rear gunner, P/O E. D. Comber-Higgs.

The funerals of Sgt Robert Lawrence Ward, P/O William Howard Trewin and Sgt Charles Oliver Steggall took place on 7 September 1941, conducted by J. Wright, Chaplain, RAF, at Chevington Cemetery, Red Row.

Pilot Officer A. A. Law: Section J, Grave 123, Edinburgh (Morningside) Cemetery

Flight Sergeant W. H. Trewin: Section H, Grave 199, Chevington Cemetery

Sergeant R. L. Ward: Section H, Grave 241, Chevington Cemetery

Sergeant C. O. Steggall: Section H, Grave 198, Chevington Cemetery

Pilot Officer E. D. Comber-Higgs: Panel 31, Runnymede Memorial

Note

On the night of 17–18 April 1941, Whitley Mk V T4266 GE-O, crewed by P/O A. A. Law, Sgt A. Whewell, P/O Mcneil, Sgt Rose and Sgt C. O. Steggall, was returning from a bombing raid on Berlin. It was hit by flak over Hamburg which damaged the port engine. At 03.50, the starboard motor seized and caught fire. At 04.00, P/O Law ditched the aircraft into the North Sea. Late in the evening of 20 April, a Hudson sighted the crew in their dinghy and dropped a bag of brandy, biscuits and cigarettes; a Hampden later dropped Lindholme rescue gear in their vicinity. At 22.30 that same evening, one very exhausted and hungry crew were rescued by ASR launch, some sixty-four hours after coming down in the sea.

On the night of 30 November – 1 December 1941, Whitley Mk V Z6506 GE-V, crewed by Sgt A. Whewell, Sgt G. C. Davies, P/O P. N. Romilly, P/O E. D. Comber-Higgs and Sgt T. H. Marlowe, took off at 16.51 for a raid on Hamburg and was lost without trace. Sgt Whewell was a member of P/O Law's crew that ditched in the North Sea in April 1941, and by coincidence, P/O E. D. Comber-Higgs was the sole survivor from the crash at Turnbull's Farm, North Broomhill. All are commemorated on the Runnymede Memorial.

The Site of the Crash

Armstrong Whitworth Whitley Z6869 GT-E, RAF Linton-on-Ouse

First Pilot:	87053 P/O Andrew Allison Law, RAFVR, age 24 +
Second Pilot:	R69644 F/Sgt Wallace Howard Trewin, RCAF, age 24 +
Observer:	R56104 Sgt Robert Lawrence Ward, RCAF, age 21 +
Wireless Operator:	755408 Sgt Charles Oliver Steggall, RAFVR, age 33 +
Rear Gunner:	82973 P/O E. D. Comber-Higgs, RAFVR, age unknown i
Squadron:	58 Squadron RAF Linton-on-Ouse
Site:	Turnbull's Farm, Broomhill
Grid:	NU24390 00178
Map:	OS Explorer 325
Note:	Fragments remain buried at the site

The crew of this aircraft are remembered on the memorial to twenty-nine aircrew and thirteen aircraft in the former RAF Acklington church, St John the Divine, Red Row, unveiled on 7 May 2011.

Bibliography

Chorley, W. R., *Bomber Command Losses, Vol. 2*
Chorlton, Martyn, *Airfields of North-East England in the Second World War*
McMillan, William, *An Anecdotal and Statistical History of RAF Acklington*
Walton, Derek, *Northumberland Aviation Diary 1790–1999*
War Diary of P/O Andrew Allison Law (Courtesy of Thomas Law)

Reference

AIR 28/17 – RAF Station Acklington Operations Records Book
AIR 27/544 – 58 Squadron ORB
AIR 27/549 – 58 Squadron ORB Appendices
Broomhill Station Police Occurrence Book
Chris Anderson, Turnbull's Farm (now Broomhill Farm)
Chris Pickering, Field House Farm
Commonwealth War Graves Commission
Dave Dunn
David Meaney, American Legion
Dennis Gray
Eric Wood
F1180 – Loss Card
Falon Nameplates www.falonnameplates.com
Jim Wilson
Mrs Joan Rose, Northumberland and Durham Family History Society
Ordnance Survey Maps
RAF Commands website www.RAFcommands.com
Register of Burials (War Graves) Chevington Cemetery
Russ Gray
Thomas Law

HURRICANE Z2893

Hawker Hurricane Mk IIc Z2893
43 Squadron
RAF Acklington

South Side Farm (now South Farm)
Lucker
5 April 1942

While trying to find the crash site location of Bristol Blenheim V6445, I was in contact with a George Thompson, whose family had farmed in the Embleton area. George put me in touch with eighty-three-year-old Dave Pyle from Seahouses.

Dave was to prove to be invaluable with my search for two crash sites: that of Hawker Hurricane Z2893, and that of Gloster Meteor WF842 in nearby Newham. Dave could recall these two sites as he had attended them both, the Hurricane as a fourteen-year-old boy and the Meteor as a twenty-four-year-old young man.

During the war years, Dave was in the Air Training Corps (ATC) 1801 Sqn. He can recall the day he saw what he recognised as a German Me 110 flying

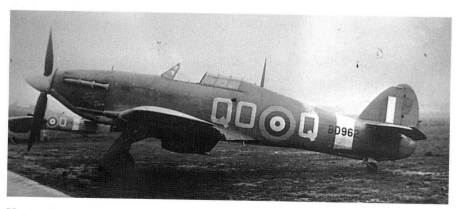

Hawker Hurricane Mk IIc. (3 Squadron Association)

low over the coast. He recalls finding it strange seeing such an aircraft over the Northumberland coast, as this type of aircraft did not have the fuel capacity to make it back to Germany and Dave could see no auxiliary fuel tanks fitted to the aircraft. To confirm what he saw, Dave went straight home and consulted his aircraft recognition sheets, which he had been supplied with by the ATC; he was right – he had seen a Bf 110.

It wasn't until many years later that Dave realised that he had seen the aircraft of Rudolf Hess, Deputy Führer to Adolf Hitler, which he had used to flee Germany on 10 May 1941 (hence the 'no auxiliary fuel tanks', since Rudolf Hess had no intention of a return flight).

Account of Dave Pyle

Dave could recall a crash in the area of the small village of Lucker, approximately 5 miles south-east of Belford. Dave knew it was early in the Second World War and thought it might have been a Spitfire. He could remember that the aircraft was some 14 feet into the ground and didn't believe that the RAF had recovered the engine. He had also seen the remains of the pilot placed into the ambulance. Dave was positive in the identification of the site's location.

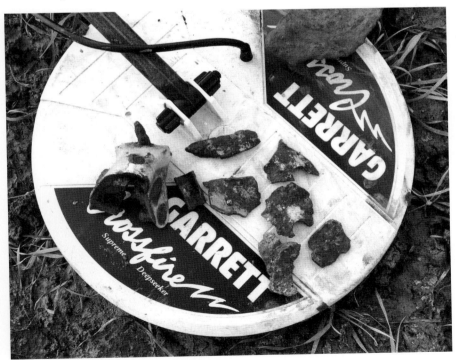

Fragments from the wreckage of Z2983. (Author)

Fragments from Z2893 guarded by a very cold Penny. (Author)

29 January 2010

When I had first spoken to Dave Pyle in early December 2009, I had got confused with the stories of the Lucker and Newham sites. I had misunderstood when Dave was in the Air Training Corps, believing it to be in the early 1950s, and I could find no trace of a fighter crash in the area for that period.

I had arranged to pick Dave up at 9 a.m.; Dave assured me he would take me straight to the field where the crash occurred. We arrived on site at 9.30 and parked next to a field on the lower part of Cock Ridge. We parked the car on the grass verge of a tight but open bend in the road. Dave pointed out that at the site of the crash the military ambulance was parked on the opposite side of the road, on the inner part of the bend. Dave can recall that the remains were taken to the ambulance in a bag the size of a pillow case.

Standing on the corner and looking directly west into the field, Dave felt that the crash site was 80 to 100 yards into the field (approximately 75 metres). The sky was blue, but the forecast was for terrible snow and hail. Next, we went to see Ed Brown, the farmer of Lower Cock Ridge Field, to ask for access. Ed was more than eager to help and allowed us to enter with a metal detector and spade to see if I could find any trace.

Ed was aware of a crash in the field but had no idea what the aircraft was, or where it had crashed.

At 9.45 a.m. we entered the field by an easy access point in the hedge (I think, over the years, that a few cars many have gone through the hedge at this point) and went back 20 metres towards the car. As we started in the direction Dave had said the site was, the weather took a turn for the worse. From the north, the sky turned black and you could see what appeared to be a wall of hailstones was coming at speed towards us; it was on us within seconds, and we abandoned the field and headed for the shelter of the car.

While waiting for the hail to clear, Dave informed me that he was a member of the Air Training Corps when this crash happened. I asked his date of birth and he replied '1927', so I suggested that he would have been thirteen or fourteen years old at the time of this crash. This meant the reason I could find no trace of a crash was that I was searching my records seven or eight years too late.

At 10.15 a.m. we resumed our position in the field and started in the direction Dave had noted. My first problem was that the field was very magnetic and my detector was giving a reading (by sound only) all the time. I needed to adjust my frequency to make the search easier. At first, I managed to find a few parts of nails, nuts and bolts, all to be expected in a field that has been cultivated for the last seventy years or so.

It was bitterly cold and I had to consider Dave.

The crash site of Z2893, 100 m beyond the fence. (Author)

At 11.00 a.m. I got a very positive reading in sound, and on the detector's screen. At a depth of 16 cm I found a piece of oxidised alloy typical of all the crash sites I have surveyed. This was enough for now, as a search area had been established for future visits.

3 February 2010

I returned to the site on my own as the weather was still reading -4 °c and bitterly cold. I had my trusted air-crash-hunting companion with me, Penny, my by now fourteen-year-old poodle. I had brought the site up on Google Earth to have an aerial view of the site; this, on occasions, produces hints as to possible search areas (you can sometimes see a shadow on the land different to the rest of the area). I had noticed a slight shadow approximately 100 metres south of where I had found the first fragment and I decided to search this first to eliminate the shadow. I was also visited by Ed Brown in the field; he had spoken to someone who had had their memory jogged and believed the crash site was further south in the field.

Two and a half hours later, I had found nothing but a few bits of iron which I firmly believe were off farm implements. I went back to the edge of the field and walked 100 paces towards the original site where the fragment was found. (I walk 115 paces to 100 metres). At 100 paces, I was exactly on the find site. I would re-conduct my search here. Within a few minutes I found a half a dozen more oxidised alloy fragments. Then, one final sweep for the day produced a coupling joint from the airframe ... this was definitely the site.

Official Documents

I firstly checked my reference books for any possibilities and came up with a 43 Squadron fatality, this being Hawker Hurricane Mk IIC Z2893.

I next contacted the National Archives for copies of the 43 Squadron Operational Records Book (ORB), which came under AIR 27/2006 for April 1941. This confirmed the crash of Hawker Hurricane Z2893 and the loss of the pilot, F/Sgt H. J. Helbock, but not the site.

My next move was to contact the RAF Museum Hendon for the F1180 (Loss Card) for this aircraft. What I needed to know was, as near as possible, where the crash happened. This revealed that the aircraft had crashed at South Side Farm, Lucker.

I then contacted the Registrar Office at Morpeth to obtain the pilot's death certificate. This revealed that R67277, Henley Joseph Helbock RCAF, had been killed in a flying accident at South Side Farm, Lucker, Northumberland.

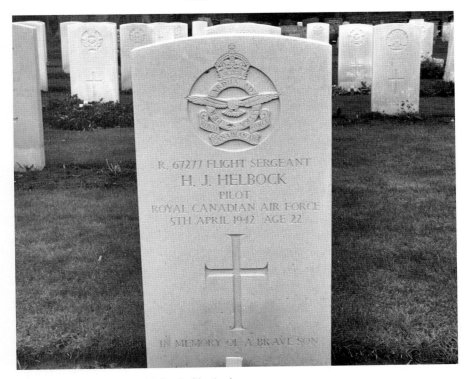

Gravestone of F/Sgt H. J. Helbock. (Author)

A Brief Account of the Crash

At this time, in 1942, 43 Squadron were undertaking the task of testing the newly developed Franks Anti-G Suit.

On 5 April, F/Sgt H. J. Helbock took off from RAF Acklington in Hurricane Z2893 while testing the Franks Suit. Over the Northumberland village of Lucker, F/Sgt Helbock was performing high speed manoeuvres. His aircraft stalled in a turn too near to the ground and the Hurricane crashed at South Side Farm, Belford. The subsequent enquiry found that F/Sgt Helbock had disobeyed orders, which were to avoid all violent manoeuvres below 10,000 feet. However, the ORB for the end of April noted that 43 Squadron's tests on the Franks Suit 'were still ongoing'.

The funeral of Sgt Harley Joseph Helbock took place on 8 April 1942, conducted by Leo Hart at Chevington Cemetery, Red Row, Northumberland.

F/Sgt H. J. Helbock: Section H, Grave 195, Chevington Cemetery
F/Sgt H. J. Helbock was from Mexico, New York (USA). He was 22 years of age when he was killed on 5 April 1942.

The Site of the Crash

Hawker Hurricane Mk IIc Z2893

Pilot:	R/67277 F/Sgt Harley (Hank) Joseph Helbock RCAF, age 22 +
Squadron:	43 Squadron RAF Acklington
Site:	Lower Cock Ridge, South Farm, Lucker
Grid:	NU15179 29435
Map:	OS Explorer 340
Note:	Fragments remain buried at the site

Bibliography

Chorlton, Martyn, *Airfields of North-East England in the Second World War*
Franks, Norman, *Fighter Command Losses Vol. 1*
Saunders, Andy, *No. 43 Squadron, 'The Fighting Cocks'*
Walton, Derek, *Aviation Diary of Northumberland 1790–1999*

Reference

3 Squadron Association
AIR 27/443 – 43 Sqn. ORB
AIR 28/17 – RAF Station Acklington ORB
Commonwealth War Graves Commission
Dave Pyle
Dennis Gray
Ed Brown
Form 1180 – Loss Card
George Thompson
Iain Arnold, Hawker Hurricane Society
Morpeth Register of Burials (War Graves) Chevington Cemetery
Mrs Joan Rose, Northumberland and Durham Family History Society
Ordnance Survey map, Explorer 34
Penny
RAF Commands website www.RAFcommands.com

METEOR WF842

Gloster Meteor T7 WF842
612 Squadron
RAF Acklington

Newham Buildings
Newham
Northumberland
17 September 1951

Account of Dave Pyle

Dave Pyle had guided me to the site of Hawker Hurricane Mk IIc Z2893 at South Farm, Lucker (Chapter 18), during our search for this site. Dave had informed me that he had been first on scene at the crash of a Gloster Meteor in the early 1950s at Newham Buildings, not far from Newham, where he had lived as a child (a distance of approximately 1 mile).

Dave had been de-mobbed from the army in January 1947; he had served in the 2nd Battalion, Duke of Wellington's Regiment.

When Dave arrived at Newham Buildings, he discovered the aircraft in the field to the west of the farmhouse, approximately 150 metres from the house. It was in the north corner of the field, facing a large hedge, lying with its nose pushed into the ground and virtually intact. He does not recall any fire but went

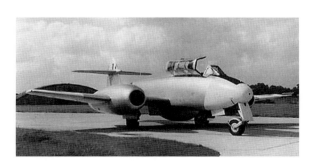

Gloster Meteor T7. (Daren Gallop)

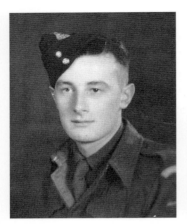

Above left: Pte Dave Pyle, 2nd Battalion, Duke of Wellington's Regiment. (Dave Pyle)

Above right: The crash site of WF842. (Author)

up close to the wreck, where he saw one of the crew still slumped in the cockpit. Walking around to the front of the aircraft, he discovered one of the crew's boots lying on top of the hedge; to his shock, the boot still had remains of the leg attached. Dave left the scene as this was too much for him.

29 January 2010

I was informed by Dave that he knew the exact location of this crash site while we were searching for Hawker Hurricane Z2983 at South Farm, Lucker, on the same day. The weather had brightened up a little, but it was still bitterly cold; this was to be a brief visit to the site just to establish the location. We arrived on site and asked the current occupant of the farm, Jane Hall, if we could search the site. Jane was very obliging and was aware of an aircraft crash on her farm, but was unsure where. Dave got his bearings, as there is now a small copse between the farm and the field. Dave recognised a small pond at the rear of the farm and headed towards the field. To our surprise, the large hedge that used to mark the northern boundary of the field had been stripped. Fortunately, signs of the hedge were still a feature in the new fence line.

Dave walked straight to the spot where the aircraft had been on the day he had attended the site, back in 1951. There was no visible trace of the aircraft, but the field was slightly marked by ridges and furrows, except in the area where we stood. Here, the earth had signs of having been disturbed – it was sunken and much smoother than the rest of the field; I have seen similar depressions at many crash sites.

30 March 2010

We returned to the site with my metal detector to see if any fragments remained. After two hours searching, nothing was found. I must admit it was a slim chance that there would be any fragmented remains, as the site is within 150 metres of the road, is a lowland flat field and had easy access for the RAF recovery crews to bring their equipment to the site.

Account from the *Journal* Newspaper, 18 September 1951

Two occupants of a twin-engine Meteor jet training plane from RAF Acklington aerodrome were killed after it crashed into a field at Newham Farm Buildings, near Ellingham last night.

Last night only one body had been recovered from the wreckage. The crash was seen by farm workers in a field 400 yards away. They saw the plane scream down and skim the top of the Steward's house before it dived into the ground and burst into flames.

Fright: Last night Mr Edward Storey the steward told the *Journal*. 'My wife got an awful fright; she was in the house when the plane crashed only 150 yards away'.

Mr Storey said the Meteor was at about 5,000 feet when he saw it first. 'It turned over like a falling leaf, fell to about 2,000 feet, tried to pull out again but did not manage it.' There was a terrific explosion when the plane hit the ground and wreckage was strewn up to 100 yards away. Alnwick and Seahouses Fire Brigades were called.

Official Documents

I firstly checked my reference books for any possibilities and came up with a 612 Squadron fatality, this being Gloster Meteor WF842; however, it recorded the station as RAF Dyce.

My next move was to contact the RAF Museum Hendon for the F1180 (Loss Card) for this aircraft, this was not available.

I contacted the Registrar Office at Morpeth, to obtain the pilots' death certificates; these revealed that P/O D. Robinson and P/O R. McKay had been killed in a flying accident at Newham Buildings.

I contacted W/O Steve Wrightson of 612 Squadron RAF. The squadron had been disbanded in 1951 and had reformed in 1987 as a medical unit. Steve had contacted the AHB (Air Historical Branch), RAF, who had advised him that I should contact them direct, and were expecting my e-mail.

Once contact had been made with the AHB, I received a reply from M. Hudson, providing a detailed account of the events of the crash – far more than I had expected.

A Brief Account of the Crash

612 Squadron were based at RAF Dyce in 1951, and moved to RAF Edzell for jet conversion; they attended their summer camp at RAF Acklington.

On 17 September 1951, Pilot Officer Robertson of 612 Squadron, Acklington, was authorised to fly Meteor T7 WF842; he was detailed to carry out general familiarisation flying with Pilot Officer McKay as passenger in the rear seat, for air experience. Both pilots were briefed and the following points were stressed:

a. The flight was for general experience for Pilot Officer Robertson and air experience for Pilot Officer McKay.
b. The flight was not to exceed 40 minutes' duration.
c. No aerobatics were to be carried out as the ventral tank was full.

The aircraft took off at 17.37. It was next seen travelling in a northerly direction in the vicinity of Chathill village at 17.40, at approximately 3,000 feet. The aircraft appeared to be flying very slowly with the port engine throttled back, turning very gently to the left, with the nose well up. Shortly after, the nose and left wing were seen to drop slightly. The aircraft continued to dive gently and recovered momentarily before the right wing dropped violently. The aircraft then went into a right-hand spin from which it did not recover before striking the ground, exploding on impact. The aircraft just missed the farm house at Newham Buildings, crashing in the field right next to the house, killing both of the crew.

The subsequent investigation revealed that all relevant Servicing Instructions, Servicing Technical Instructions and modifications to the aircraft had been incorporated. When the aircraft crashed, both engines were under low power and low and high pressure fuel controls were found in the fully open position. All flying control cables and rods were apparently working, although the dive brakes were open. It was impossible to tell whether these had been opened by the pilot or on impact. The aileron spools were found to be fractured but there was no indication as to whether this had occurred in the air or as a result of the impact. Neither pilot had attempted to abandon the aircraft.

The Court thought that the most likely cause was a failure to fly the correct asymmetric or stalling technique.

The funerals of both 268054 P/O Roderick Mckay and 2684061 P/O Douglas Robertson, took place on 21 September 1951.

Pilot Officer D. Robertson: B. G. No. 157, Dyce Old Churchyard, Aberdeenshire
Pilot Officer R. McKay: Kaimhill Crematorium, Aberdeen

The Site of the Crash

Gloster Meteor T7 WF842 612 Squadron RAF

Pilot:	2684061 P/O Douglas Robertson RAF, age 28 +
Second Pilot:	268054 P/O Roderick McKay RAF, age 29 +
Squadron:	612 Squadron, RAF Acklington
Site:	Newham Buildings, Newham, Northumberland
Grid:	NU16538 26855
Map:	O/S Explorer 340
Note:	No wreckage remains at site

Bibliography

Walton, Derek, *Northumberland Aviation Diary 1790–1999*

Reference

Commonwealth War Graves Commission
Dave Pyle
Ian Burnett, Cemeteries Inspector, Aberdeen Council
Jane Hall
M. Hudson, Air Historical Branch
Mrs Joan Rose, Northumberland and Durham Family History Society
Ordnance Survey Maps
RAF Commands web Site www.RAFcommands.com
Roots Chat forum - www.rootschat.com
The *Journal* Newspaper
W/O Steve Wrightson, 612 Squadron

BEAUFIGHTER R2473

Bristol Beaufighter Mk II R2473 HU-
406 Squadron RAF Acklington

Stallion Wood Field
Eshott Home Farm
14 September 1941

In late 2009, I was nearing completion of my research of aircraft which had crashed in the villages surrounding the former RAF Acklington. All aircraft had a direct association with the aerodrome, as each one was either based at Acklington or had been diverted there to land from operations due to poor weather conditions. Virtually all the accidents surrounding the village of Eshott were aircraft which were associated with RAF Eshott, 2 ½ miles to the south-south-west of RAF Acklington. I had found records and local stories of two Acklington aircraft which had crashed in the Eshott area; Bristol Beaufighter R2473 was one of them.

The records I had only gave brief details of the crash, providing only a distance of 3 miles south-west of the aerodrome; from this measurement, it would appear that the aircraft had crashed inside the perimeter of RAF Eshott, however this was not the case. Some RAF records only give an estimated location, which is not always accurate.

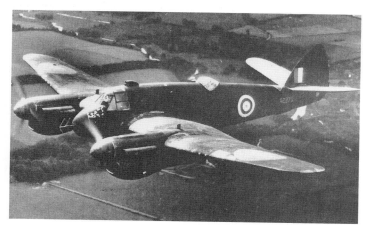

Bristol
Beaufighter
Mk II. (RAF
Museum
Hendon)

Account (Source Wishes to Remain Anonymous)

I was introduced to an Eshott man who has asked that his family name not be used but was more than willing to pass on any information he could regarding this crash.

In May 2010, he was awaiting a visit from his uncle who, in 1941, lived in Eshott. This man's uncle would prove to be an invaluable asset to the investigation of three sites in the Home Farm area. In 1941, he was eleven years old and had a good recollection of events. He remembered the crash of the Beaufighter on Eshott Home Farm. He recalled that the aircraft had spun into the ground behind the farm in a field known as Stallion Wood Field. The first on scene to the aircraft was the byre man, who lived in what is called the 'Herdsman's House', which is at the south end of the farm. Stallion Wood Field is approximately 300 metres directly south, behind the 'Herdsman's House'. He did not mention any signs of fire at the crash scene.

Fathers, Brothers and Sons by Larry Gray

On browsing the internet, I came across a book entitled *Fathers, Brothers and Sons* by Larry Gray, which had a detailed account of the crew of R2473, F/O H. J. Findlay and F/Sgt E. K. Vickers. The book mentions that a gunner manning a light machine gun at the end of the runway had identified a likely crash site as 'Crowther's Farm'.

Note: I can find no record of a 'Crowther's Farm' in the Eshott area, but that does not mean there was not a farm worker named Crowther!

Access

In 2010, the land surrounding Eshott Home Farm had been sold to various owners; fortunately, the new owner was the same man who had bought Suckler Riggs, the site of the crash of Supermarine Spitfire R7063 in October 1943. Access had been approved and the search for fragments to positively identify the site was to commence.

8 June 2010

I arrived on site at 9 a.m. with my air-crash-hunting poodle, Penny. As always, she was keen to get into the open fields. We only had a short distance to walk to the search area, but it was a damp misty morning. Penny was togged up in her flying jacket to keep the damp out; after all, she is fifteen (that's 105 in human years). Everything matched the description of the field that I had been given by my local source: a scrub field, which is cut in half by a track. The part of the field to the north of the track was the search area. With this being a lowland site and

within 100 metres of an easily accessible track, I did not build my hopes up too much; this site would have been easily cleared by the RAF Maintenance Unit sent to clear the wreckage at the time of the crash. As expected with lowland sites, after sixty-nine years of farming, I unearthed enough agricultural debris to build my own plough. I did, however, locate some alloy fragments, but I could not be certain that they were from R2473, as the deterioration of the alloy was not as advanced as the debris I have found at other sites.

Official Documents

I firstly checked my reference books for any possibilities and came up with a 406 Squadron crash, this being Bristol Beaufighter Mk II R2473.

I next contacted the National Archives for copies of the 406 Squadron Operational Records Book (ORB), which came under AIR 27/1791 for September 1941. This confirmed the crash of Bristol Beaufighter R2473 but not the site exact site.

My next move was to contact the RAF Museum Hendon for the F1180 (Loss Card) for this aircraft. What I needed to know was, as near as possible, where the crash had happened. This revealed that the aircraft had crashed 3 miles south-west of RAF Acklington. Towards the end of the crash report, the distance from RAF Acklington is recorded as '2 miles from drome'. This last statement places the site in the exact area of Stallion Wood Field on Eshott Home Farm.

Contacting the Registrar Office at Morpeth, to obtain the crew's death certificates revealed that C/1179 Flying Officer Hugh John Findlay and R63911 Flight Sergeant Edwin Karl Vickers had been killed in a flying accident at Eshott Home Farm.

A Brief Account of the Crash

Beaufighter R2473, crewed by F/O H. J. Findlay and F/Sgt E. K. Vickers, along with another 406 Squadron Beaufighter piloted by P/O J. R. B. Firth, took off from RAF Acklington at 21.35 hours on a night training exercise. They had been briefed by 'B' Flight commander S/L J. A. Leathart to carry out GCI (Ground Controlled Intercept) and AI (Airborne Intercept) flying. Cloud was at 2,800 feet and both aircraft climbed to clear skies at 5,000 feet. Various exercises were carried out over the next two and a half hours, with P/O Firth landing his aircraft first. At 23.55 hours, P/O Findlay requested to land and reported over the wireless that he 'may pancake'!

At the leeward end of the runway (south-west approach), construction work was marked with red Glim lamps to guide the aircraft. R2473 was seen to be approaching the aerodrome when the aircraft spun into the ground at an angle of 45 degrees, resulting in the crashed aircraft facing away from the aerodrome.

Right: Gravestone
F/O H. J. Findlay.
(Author)

Far right: The
gravestone of F/
Sgt E. K. Vickers.
(Author)

The official cause of the crash is recorded as: 'Normal circuit approach, loss of flying speed during approach, resulting in a stall which the pilot was unable to correct, the possibility of some mechanical trouble or failure cannot be excluded.'

The funerals of F/O Hugh John Findlay and F/Sgt Edwin Karl Vickers took place on Wednesday 17 September 1941, conducted by Revd J. Whinbread, RAF, at Chevington Cemetery, Red Row.

F/O H. J. Findlay: Section H, Grave 240, Chevington Cemetery
F/Sgt E. K. Vikcers: Section H, Grave 245, Chevington Cemetery

Note: Pilot Officer Findlay and Flight Sergeant Vickers are remembered on the memorial to twenty-nine aircrew and thirteen aircraft in the former RAF Acklington church, St John the Divine, Red Row, unveiled on 7 May 2011

The Site of the Crash

Bristol Beaufighter Mk II R2473 HU- 406 Sqn RCAF

Pilot:	C/1179 F/O Hugh John Findlay RCAF, age 28 +
Obs:	R/63911 F/Sgt Edwin Karl Vickers, age 28 +
Squadron:	406 Squadron RCAF
Site:	Stallion Wood Field, Eshott Hall Farm
Grid:	NZ20254 97074
Map:	OS Explorer 325
Note:	No wreckage remains at the site

Penny at R2473 site. Note Herdsman's Cottage behind her. (Author)

Bibliography

Chorlton, Martyn, *Airfields of North-East England in the Second World War*
Gray, Larry, *Fathers, Brothers and Sons*
McMillan, William, *An Anecdotal and Statistical History of RAF Acklington*
Walton, Derek, *Northumberland Aviation Diary 1790–1999*

Reference

AIR 27/1791– 406 Sqn ORB
AIR 27/1792 – 406 Sqn ORB appendices
AIR 28/17 – RAF Acklington ORB
A local eyewitness
Broomhill Station Police Occurrence Book
Commonwealth War Graves Commission
Dennis Gray
Duncan Clark, for land access
F1180 – Loss Card
Falon Nameplates www.falonnameplates.com
Mark Sanderson, for first visit to Eshott Home farm
Mrs Joan Rose, Northumberland and Durham Family History Society
Ordnance Survey Maps
Penny
RAF Commands website www.RAFcommands.com
Register of Burials (War Graves), Chevington Cemetery

SPITFIRES P8360 & P8362

Supermarine Spitfires Mk IIa P8360 & P8362
57 Operational Training Unit
RAF Eshott

Eshott Hall Farm, Eshott
27 February 1943

During my research and planning for a memorial for twenty-nine aircrew, regarding thirteen crash sites surrounding RAF Acklington, I was finalising the details of a 406 Squadron Bristol Beaufighter R2473 and a 43 Squadron Hawker Hurricane B954. Over the years, the land around the village of Eshott has been passed down through families, with some farms and land having been sold to new owners. I was in the process of contacting local landowners for access to fields which I had chosen for a search area. Once access was agreed, the landowners whose fields bordered my search area had to be informed of my presence, just in case I drifted into the wrong field; I knew I wouldn't but it is best to be safe.

Local Advisor (Source Wishes to Remain Anonymous)

I had been advised to contact a local man from Eshott who was part of the Acklington Parish Council and had an active interest in the local history. He was helpful in identifying sites but was unsure of the exact aircraft, although he had possibilities of the type of aircraft which had crashed. These were from stories from his father and uncle, who had lived and worked in Eshott throughout the war years. This pointed to three possible sites; one site he had mentioned was that of a Spitfire crash in a field known as 'Cottage Field' very close to the village.

Account of Glen Sanderson

I first met Glen on 12 December 2009, while applying for funding from Maidens Hall Community Benefits Fund, which approves funding from UK Coal. Glen

had informed me that he was aware of several crash sites in the Eshott area, as his father had farmed the area throughout the Second World War, as with the local advisor; Glen had pointed out three possible sites, one of which was a Spitfire in Cottage Field, Eshott.

Rough Jottings

While trying to identify the exact site, I came across some rough jottings I had made from the draft notes of *An Anecdotal and Statistical History of RAF Acklington*, of which only five copies were ever printed. The notes mentioned two Spitfires which had collided above Eshott Hall Farm in 1943. The brief notes were of two Mk IIa Spitfires; one had fallen into Cottage Field in flames (pilot killed) and the other in Stallion Wood Field (the pilot bailed out, but was too low for the parachute to open and was killed).

Not a lot to go on, but this brief note had the same location as that mentioned by Glen Sanderson and my local advisor, Cottage Field; they matched with the possible type of aircraft: a Spitfire! Matching these similarities with official records would lead to the positive identification for both crash sites.

Official Documents

I firstly checked my reference books for any possibilities and found a 57 OTU collision over Eshott, this being Supermarine Spitfires Mk IIas P8360 and P8362. It also provided a valuable link, as one of the pilots mentioned was Australian.

Supermarine Spitfire Mk IIa. (RAF Museun Hendon)

I next contacted the National Archives for copies of the 57 OTU Operational Records Book (ORB), which came under AIR 29/683 for February 1943. This confirmed the collision and subsequent crashes of Supermarine Spitfires P8360 and P8362, but not the exact site.

My next move was to contact the National Archives of Australia for the F1180 (Loss Card) for this aircraft. What I needed to know was, as near as possible, where the crash had happened. I was expecting a basic report, similar to the British archives, but to my surprise, there was a full account of the collision, including eyewitness statements from the 'Proceedings of Court of Inquiry of Investigation: Flying Accidents'. The investigation reports confirmed the names of the two pilots and the aircraft involved and the crash sites as being on Eshott Home Farm.

Spitfire IIa P8362, 1668 Sergeant Håkon Langseth Myhre (Norwegian).
Spitfire IIa P8360, 412884 Flying Officer Ronald Charles Bell (Australian).

These documents also provided a map grid reference, 693177 (British Cassini Grid). This is the site of Eshott Home Farm.

Note: Form 765 of this report has F/O Bell in P8362, although the rest of the report places him in P8360.

From here, I contacted the National Archives of Norway and was assisted by Jørgen Engestøl. He confirmed my research that Håkon Langseth Myhre had escaped from Nazi-occupied Norway on what was known as the 'Shetland Bus', a fleet of small fishing vessels operating from Norway to Great Britain. Along with fifteen others (including two of his cousins), Håkon Myhre boarded the M/B *Glimt* (M303 HO) on 25 May 1941 from Volda; after a stormy voyage, they landed at Sumburgh Head, Shetland, on the 29th, and then carried on to Lerwick, arriving on 1 June.

Using Google Translate, I contacted the Norwegian Air Force Museum; their records still had Sergeant Håkon Langseth Myhre as being buried in Chevington Cemetery, this I have rectified with their records.

I then contacted the Registrar Office at Morpeth to obtain the death certificates of both pilots; this revealed that Sgt H. L. Myhre and P/O R. C. Bell had been killed in a flying accident at Eshott Home Farm.

Cross-Referencing

All the official documents located the collision of P8360 and P8362 over the village of Eshott, and stated that they crashed on Eshott Home Farm's land. My initial rough jottings identified two possible sites for Spitfire crashes involved in a collision; I also had two other accounts naming a field where it was believed that a Spitfire had crashed

in flames, 'Cottage Field'; this also matched with my 'ruff jottings'. The final piece of the jigsaw is matching what happened seconds after the collision took place; my jottings mentioned that after the collision, one of the aircraft had 'fell into Cottage Field and burst into flames', and that the pilot had bailed out of the second aircraft, but was too low for his parachute to open. In the official report, it records that the pilot of P8360, at a height of 750 feet, had bailed out but his parachute had been unable to open. It also records that the crash site of P8360 is 500 yards south of P8362.

Note: Stallion Wood Middle Field is 500 yards south of Cottage Field.

25 May 2010

Having gained access to Cottage and Stallion Wood Fields, I arrived on site straight from work at 5.15 p.m. With these two sites being in close proximity of the buildings of Eshott Home Farm, and within easy access for the recovery crews back in 1943, my expectations of locating any fragments were low. Both fields have been ploughed and farmed annually for the past sixty-seven years.

On entering Cottage Field, I realised my search would be difficult and painful; the field from hedgerow to hedgerow was shoulder depth in one of the worst

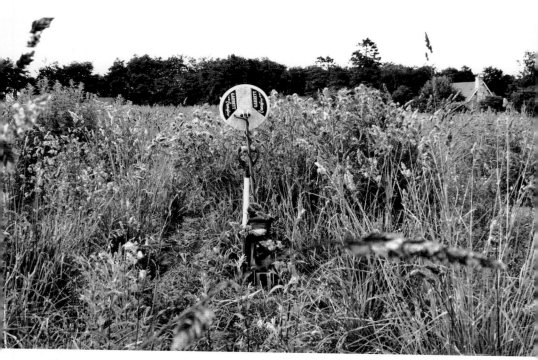

Cottage Field, complete with thistles. (Author)

things ever imported from north of the border, very large Scottish thistles! This was going to hurt!

Although I had plenty of evidence that this was the site, no one could actually point to an area in the field to search. Three gruelling and very stingy hours later, I had covered the whole field, with some tiny fragments to show for my efforts. I left the site for a hot bath and a coating of Sudocrem.

26 May 2010

My shifts were favourable for two consecutive days and the weather was holding up. Not only was I red from the stinging thistles, I was going to get a tan to cover my pain. As with Cottage Field, my expectations for Stallion Wood Field were low.

This time I was not disappointed. After two and a half hours, I had covered the small field with no fragments found, although I must admit I unearthed enough rusty parts to build a small plough! This is quite common with low ground sites that are within easy access to roads.

3–5 October 2010

I had been trying for some months to locate a contact address for the Leirshaugen Kirche and Gravlund in Volda, Oslo. I must admit I had no success; I did find, however, a 'Parish Council Newsletter' for Volda, but no contact address. The document was officially signed by the President of the committee. I added the word 'president' to my search engine title. It brought up the website of the Rotary Klubb, Volda. My thoughts were that the Rotary Club in the UK are a very charitable organisation, and I presumed the Volda branch would be similar. Cheeky, I know, but a contact might be found with their help, and to be fair I had run out of ideas. I e-mailed Harald Indresøvde, president of the Volda Rotary Cub; a random shot, but I had to try. To my surprise, Harald replied within ten minutes; this one line answer knocked me for six!

> Chris Davies
> I think I can help you. I know some family members and will contact them tomorrow.
> Harald Indresøvde, President, Volda Rotary Club.

My random choice had struck gold. I was contacted by Peter Warren, the nephew of Sgt Håkon Myhre on 4 October 2010.

5 October 2010

I had planned to return to this site for a final sweep of the area. As before, I was not expecting to locate any fragments as Stallion Wood Field has been cultivated for the past sixty-seven years. Clearing access with the landowner, I had finished work at 12.30 and was on site for 12.45. The field had been cropped and re-planted and looked a far larger expanse than my last visit. I trawled up and down the field, unearthing plenty of broken farm debris but nothing from an aircraft. I had an area in my mind where I thought the aircraft of Sgt Myhre had crashed. I did not go straight to my chosen area; instead, I broke the field into sections, making my way eventually towards where I thought the site was located. There was no visible depression in the field and no obvious signs, so I had to cover the whole field just in case.

At 3.07 p.m., I picked up a positive reading familiar to readings at other sites; I uncovered a section of alloy hydraulic pipe, typical of piping I have found at other sites on high and low ground. A concentrated sweep of the surrounding area produced no other finds. I was surprised to find this one piece, and I do consider this to be the exact location.

A Brief Account of the Crash

On 27 February 1943, F/O R. C. Bell and Sgt H. L. Myhre were to undertake formation flying practice, along with three instructors and nine pupils of 'A' flight, No. 44 course, Advanced Training Squadron (ATS) 57 OTU, RAF Eshott. The flight had been authorised by Chief Flying Instructor Squadron Leader D. S. Yapp. Both pilots would be part of 'Yellow Section', led by F/O Baily, and had been fully briefed on the manoeuvres expected during the flight.

Crash site of P8360, 20 m in front of the centre of the wood. (Author)

The flight took off from RAF Eshott at 15.30 hours; Yellow Section consisted of four aircraft, numbered 1–4 so as to ascertain their positions. 'Yellow 1' was Instructor F/O Baily, 'Yellow 2' was F/O Bell, 'Yellow 3' was Sgt Myhre and 'Yellow 4' was P/O K. W. Chivers. The section had been in the air for approximately 1 ¼ hours and were heading in a north-easterly direction over RAF Eshott at a height of 1500 feet. They were instructed to get into position from 'line abreast' to 'line astern'. At this point, Yellows 2, 3 and 4 were forming up on Yellow 1. It seems that Yellow 2 had slowed down too early, causing Yellow 3 to overshoot Yellow 2 and pass underneath. At the same time, Yellow 2 received a downward bump, causing it to cut the tail off Yellow 3. At approximately 750 feet, Yellow 3 was seen to leave his aircraft, but his parachute did not open until 150 feet; Yellow 2 spun into the ground moments later, bursting into flames.

Note: Strangely, throughout the 'Proceedings of Court of Inquiry of Investigation. Flying Accidents', Flying Officer R. C. Bell is referred to as 'Pilot Officer'. Pilot Officer R. C. Bell was promoted to Flying Officer on 24 December 1942.

F/O Ronald Charles Bell and Sgt Håkon Langseth Myhre were buried at 14.00 on 3 March 1943, in a joint ceremony conducted by R. J. Richards, Chaplain, RAVFR, at Chevington Cemetery, Red Row. The cortège was composed of their brother officers.

F/O R. C. Bell: Section H, Grave 247, Chevington Cemetery
Sgt H. L. Myhre: Square D, Section 7, Grave 1, Leirshaugen Cemetery, Volda

Note: Sergeant Håkon Langseth Myhre, RNAF, was originally buried at Chevington Cemetery, Red Row, alongside Flying Officer Ronald Charles Bell. There is a vacant plot in the Commonwealth War Graves site next to F/O Bell.

Sgt H. L. Myhre's remains were repatriated back to his homeland of Norway and interned at Leirshaugen Gravlund, Volda, on 19 April 1947.

The Site of the Crash

Supermarine Spitfire Mk IIa P8360

Pilot:	Aus/412884 Flying Officer Ronald Charles Bell RAAF, age 21 +
Squadron:	57 OTU RAF Eshott
Site:	Cottage Field, Eshott Home Farm, Eshott
Grid:	NZ20500 97500
Map:	OS Explorer 325
Note:	No wreckage remains at site

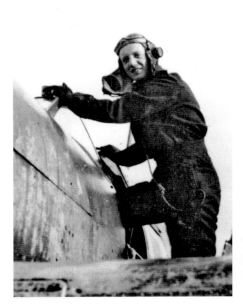

Above left: Sergeant Håkon Langseth Myhre. (Peter Warren)

Above right: Gravestone of F/O R. C. Bell. (Author)

Below: Grave of Sgt Håkon Langseth Myhre, Leirshaugen, Volda, 2010. (Peter Warren)

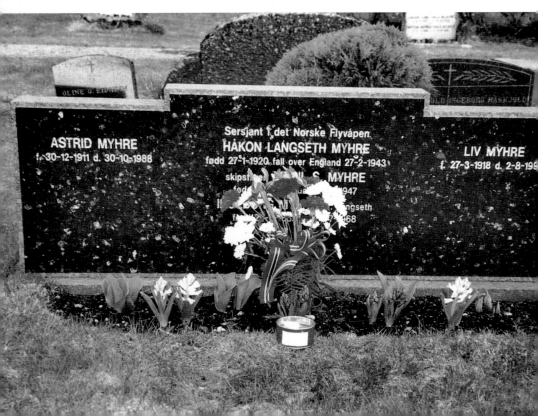

Supermarine Spitfire Mk IIa P8362

Pilot:	1668 Sergeant Håkon Langseth Myhre RNAF, age 23 +
Squadron:	57 OTU RAF Eshott
Site:	Stallion Wood Field, Eshott Home Farm, Eshott
Grid:	NZ20505 96971
Map:	OS Explorer 325
Note:	Fragments remain buried at site

Bibliography

Chorlton, Martyn, *Airfields of North-East England in the Second World War*
McMillan, William, *An Anecdotal and Statistical History of RAF Acklington*
Morgan, E. B., and Shacklady, E., *Spitfire: the History*
Walton, Derek, *Northumberland Aviation Diary 1790–1999*

Reference

AIR 29/683 – 57 OTU ORB
A Local advisor
Broomhill Station Police Occurrence Book
Commonwealth War Graves Commission
Dennis Gray
F1180 – Loss Card
Glen Sanderson
Harald Indresøvde, President, Volda Rotary Club
Jeff and Duncan Clark, for Stallion Wood Field
Joe Mclean, Grant Thornton Recovery and Reorganisation, for first visit to
 Eshott Home Farm Cottage Field
Jørgen Engestøl, Riksarkivet (the National Archives of Norway)
Major Anders Utgård, Norwegian Air Force Museum
Mark Sanderson, for first visit to Eshott Home Farm
Mrs Joan Rose, Northumberland and Durham Family History Society
National Archives of Australia
Ordnance Survey Maps
Peter Warren, nephew of Sgt Mhyre
RAF Commands website www.RAFcommands.com
RAF Museum Hendon
Register of Burials (War Graves) Chevington Cemetery

WELLINGTON R1707-U

Armstrong Vickers Wellington Mk Ic R1707-U
20 Operational Training Unit
RAF Lossiemouth

Barley Riggs Field
Benridge Moor Farm
Morpeth
2 June 1943

In early May 2010, I was beginning to prepare the contents of this book. I had decided on a format and layout of the stories and writing had begun. During this time, I was re-checking my eyewitness accounts with copies of the official records I had. While sifting through a collection of police accounts, my attention was drawn to an account from 2 June 1943. The location of the crash was in the Morpeth area, near Pigdon. I had a vague contact in the area, John Creighton of Maiden Hall Farm (a little way along the road from Pigdon); John had, in 1992, dressed two walking sticks with deer horns for me – a distant contact but a good place to start.

Extract from Police Record

A Wellington bomber, aeroplane no. R1707, on an operational flight from RAF Lossiemouth crashed in a field at Pigdon Farm and continued into a field at Benridge Moor Farm. The plane was seen to be travelling at a low altitude from west to east. The plane appeared to be on fire before crashing and exploding, the wreckage was strewn over 500 yards. Map ref: 694093, (British Cassini Grid).

I had also received a report from the RAF Commands Forum, mentioning that the aircraft had smashed through a hedgerow, a feature I would have to look for once on site.

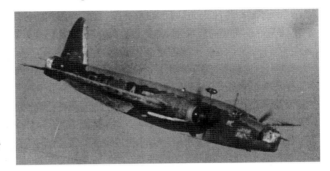

Armstrong Vickers
Wellington Mk Ic. (RAF
Museum Hendon)

Contacts

I spoke to John Creighton at Maidens Hall Farm; John was able to provide me with the name of the owner of Pigdon Farm in the 1940s, Richard Elliot. He was also able to provide the name of the Benridge Moor Farm owner, Thomas Potts. John mentioned that both farms had been sold a few times over the past sixty years. The present owner of Benridge Moor Farm is Richard Addison. Richard's father, Peter, had bought the farm in 1972. John believed that Thomas Potts had no living relatives. John and his family had lived in the area all of his life, and he was unaware of an aircraft crashing within a mile of his farm.

When I spoke to Richard Addison at Benridge Moor Farm, he was totally unaware that a crash had happened on his land. On checking with his father, Peter, who had sold the farm as an auctioneer before he himself bought the farm, had no knowledge of a crash on their land.

20 May 2010

My air-crash-hunting poodle, Penny, watched me put my detector and spade in the car, fully prepared for our next search. With this being a 'low land' site, Penny would be fine as she now is fifteen years old, selectively deaf and her eyesight is beginning to fail, but an opportunity to be out in the open fields would never deter her.

I had arranged to meet with Peter Addison, to explain that my objective was to locate the actual crash site of R1707. On my way to Benridge Moor Farm, I decided that before I arrived, it would be best if I checked the grid reference given in the police report. Fortunately, I had been given a 1940s Home Guard map by Dave Dunn. I was lucky; the map just covered the area west of Morpeth and all three farms I have mentioned were identifiable.

The old grid reference was basically the location of Benridge Moor Farm, which gave me an area to start. Richard was very informative in explaining the boundaries of his farm, and where his land met with that of Pigdon. We both agreed that the

Penny in front of the gap which was left in the hedgerow by R1707. (Author)

grid reference was that of the farm; Pigdon Farm was visible, but the boundary between the two farms was half a mile long in a northerly direction.

Clearly visible on the old and new maps was a raised mound on the land, a spot height marked at 424 feet or 127 metres; this partially blocked the visibility of the two farms. This would be my search area to start with. I had a time scale of three hours on site. Taking into account that I had two separate pieces of information that had suggested that the aircraft had gone from one field and into another, I moved into a position 20 metres from the hedgerow of the first two fields I had chosen to start my preliminary search. My theory was that between the boundaries of the two farms, there was evidence of a 'raised hedgerow', with what were now evenly spaced trees at a height of around nine metres. As with all low land sites, I was not expecting to find large remains of the aircraft, only fragments of oxidised alloy. I also expect to find a high degree of agricultural debris; I was not to be disappointed. I found all sorts of plough points, cultivator spikes and farm machinery cotter pins, but no sign of oxidised alloy. Penny was by my side all the way, checking every patch that I dug, then snorting in disgust when all that came up were old bits of plough. We decided to leave and come back another day.

As I left Benridge Moor, I called into Pigdon Farm. I met with Michael Clippendale, who had recently acquired the farm. Explaining what I was looking for, Michael was helpful in allowing me access to his land. I pointed out the boundaries from 1943 and my theories of where the crash site was. Michael reiterated the land boundaries now. The two fields on his land had crops in them; I asked that if I had no luck on the Benridge fields, could I return in September to his fields? This would be when the crops would have been cleared, preventing any damage to the crops. This was agreed on the promise that if I found any treasure and not aircraft fragments, half was his, a fair deal I believe.

25 May 2010

My wife Sue was on an evening shift at work, and I was at a loss at what to do. I logged onto Google Earth, focusing on the boundary of Pigdon and Benridge Moor farms. Following on from where I broke off my search on the 20th, I followed the hedgerow to the north. It became apparent that there were evenly spaced trees on this hedgerow, with one prominent gap and one gap slightly wider than the rest between the spaced trees. The prominent gap was where the line of a telegraph wire crossed from Benridge Moor to Pigdon. The lesser gap brought on a 'sixth sense'. I was drawn to this gap – I now had a plan.

Penny was at my heel; as I put my kit in the car, I grabbed her flying jacket and neck tie. I was positive we would locate the site at or near this gap.

We arrived at Benridge Moor Farm at 6 p.m., first clearing access from Richard and Peter. I explained to Richard that I had identified a gap in the hedgerow, but on the ground it was not as clear as the aerial view I had from Google Earth. To me, there was a distinctive gap, as this was a raised hedgerow. My approach would be the same as that on the 20th: start at approximately 15–20 metres from the hedge. I was approaching the site and started my started my search at 6 p.m. I had only covered a few metres when, at 6.08 p.m., I picked up a positive reading on my metal detector. I dug a small patch of turf and found a fragment of oxidised alloy, typical of the fragments I have found at most sites. The area was alive with readings, all of the same magnitude; I had located the final resting place of R1707.

The distance from the site to the farm of Benridge Moor was 403 metres. The crash would have been clearly visible from the farm house in 1943: the field boundaries at this point have remained the same for the past seventy years.

I reported my findings to Peter and Richard Addison; both were intrigued to find that six airmen had died in full view of their home. Richard asked if he could have a copy of my finished chapter to add to the farm history, an event that was 'almost forgotten' but should never be forgotten.

Penny guarding fragments from the wreckage of R1707. (Author)

Official Documents

Morpeth Police records held at Northumberland County Archives, Woodhorn Museum, Ashington, listed the crash of Wellington R1707-U, 2 June 1943, as crashing onto Pigdon land then passing onto Benridge Moor Farm, locating the site as 'Benridge Moor Farm'.

The F1180 (Loss Card) or Bomber Command loss card for this aircraft gave an approximate time of the crash as 11.30 p.m. and records the site as Pigdon Farm. I can only surmise the difference between the police and RAF reports is the police record states the final resting place of the aircraft and the RAF record states the initial impact of the aircraft.

My reference books also matched the same aircraft and date, listing the names of the crew who lost their lives.

I next contacted the National Archives for copies of the 20 OTU ORB (Operational Records Book), which came under AIR 29/664 for June 1943. This confirmed the crash of Armstrong Vickers Wellington R1707-U.

Morpeth Registrar's Office confirmed the crew's names; this I cross-referenced with the Commonwealth War Graves Commission. The Registrar has the deaths of the crew recorded as Pigdon Farm and not Benridge Moor Farm.

A Brief Account of the Crash

Wellington R1707-U, of 'A' Flight 20 OTU, crewed by F/O A. T. L. Rossignol (pilot), F/O E. E. Adlard (navigator), Sgt E. Morgan (navigator), Sgt D. E. Faulkner (wireless operator), P/O J. Fallon (air bomber), and Sgt J. R. J. Clarke (rear gunner), took off from RAF Lossiemouth on a night cross-country exercise. At approximately 11.30 p.m. the aircraft was seen to be flying at a low altitude, from west to east, by Joseph Wilkinson of Pigdon Farm. The aircraft appeared to be on fire before crashing into a field at Pigdon Farm, then travelling through a raised hedgerow and exploding at Barley Riggs field, Benridge Moor Farm. Eyewitnesses tell of the bomber exploding in the air prior to impacting into the fields. All six crew members were killed and their dismembered bodies were found intermingled with the wreckage. The cause of the crash is not known.

Some believe the aircraft was struck by lightning; it is noted on the F1180 that the aircraft 'may have been struck by lightning'. However, I can find no official evidence of this happening.

F/O A. T. L. Rossignol: Row A.E., Grave 34, Morpeth (SS Mary and James) Churchyard

F/O E. E. Adlard: Section 22 C, Grave 168, Wallasey (Rake Lane) Cemetery

Sgt E. Morgan: Section N.N. C of E, Grave 737, Preston (New Hall Lane) Cemetery

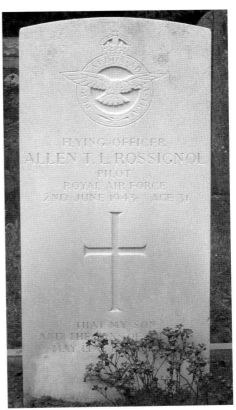

Grave stone of P/O A. T. L. Rossignol.
(Author)

Sgt D. E. Faulkner: Section Z.G.L., Grave 6, Brighton City Cemetery (Bear Road)

P/O J. Fallon: Section N, Grave 1235, Salford (Weaste) Cemetery

Sgt J. R. J. Clarke: Section 14, Grave 340, St Helens Cemetery

F/O Allen Theodore Lewis Rossignal was an American from Washington DC, serving with the Royal Air Force Volunteer reserve.

The Site of the Crash

Vickers Wellington R1707-U 20 Operational Training Unit RAF

Pilot:	130612 F/O Allen Theodore Lewis Rossignol RAFVR, age 31 +
Navigator:	134701 F/O Ernest Edward Adlard RAFVR, age unknown +
Navigator:	1434778 Sgt Eric Morgan RAFVR, age 20 +
W/Op - A/G:	1336161 Sgt Dennis Edwin Faulkner RAFVR, age 20 +
Air bomber:	139843 P/O Joseph Fallon RAFVR, age 29 +

R/G:	1483604 Sgt John Raymond Joseph Clarke RAFVR, age 21 +
Site:	Barley Riggs Field, Benridge Moor Farm, Morpeth
Grid:	NZ15895 88709
Map:	O/S Explorer 325
Note:	Small fragments remain at the site

Bibliography

Chorley, W. R., *Bomber Command Losses Vol. 7*
Chorlton, Martyn, *Airfields of North-East England in the Second World War*
Walton, Derek, *Northumberland Aviation Diary 1790–1999*

Reference

AIR 29/664 - 20 OTU ORB
Commonwealth War Graves Commission
Dave Dunn
Dennis Gray
F1180 - Loss Card
John Creighton
Members of the RAF Commands website www.RAFcommands.com
Michael Clippendale
Morpeth Station Police Occurrence Book
Mrs Joan Rose, Northumberland and Durham Family History Society
Ordnance Survey Maps
Peter and Richard Addison
Penny

HURRICANE Z2807

Hawker Hurricane Mk IIa Z2807 FT-D
43 Squadron
RAF Acklington

Pylon Field
Quarry House Farm
Denwick
Alnwick
12 October 1941

During a conversation with Alan Shotton, a work colleague, Alan had asked if I had had any more luck in locating crash sites. I assured him that my progress was good, having, on 21 October 2010, located the site of Boulton Paul Defiant N3364 at Beacon Hill, Morpeth.

Knowing Alan had originated from Alnwick and still had tribal connections in the area, I mentioned that a few years back, when researching the collision of Hawker Hurricanes L2066 and L1734 over Red Row, I had come across a record of a collision over the Denwick area of Alnwick. However, I had no connections or contacts in the Denwick area and at first glance, my reference book recorded that one of the aircraft had crashed on landing at base. Alan's late father, Bob Shotton, was a Lancaster rear air gunner during the Second World War, and was

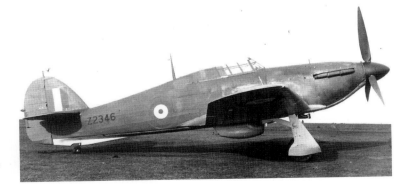

Hawker Hurricane Mk IIa. (Iain Arnold, Hawker Hurricane Society)

an active member of the Alnwick branch of the Royal Air Force Association. Alan was aware of his dad's pals and former contacts.

25 October 2010

Firstly, Alan gave me the details of Silvermoore Farm, one of the farms at Denwick, owned by his acquaintance, Ralph Thompson. Ralph could vaguely remember some distant tale, but he would have to speak to his grandmother, and he would get back to me.

In the meantime, Alan suggested I contacted Northumbrian photographer George Skipper; George was well versed in local historical events, and if he didn't know, he would know a man who would. George welcomed my questions; unfortunately, he was unaware of the crash, but he knew a man that might: Jack Knox.

I rang Jack Knox, and as you have to do, verified my identity by name dropping Alan, Ralph and George. Jack, I discovered, was eighty-seven years old, and a former RAF armourer who had served at both RAF Eshott and RAF Milfield. He had witnessed the collision of a Spitfire and and a USAAF Havard at Eshott in 1943. Jack had not known of a crash at Denwick, but he knew someone who would: his cousin Anne Woodcock, who had lived at Denwick all her life. If anyone knew, Anne would. I left my details for Jack as the evening was getting late. Ten minutes later, Jack called me back with the contact details of his cousin Anne; she could remember a crash in the Denwick area.

Account of Anne Woodcock, *née* Forster, 26 October 2010

Anne Lived at Denwick; at the time of the crash, she was four years old. Anne could remember being carried to the site on her father's shoulders. Anne explained that her memory of the day was very faded, but her father had returned to the site, recovered some Perspex and made a ring for her; years later, she passed this ring onto her daughter. Anne described the site to me as being in the first field on the right, after the old quarry, on the Denwick to Longhoughton road. The aircraft had crashed in the far left-hand corner of the field. Anne told me she had spoken to her friend (who was a little older) before I had called her, and passed on the contact details of Alison Thompson.

Account of Alison Thompson, 26 October 2010

Alison lived at Quarry House Farm, Denwick, and was seventeen years old at the time of the crash. Alison told me she saw two aeroplanes flying in the Denwick area, over Quarry House Farm. It was late afternoon, and the two aircraft seemed

The author's metal
detector on site.
(Author)

to be doing aerobatics. Alison saw one of the aeroplanes go into a steep dive and closed her eyes, as she knew it was going to crash. When she opened them, she saw a plume of smoke. Her father had run from the farm to Denwick to raise the alarm, as that was where the nearest telephone was situated. Alison was aware that the pilot had been thrown some distance from the aircraft and knew that the he was Canadian. The severed tail fell to the ground near the Denwick Burn.

I asked Alison to direct me to where she remembered the wreck of the aircraft had lain. Alison described the site as being in the first field on the right, after the old quarry, on the Denwick to Longhoughton road. I asked, 'If I was standing on the edge of the road, facing the field, could you recall where the site was?' Alison explained the crash site was in the far top left corner, near a raised hedge. During our conversation, it became apparent that Alison was Ralph Thompson's grandmother.

Alison believed the land now belonged to Jimmy Robson, Goldenmoore Farm, Denwick; Jimmy in turn advised that the land now belonged to the Duke of Northumberland's estate. Jimmy passed on the contact details of the estate manager, Richard McAllister. I requested permission from Richard for access to the field, explaining my purpose and that I intended to dig small holes only to a depth of 18 inches (45cm) and not a great 'excavation pit'; access having been approved, I set a date for 28 October. I asked Richard, 'What was the name of the field?' Richard said, 'Pylon Field, as there is a pylon located in the north-west corner of the field.'

28 October 2010

Having an early finish from work at 12.30 p.m., my plan was to visit Chevington Cemetery and take a few photographs of the reminders from the aviation accidents I have researched. This completed, I moved onto Pylon Field at Denwick. This being a lowland site, I expected the usual amount of agricultural debris; after all, this was another field which had been ploughed regularly for nearly seventy years.

Arriving at 1.30 p.m., car locked and metal detector switched on, I moved down the eastern side of the field, away from the road; this would give me an idea of the amount of debris to expect. Surprisingly, the readings were low. I had chosen to walk approximately two thirds of the way down, to where a single oak tree stood approximately 200 metres from the bottom of the field; here was where I would start my search. I had planned to cover an area of 200 square metres; marking where I had started, I was to sweep 200 metres in a straight line and place another marker, and this would create a boxed-off area.

I moved onto the field; within 100 metres I noticed a positive reading on the detector – it was a reading for brass. I decided to dig this first, and place my marker in a few minutes. At 1.45 p.m., fifteen minutes after arriving on site, I discovered fragments of a broken round of .303 ammunition – it still had the cordite inside its casing. A sweep around the immediate area produced a further two broken rounds and a complete round which still had the machine gun belt link attached. Several fragments of alloy were unearthed, providing positive evidence of crash site of Z2807.

5 November 2010

Along with my air-crash-hunting poodle Penny and her 'poodle under training' Daisy, we arrived on site for 9 a.m. This would be my last visit to this site to conduct a search as only fragments remain. Now knowing exactly where the site was, we walked straight to it. The hunters were eager to help. I unearthed a few more fragments, confirming my beliefs that the site had been cleared of all large debris by the maintenance unit which recovered the wreck back in 1941. I placed

Fragments from the wreckage of Z2807 unearthed on 28 October 2010. (Author)

the few fragments alongside the others that I had found on 28 October. Before leaving the site, I said the Lord's Prayer for Sgt J. A. R. Turner RCAF.

I did not realise at the time that this would be Penny's last search; sadly, my most trusted and faithful companion and friend passed away on 28 December 2010.

Official Documents

My reference book records a collision of Hurricanes Z2807 and Z3270 that occurred over Alnwick, and that Z2807 crashed on landing at base (RAF Acklington) while the other aircraft involved, Z3270, force-landed at Embleton.

Morpeth Registrar Office provided a copy of the death certificate entry of R/74223 Sgt John Allen Ryerson Turner, having been killed in a flying accident at Denwick Rural District.

The National Archives held the 43 Squadron Operational Record Book (ORB) under AIR 27/442 for January to December 1941, with appendices. This confirmed the death of Sgt Turner in a collision near Alnwick.

The RAF Museum Hendon provided the F1180 (Loss Card), confirming the site as Denwick.

A Brief Account of the Crash

On 12 October 1941, F/Lt Hutchinson (Z3270) and Sgt J. A. R. Turner (Z2807) were conducting a 'non-operational' flight, carrying out practice beam and quarter attacks near Alnwick; Z3270 was the target. At approximately 4.50 p.m., Sgt Turner made a planned dummy attack on Z3270, attacking from beneath. During this attack, the propeller of Z3270 sliced off the tail of Z2807, sending Z2807 diving towards the ground out of control. Sgt Turner was thrown from his aircraft when it impacted with the ground at Denwick, near Alnwick.

F/Lt Hutchinson lost consciousness but regained control and carried out a forced landing near Embleton, with cuts and bruises on his face. He was congratulated by the squadron commander because of the presence of mind he showed, and by the way he handled his badly damaged aircraft; the blades of the propeller had been broken off and as a result of the collision, the instruments had been made unserviceable.

This was Sgt Turner's third practice flight of the day; the first was at 9.25 a.m. for 30 minutes practicing aerobatics (Z2577), the second at 11.30 a.m. for 30 minutes, practicing beam quarter attacks (Z3316). Sgt Turner had recently joined 43 Squadron on 7 October from 55 OTU.

The funeral of Sgt John Allan Ryerson Turner took place on 15 October 1942, conducted by J. Wright, Chaplain, RAF, at Chevington Cemetery, Red Row, Northumberland.

Above: Daisy and Penny assist with the search for Z2807. (Author)

Left: Gravestone of Sergeant J. A. R. Turner. (Author)

Sgt J. A. R. Turner: Section H, Grave 201, Chevington Cemetery, Red Row

The Site of the Crash

Hawker Hurricane Mk IIa Z2807 FT-D RAF Acklington

Pilot:	R/74223 Sgt John Allan Ryerson Turner, RCAF, age 22
Squadron:	43 Squadron, RAF Acklington
Site:	Pylon Field, Quarry House Farm, Denwick, Alnwick
Grid:	NU21370 1537
Map:	OS Explorer 332
Note:	Fragments remain buried at the site

Bibliography

Chorlton, Martyn, *Airfields of North-East England in the Second World War*
Saunders, Andy, *No. 43 'Fighting Cocks' Squadron*
Walton, Derek, *Northumberland Aviation Diary 1790–1999*

Reference

AIR 27/442 – 43 Squadron ORB
AIR 28/17 – RAF Station Acklington ORB
Air Historical Branch
Alan Shotton
Alison Thompson
Anne Woodcock
Commonwealth War Graves Commission
Dennis Gray
F1180 – Loss Card
George Skipper
Jack Knox
Ordnance Survey Maps
Ralph Thompson
Register of Burials (War Graves) Chevington Cemetery
Registrar Office, Morpeth
Richard McAllister
The Aviation forum – www.keypublishing.com

SPITFIRE K9935

Supermarine Spitfire Mk I K9935
58 Operational Training Unit
RAF Acklington

Temple Hill Field
Togston Barnes Farm
Togston
14 April 1941

During my search for the sites of Hawker Hurricanes L2066 and L1734 (Chapter 5), and AM282 (Chapter 6), I had found sources which had a Spitfire crash at Whitefield Farm, Red Row. Luckily for me, Ethel Elliott lives here. Her local knowledge would help identify or eliminate any beliefs of an aviation accident of this farm. Ethel has lived on Whitefield Farm all of her life.

April 2008

I spoke with Ethel on numerous occasions during April about various crashes that had happened in the Red Row and Broomhill area. Tea and biscuits was always the order of the day, a very helpful appetiser when gathering information. Ethel was positive that no aircraft had crashed on Whitefield land before, during, or after the Second World War. She recalled when a German aircraft dropped incendiary bombs in the field to the west of the farm, creating a small fire in the crop. Ethel produced one of the tail fins from one of these bombs.

The only aircraft she knew of that had involved Whitefield Farm was that of a heroic flight by two Danish men in June 1941 in a De Havilland Hornet Moth, registration, OY-DOK. Ethel's account was not of the brave feat of crossing the North Sea in a small biplane, but of the Dad's Army version, regarding the actions of the company of Royal Scots billeted at the farmhouse.

This aircraft was picked up by the radar station at Ottercrop Moss and aircraft from RAF Acklington were alerted and took off to intercept. At the same time, the company of soldiers at Whitefield were sent to search the beach at Druridge

Supermarine Spitfire Mk I. (RAF
Museum Hendon)

Bay for any aircraft landing. At around midnight, the troops returned to the farm
and bedded down for the night, their commanding officer stating, 'No aircraft
has landed around here tonight.' The farm window shutters were already closed
for the blackout. While the soldiers were on Druridge Bay beach, OY-DOK had
landed and the occupants were being held at RAF Acklington. The following
morning, as the troops opened the shutters, before them stood OY-DOK!

A full account of this epic flight by Sub Lieutenant Thomas Sneum and Sub
Lieutenant Kield Pedersen, both originally of the Danish Fleet Air Arm, can be
found in archives of the *Journal* newspaper, ncj.library@ncjmedia.co.uk

Since Ethel was positive of no aircraft crashing on the farm of Whitefield, I decided
to check with the Morpeth Registrar Office for any trace of a fatality. I had the name
of the pilot from two or three sources, P/O R. H. Jagger; the certificate of death
would not prove the exact location of the crash, but would indicate the area, therefore
narrowing my search. This was my first venture in contacting the Registrar Office. The
death certificate had recorded that P/O R. H. Jagger had in fact been killed in a flying
accident at Togston Barnes Farm, Togston, some three miles north of Whitefield
Farm. This anomaly brought to my attention that not all accounts are accurate.

There are two farms with the name 'Togston', Togston Barnes and Togston
East. Both farms had been worked by the same family, the Forsyths; however, over
the years the family had moved on. The family that lived at Togston Barnes Farm
now informed me that John Forsyth had moved to Acklington. This is my area;
through contacts in Acklington village, I was put in touch with John Forsyth.

Account of John Forsyth

John was a youngster at Togston Barnes during the Second World War, the farm being
worked by his parents. He could recall only one aircraft that had crashed on the land
of Togston Barnes. John told me it was a Spitfire, and that it had crashed on approach
to Acklington in a field known as Temple Hill; John described the exact position in

the field. When John started working the farm, it was noticed that in this field, when preparing for planting, the plough always got caught on something one to two feet underground. It was discovered that it was part of the aircraft. John and his brother had tried to dig it out, and even used a tractor to pull it out, but this failed as the tractor kept stalling. They decided to fence off this area of the field, and just plough round it.

Over the years, open cast coal mining has had its toll on the landscape surrounding the former RAF station of Acklington. The field which K9935 crashed into was the area where the baffle banks were placed when the area to the west and north of what was Togston Barnes land was subject to mining. John, like me, is unsure whether or not the opencast dug out the wreckage, or of the depth of the baffle banks that covered the site. Attempts with my metal detector revealed a large amount of opencast debris.

Official Documents

I firstly checked my reference books for any possibilities and came up with a 58 OTU crash, this being Supermarine Spitfire K9935.

I next contacted the National Archives for copies of the 58 OTU Operational Records Book (ORB), which came under AIR 29/684 for April 1941. This confirmed the crash of K9935.

My next move was to contact the RAF Museum Hendon for the F1180 (Loss Card) for this aircraft. What I needed to know was, as near as possible, where the crash had happened. The museum only had a copy of the Air Ministry Form 78 (AMF 78), the movement card; therefore, I was unable to determine the site from this.

Gravestone of P/O R. Jagger. (Ron Saunders)

My contact at the Air Historical Branch at RAF Northolt could not locate their copy of the F1180, but managed to locate a site from the Casualty Listings. This recorded the pilot as P/O R. H. Jagger, and the crash site as Radcliffe Farm!

I had been given an Ordnance Survey map, Sheet NU 20 (1938–1953), covering the Hadston to Amble area, by Eric Wood. There is no trace of a 'Radcliffe Farm' in the area. Checking with local landowners, there is no recollection of a farm in the area being called Radcliffe Farm. The former mining village of Radcliffe is 1½ miles from Temple Hill Field, at Togston Barnes.

I then contacted the Registrar Office at Morpeth to obtain the pilot's death certificate; this revealed that 61220 P/O Richard Hugh Jagger had been killed in a flying accident at Togston Barnes Farm, Togston, Northumberland.

St Margaret's, Tylers Green, Buckinghamshire

The Commonwealth War Graves Commissions register acknowledges P/O Jagger; however, it only lists that he was buried at St Margaret's Churchyard, and records no location within the churchyard. I could only presume P/O Jagger had a private headstone. Contacting Mike Bisset from the parish of Tylers Green, he forwarded my details to Ron Saunders, a local historian. Ron went out of his way and found the grave of P/O Jagger and sent me a photograph. Ron also managed to recover the newspaper cutting from the *Bucks Free Press*, dated 18 April 1941.

Note: The Morpeth Registrar records P/O R. H. Jagger as serving with the RAF, as stated in the newspaper cutting mentioned above. P/O Jagger was actually a serving officer with the RAFVR; this is marked on his headstone.

A Brief Account of the Crash

Supermarine Spitfire K9935 was stationed with 58 Operational Training Unit at RAF Grangemouth, near Falkirk, Scotland. K9935, piloted by P/O R. H. Jagger, was detached to RAF Acklington for live firing practice at the ranges over Druridge Bay. Taking off from Acklington, P/O Jagger was to take part in an air to air firing practice over the Northumberland coast. After completion of the exercise, P/O Jagger made to approach Acklington aerodrome from the north-east; the aircraft stalled and spun into the ground at Togston Barnes Farm, killing the pilot.

Note: K9935 was approaching RAF Acklington to land; Temple Hill field is in line with the north east runway. On the same approach, within a distance of two miles, are the crash sites of Hawker Hurricane P3411 at Alnwick Road, Short Stirling EH880 at Cliff House Farm, Spitfire K9935 Temple Hill, and Hampden L4072 at the Church of Christ.

P/O R. H. Jagger: Section E5, Grave 126, Tylers Green (St Margaret) Churchyard

The Site of the Crash

Supermarine Spitfire K9935, 58 OTU RAF
Pilot: 61220 Pilot Officer Richard Hugh Jagger, RAFVR, age 24 +
Squadron: 58 OTU RAF
Site: Temple Hill Field, Togston Barnes Farm, Togston, Northumberland
Grid: NU24519 01969
Map: OS Explorer 325
Note: No wreckage remains at the site

Pilot Officer Jagger is remembered on the memorial to twenty-nine aircrew and thirteen aircraft in the former RAF Acklington church, St John the Divine, Red Row, unveiled on 7 May 2011.

Bibliography

Chorlton, Martyn, *Airfields of North-East England in the Second World War*
Morgan, E. B. and Shacklady, E., *Spitfire: the History*
Walton, Derek, *Northumberland Aviation Diary 1790–1999*

Reference

AIR 29/684 – 59 OTU ORB
Commonwealth War Graves Commission
Dennis Gray
Eric Wood
Ethel Elliott
F1180 – Loss Card
Falon Nameplates www.falonnameplates.com
John Forsyth
Mrs Joan Rose, Northumberland and Durham Family History Society
Newcastle Journal newspaper ncj.library@media.co.uk
Ordnance Survey Maps
RAF Commands web Site www.RAFcommands.com
Ron Saunders

SPITFIRE X4011

Supermarine Spitfire Mk I X4011 DW-O
610 Squadron
RAF Acklington

Highway Road
Inglenook
Acklington
5 November 1940

While researching aviation accidents in the villages around the former RAF Acklington, I had read a report of Spitfire X4011, which had crashed on take-off at Acklington. The pilot's name and squadron were recorded in the brief report. No further account was available to narrow down the possible area of the crash.

In early February 2009, I contacted the Registrar Office at Morpeth to collect details from the pilot's death certificate. The location given on the certificate was 'Highway Road, Acklington'. This, I assumed, would be an easy one to locate. All I needed was to be directed to Highway Road, and I could narrow it down from there. They do say that you should never 'assume' as it 'can make an ass out of you and me' (ass-u-me)! This was to become apparent in the early stages of my search.

Working in the area and having many connections, I started to ask the obvious question, 'Where is Highway Road, Acklington?' All who were asked shook their heads, explaining there is no such road. Scouring through old maps, Googling, nothing was found. Even with Google Earth, which sometimes still has streets on its data base which have long since gone, I drew a blank.

Supermarine Spitfire
Mk I X4011 DW-O.
(RAF Museum
Hendon)

The crash site of X4011; no evidence remains at the site. (Author)

At the same time, I was speaking with John Forsyth while tracing the crash site of Spitfire K9935 at Togston Barnes; I happened to mention I was looking for Highway Road, Acklington. John could not place the road either; however, he suggested I speak to Nelson McDougal, as Nelson had lived in Acklington all of his life and had lived here as a child during the Second World War – if anyone would know, Nelson would. John would organise for me to meet with Nelson.

Account of Nelson McDougal

I met with Nelson McDougal at his home in Acklington Village, on 11 February 2009. I had to ask, 'Where is Highway Road?' Nelson explained that there is no such place as Highway Road, but that the road from Acklington Village to Amble via Togston was known as 'The Highway' to Amble, the 'Low-way' being from Chevington Drift, via Radcliffe, to Amble.

Nelson explained that there was only ever one aircraft which had crashed on this road and that it was a Spitfire. The aircraft had crashed into a raised hedge on take-off, on the edge of what was known as the 'Triangle Field', and that the engine had detached from the aircraft and crossed the road, leaving the main body of the aircraft trapped in the raised hedge.

He was certain of the site, as at the time he lived in the cottage called Inglenook; this cottage still stands today. Nelson had walked past the site for several days on

his way to school in Acklington Village. He pinpointed the location of the main wreckage as being near enough the entrance closest to Acklington Village, to what is now known affectionately as 'The Quarters'. The engine travelled across the road into the paddock opposite.

Note: The 'Quarters' are built on what was the 'Triangle Field'; some still refer to the Quarters as the Triangle. The Quarters refers to the former RAF Acklington Married Quarter 'Patch'.

Nelson was also witness to a serious accident at RAF Acklington in 1947 involving a De Havilland Mosquito piloted by F/Lt D. E. Byrne, with the station Medical Officer, F/O C. Johnson MB, BS as passenger. He was practicing for Battle of Britain Day. This had been observed by Nelson over a few weeks, as the practice usually took place over the lunch time period. Nelson noticed that the pilot was performing a slow roll, the engines cut and the aircraft dropped out of the sky into the middle of the airfield, killing both F/Lt Byrne and F/O Johnson. There is no trace of this crash site, as the heart of RAF Acklington was torn apart by opencast mining.

It is with great sorrow and regret that George Nelson McDougal passed away on 9 April 2009, aged eighty, six weeks after our meeting. He was laid to rest in Acklington Church yard on 20 April 2009.

Official Documents

I firstly checked my reference books for any possibilities and came up with a 610 Squadron crash from RAF Acklington, this being Supermarine Spitfire X4011 DW-O.

I next contacted the National Archives for copies of the 610 Squadron Operational Records Book (ORB); this came under AIR 27/2106 for April 1941. This confirmed the crash of Supermarine Spitfire X4011, but noted the site as Acklington aerodrome.

I contacted the 610 'Cheshire' Squadron Association; they confirmed the aircraft's Squadron (DW) and individual identification (O) letters.

The Air Historical Branch had no F1180 (Loss Card), but their casualty records mentioned that the crash was RAF Acklington Aerodrome.

My next move was to contact the RAF Museum Hendon for the F1180 (Loss Card) for this aircraft. What I needed to know was, as near as possible, where the crash occurred. This revealed that the aircraft had crashed at Acklington aerodrome.

I then contacted the Registrar Office at Morpeth to obtain the pilot's death certificate; this revealed that 83255 P/O Donald McIntosh Gray had been killed in a flying accident at Highway Road, Acklington.

Broomhill police Occurrence Book for 5 November 1940 gives a clear account of the crash, making the location recorded on P/O Gray's death certificate understandable.

Grave of P/O D. M. Gray. (Author)

A Brief Account of the Crash

Spitfire X4011 DW-O, piloted by Pilot Officer Donald McIntosh Gray of 610 Squadron, was preparing for a night take-off on 5 November 1940. He was instructed to use the south to north runway to commence his patrol. As the aircraft took off, he reported that he was having difficulties. To the right of the north end of the runway is a white house. P/O Gray pulled the struggling aircraft to the right to avoid the building and touched down in a grass field to the north side of the aerodrome. The left wing caught a gun post and was torn off; the aircraft then carried on for a further 250 yards and crashed into the raised hedge at the edge of the Triangle Field, 300 yards to the west of Acklington Village, on the south side of the Broomhill to Acklington highway, bursting into flames. The engine detached and crossed the road, settling in the paddock next to Inglenook. P/O Gray was thrown from the wreckage onto the highway and was killed.

Note: November 1940 was a difficult month at Acklington for 610 Squadron, losing four pilots in air accidents between the 4th and the 11th.

P/O D. M. Gray: Section H, Grave 285, Chevington Cemetery

Pilot Officer Gray is remembered on the memorial to twenty-nine aircrew and thirteen aircraft in the former RAF Acklington church, St John the Divine, Red Row, unveiled on 7 May 2011.

The Site of the Crash

Supermarine Spitfire Mk I X4011 DW-O RAF

Pilot:	83255 P/O Donald McIntosh Gray, RAFVR, age 21 +
Squadron:	610 Squadron RAF
Site:	Highway Road, Inglenook, Acklington
Grid:	N23140 01924
Map:	OS Explorer 325
Note:	No wreckage remains at the site

Bibliography

Chorlton, Martyn, *Airfields of North-East England in the Second World War*
McMillan, William, *An Anecdotal and Statistical History of RAF Acklington*
Morgan, E. B. and Shacklady, E., *Spitfire: the History*
Walton, Derek, *Northumberland Aviation Diary 1790–1999*

Reference

610 Sqn Association
AIR 27/2106 – 610 Squadron ORB
AIR 28/17 - RAF Station Acklington ORB
Broomhill Station Police Occurrence Book
Commonwealth War Graves Commission
Dennis Gray
F1180 – Loss Card
Falon Nameplates www.falonnameplates.com
Google Earth
John Forsyth
Key Publishing forum web site, www.keypublishing.com
Mrs Joan Rose, Northumberland and Durham Family History Society
Nelson McDougal
North East Diary 1939-1945 – Roy Ripley and Brian Pears
Ordnance Survey Maps
RAF Commands website, www.RAFcommands.com
Register of Burials (War Graves) Chevington Cemetery

SPITFIRE P8587

Supermarine Spitfire Mk IIb P8587
57 Operational Training Unit
RAF Eshott

Bellyside Hill
Dunsdale
Cheviot
25 March 1943

I had first visited this site with my friend and colleague Stu Dixon on 13 July 2005. The day was planned for an eleven-mile hike around and over the Cheviot massif, encompassing the seven crash sites on Cheviot Hill. This was the early stages of my searches, as I had only just started to look for the well-known and well-recorded sites.

We were confident of locating the site, as we had obtained a six-figure grid reference, NT906 225, from two locally produced books. Armed with a 1992 'Gulf War' style Magellan GPS, this grid reference, once plotted, should take us to within one hundred metres of the site.

Departing from Langleeford, we were to head the four miles around the foot of the north side of the Cheviot. We would then make our ascent from Dunsdale

Supermarine Spitfire Mk IIb. (RAF Museum Hendon)

up the spine of Bellyside Hill. Approaching the location, the reading on my GPS drew us closer to the site. Once we had arrived, it became apparent that there was no wreckage, but we did see an indentation in the ground, a possible crash site. Carrying on our hike, we found the other six sites with relative ease. I was still not convinced that I had found the location of P8587.

23 September 2009

With the success of locating the sites of Hawker Hurricane N2522, Vickers Wellington R1535 and Ju 88 3E+BH during 2008, I once again teamed up with Sarah Wilson and Basil Oliver, not forgetting my air-crash-hunting poodle, Penny. Basil had been directed to location from Dunsdale in 1947, but had not visited the site.

We met at Powburn service station for 9.30 a.m. I arrived early with Basil; he was very open with me, recalling the crashes he had attended as a young boy and as a teenager involved in the rescue and recovery of the victims from the crashes on Cheviot. I was honoured as Basil told me, 'I have never told anyone what I really saw, you know I can still see it all as plain as day, I still wake up thinking about it!' I have recalled Basil's experiences in several chapters and dedicated the two following chapters (29 and 30) specifically to Basil.

We teamed up with Sarah and set off for Hethpool in the College Valley. Here we would transfer into Sarah's Land Rover, as the road is a little uneven to Dunsdale. Standing at the gate of Dunsdale, Basil explained that he had been told the Spitfire had crashed south-east of Dunsdale, on Bellyside Hill. I pointed out that the grid reference was to the south-west! Armed with my metal detector, we decided that it would be best to search the area of the grid reference. A track from Dunsdale (which is not marked on the map) takes you up the spine of Bellyside Hill to some redundant peat diggings. The grid reference is to the right of this track as you climb the hill. Penny led the way, showing off to Basil and Sarah, guiding us up the track. We arrived on site for 11.00 a.m.

As this is a wide open area, on approach I find it prudent to switch on my detector and start to sweep the approach area, just in case I stumble across fragments (you never can tell). It was a bit breezy and the heather was so deep that Penny was struggling to cope. On our days out I do not like to leave Penny tethered, preferring her to be with me at all times. To deal with her struggle, my only option was to carry her; this, I have to admit, is one of the parts of the day she loves, 'rescued by her Pa'. For three hours, we searched the grid area with nothing found, but Penny was relaxing in my rucksack.

We stopped for lunch, approximately 100 metres above the peat diggings, and discussed the area Basil had been told the site was. This location was much further down the hill on the Goldsclough side of the track; the grid reference is on the Dunsdale side of the track. Heading down the hill, I searched in the

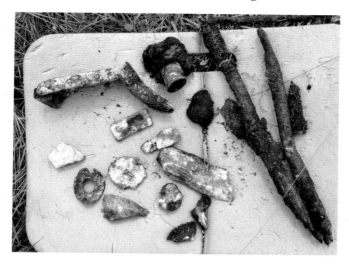

Fragments from the wreckage of P8587 found on 1 July 2010. (Author)

area towards Goldsclough, but again, nothing was found. Before we packed up and left, Sarah told me she would contact John Dagg; as a child, he had lived at Dunsdale at the time of the crash. It would be some time before Sarah would see John, nearly seven months, but his account was worth the wait.

Account of John Dagg (as Told to Sarah Wilson)

Bob Jackson, the shepherd at Goldsclough, heard an aircraft in low cloud flying in a south-westerly direction; this was at 11.30 a.m. Believing it had crashed, Bob headed up the hill in the general direction from where he had heard the sound of the aircraft crashing. On arrival at the crash site, he found that the aircraft had broken up on impact. The engine had become detached and travelled up the hill a short distance. The aircraft was on fire, with live ammunition exploding from the heat. Bob ascertained that the pilot had been killed. He left the site and walked down the 'peat track' to Dunsdale.

John described the site as being on the Goldsclough side of the peat track, close to the 'peat diggings' on approximately the third rise on the hill, but definitely, definitely, not on the Dunsdale side of the track.

1 July 2010

Sarah was unable to make this trip due to teaching commitments, but had secured for me to have vehicle access to Dunsdale through Jane Matheson of The College Valley Estates. Unsure of what the search area would be like and remembering the

conditions from ten months earlier, I decided to leave Penny at home. She was not happy and snorted as I put my kit in the car and said goodbye.

I arrived at Dunsdale at 8.45 a.m.; with metal detector in hand I started up the peat track on Bellyside Hill. I arrived at the peat diggings, which are still visible but can be missed if you do not know what you are looking for; here is where I would start my search. I broke the area into sections and started to sweep. Always remembering where the original grid reference was, I imagined the line the engine may have travelled after it had become detached from the fuselage. After two and a half hours, I had found no trace of the aircraft; I had expected to locate a trail of fragmented debris in the direction of the grid reference. I searched an area of approximately 150 square metres and found nothing. I was on the Goldsclough side of the track, and was beginning to gain height; I moved over the track to the Dunsdale side towards the grid reference. I still had no trace, and then moved back to the peat diggings. I do recall saying to myself, 'Come on Eric ... show me where you are.'

Taking stock of my surroundings, added with finding nothing, I was beginning to doubt the search area. Looking up the track, I saw where Basil, Sarah and I had had lunch some ten months earlier. This was nearly 150 metres to the east of the original grid reference. I noticed a small plateau above this site, a further 150 metres to the east (a total of 300+ metres). Something drew me to this area; I climbed onto the plateau and at 11.52 a.m., I found the fragmented remains of P8587.

The first few pieces were oxidised engine casing; I was on the site where the engine had stopped. The trail of fragments was in a north-easterly direction, moving downhill; this trail was around 30 metres long and led to fuselage debris. Reversing this description has the aircraft travelling in a south-westerly direction. Gathering some rocks from the surrounding area, I built a small cairn and placed the fragments inside.

The cairn built by the author at P8587 crash site, 1 July 2010. (Author)

5 July 2010

Knowing that my trusted Penny had missed out on the initial discovery of P8587, I wanted her to visit the site. After a long weekend at work, Monday 5 July was my day off. I had convinced Sue and my daughter Holly to come along, 'just for a few hours'. On this occasion, I would be bringing a trainee air crash hunter; this would be in the guise of Holly's seven-month-old poodle pup, Daisy. This was Daisy's first outing in the Cheviots, and her first crash site. We arrived on site for 10 a.m., a little windswept, but ready to go. I explained to the girls, and to Sue and Holly, where I wanted to search. After a brief lesson in how to read the metal detector screen, Holly took control and started to sweep the area I had pointed out. Within minutes, we had finds from the initial impact area. Penny, leading by example, brought Daisy to investigate every hole that was dug. We placed the new fragments along with the items I had found on the 1st. We then proceeded to build a better and stronger cairn to hold the pieces.

29 July 2010

Having just completed night shift, and allowing myself some extra free time, I set off to revisit the site. I had Penny and Daisy with me, both eager to get into the hills and the fresh air. Daisy was beginning to learn from Penny what to expect. Arriving on site (a little late, as I had forgotten to pack my metal detector and had to turn back) for 10.30, the search started. I was getting positive readings and uncovering small fragments.

When you step back and take a close look at the ground, there is a definitive scar where the aircraft crashed. A few larger bits of fuselage were uncovered,

Penny guarding the propeller tip from P8587, 29 July 2010. (Author)

Penny and Daisy guarding the newer and stronger cairn 29 July 2010. (Author)

but nothing that you could possibly identify. I was preparing to leave when I got a good, strong reading. At first it appeared that I had been tricked by the magnetism in the small rocks under the surface, but I persevered. At 12.30 the tip of a broken propeller blade became visible, providing the best evidence so far of the aircraft. A good few hours searching had produced a fine result, but time was not on my side and I left the site to get some sleep.

Official Documents

I firstly checked my reference books for any possibilities and came up with a 57 OTU crash, this being Supermarine Spitfire Mk IIb P8587; this was in 2005.

I next contacted the National Archives for copies of the 57 OTU Operational Records Book (ORB); this came under AIR 29/683 for March 1943. This confirmed the crash of Supermarine Spitfire P8587, recording the crash site as Dunsdale.

My next move was to contact the RAF Museum Hendon for the F1180 (Loss Card) for this aircraft. What I needed to know was, as near as possible, where the aircraft had crashed. This revealed that the aircraft had crashed at Dunsdale, but not the exact site.

I then contacted the Registrar Office, Morpeth, to obtain the pilot's death certificate; this revealed that 401893 F/Sgt Eric Lindsay Brown had been killed in a flying accident at Dunsdale, Cheviot.

The National Archives of Australia revealed more evidence of F/Sgt E. L. Brown, although this was riddled with anomalies. Some of the documents record the crash as Dunsdale, Northumberland, some as Dunstable, Bedfordshire, at 10.30 a.m., noting they cannot find a Dunstable at Newcastle on the Gazetteer. Some correspondences have F/Sgt Brown serving with 57 OTU, and others with 58 OTU. A letter from the casualty section of the Royal Australian Air Force (RAAF) dated 24 June 1943 apologises to Mr G. Brown (F/Sgt Brown's father) for the error in transmission regarding the loss of his son and rectifies the location as 'Dunsdale, Kirknewton, Wooler, in the County of Northumberland'.

Grave stone of F/Sgt E. L. Brown. (Author)

A Brief Account of the Crash

Supermarine Spitfire P8587 of 57 Operational Training Unit, piloted by Flight Sergeant Eric Lindsay Brown, took off from RAF Eshott at 10.40 a.m. on 25 March 1943 on a solo training flight carrying out air firing practice. He was flying over the Cheviot Hills. At 11.30 a.m., flying in a south-westerly direction in low cloud, the aircraft flew into the side of Bellyside Hill on the north side of the Cheviot massif, killing F/Sgt Brown. Upon impact, the engine separated from the main fuselage and continued up the hill for approximately 38 metres; two ewes were also killed, either by the resulting fire or by the aircraft itself.

The F1180 records: 'the pilot failed to carry out briefing instructions'. The investigation report states, 'Bad airmanship, descended through 10/10 cloud, should have either obtained a directional fix or should have gone east and descended through broken cloud, pilot disregarded instructions not to go inland'. The report concludes with: 'accident could have been avoided if adequate Direction Finding and Fixing facilities existed at unit'.

There are some speculations that F/Sgt Brown may have been searching for the sites of two German aircraft that had been shot down in the area on the night of the 24th. There is no substantive evidence to support these theories. The wreckage was removed from Bellyside Hill by 83 Maintenance Unit RAF Millfield.

The funeral of F/Sgt Eric Lindsay Brown, RAAF, took place on 29 March at 3 p.m., conducted by A. Locke, Chaplain, RAF Eshott, at Chevington Cemetery, Red Row, Northumberland.

F/Sgt E. L. Brown: Section H, Grave 281, Chevington Cemetery

The Site of the Crash

Supermarine Spitfire Mk IIb P8587 57 OTU RAF
Pilot: Aus/401893 F/Sgt Eric Lindsay Brown RAAF, age 24 +
Squadron: 57 OTU RAF
Site: Bellyside Hill, Dunsdale, Cheviot
Grid: NT90875 22613
Map: OS Outdoor Leisure 16
Note: Fragments remain at site; small cairn built 1 July 2010 at Grid, strengthened on 5 July 2010

Bibliography

Chorlton, Martyn, *Airfields of North-East England in the Second World War*
Clark, Peter, *Where the Hills Meet The Sky*, 2nd edition, Glen Graphics, 1997
Earl, David W., *Hell on High Ground Vol. 2*
Morgan, E. B. and Shacklady, E., *Spitfire: the History*
Walton, Derek, *Northumberland Aviation Diary 1790–1999*
Wilson, Sarah, *Reflections: The Breamish Valley and Ingram*

Reference

AIR 29/682 – 57 OTU ORB
Basil Oliver
Commonwealth War Graves Commission
Dennis Gray
F1180 – Loss Card
Google Earth
Jane Matheson, College Valley Estates
John Dagg
Mrs Joan Rose, Northumberland and Durham Family History Society
National Archives of Australia
Ordnance Survey Maps
Penny & Daisy
RAF Commands website www.RAFcommands.com
Register of Burials (War Graves) Chevington Cemetery
Sarah Wilson
Wooler Police Station Occurrence Book

SPITFIRE R6762

Supermarine Spitfire Mk I R6762 PW-E
57 Operational Training Unit
RAF Eshott

Blawearie Field
Eshott Home Farm
12 April 1944

In February 2008, I was invited by ACIA member Russ Gray to assist in locating the crash site of a United States Army Air Force P47D-21RE Thunderbolt, serial number 42-25530. This aircraft had collided with Supermarine Spitfire R6762 PW-E over RAF Eshott. The P47 had crashed in the field opposite the sewerage works of RAF Eshott (grid ref.: NZ18474 97435, OS Explorer 325). The search was made easier as a picture supplied to Russ from the USAAF showed in the background buildings from RAF Eshott, and the landowner Stephen Hogg allowed us access to his field Bockenfield Moor. Fortunately, the buildings were still standing when we visited the site.

From here we basically held the photograph out in front of us, and walked along the edge of the field until we were in line with the buildings. Then, it was a matter of walking towards the buildings until the photograph matched the surrounding

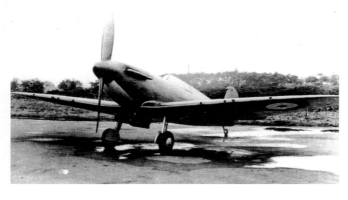

Supermarine Spitfire Mk I. (RAF Museum Hendon)

area. Fragments of engine casing, alloy and the tip of a .50 calibre round were found. One of the photographs showed the crater the aircraft made when it crashed. All fragments were found in a wide circular area in conjunction with the photograph.

I had been told of a rumour that R6762 had crashed into a field called 'Blawearie', however, after speaking to one or two local farmers, it became clear that there were possibly five fields by the this name, all next to each other, and all owned or farmed by different people.

Local Advisor (Source Wishes to Remain Anonymous) May 2010

The site of R6762 was going to prove to be more difficult to locate. I had a stroke of luck when talking to a local advisor. When asking advice regarding Beaufighter R2473 (Chapter 20) and Spitfires P8360 and P8362 (Chapter 21) in the Eshott area, my advisor, without prompt, directed me towards a field belonging to Eshott Home Farm in 1944 called 'Coach Roads Field'. This, he explained, 'was where a Spitfire had crashed, it had collided with an American Thunderbolt, there was hell on about it, as the Yanks should not have been in the area'.

This was the most positive information regarding the site of R6762 I had to date. It was also a field right next to one of the 'Blawearie' fields, which I must admit was one identified to me third-hand, but from the account of an eyewitness. This was to narrow my search area down from the possibility of five fields to two.

Blawearie Field. (Author)

9 September 2010

In May 2010, Coach Roads Field was full of un-ripened wheat. Having agreed access to the field with the new landowners, I would have to wait for the wheat to be cropped in September.

Arriving on site at 8 a.m., the field appeared larger than it had when it contained a full-grown crop. This site, as with the other Eshott sites, is a low ground site, very close to the road, with a coach track splitting the field in two. My local advisor had identified the site as being in the west side of the field. My expectations of locating any wreckage after sixty-six years of arable farming were low, but you have to try.

The weather was damp and drizzly, so my air-crash-hunting pooch Penny was left at home (much to her annoyance). Breaking the field down into sections, I searched for over four hours in poor conditions. Again, I discovered enough broken pieces of farming equipment to seriously consider building my own plough. Only one piece of alloy metal was found, and this I could not identify or compare to fragments I have found at other sites. Just as it was time to leave, the weather broke. Just my luck!

11 September 2010

Having no luck in finding anything in Coach Roads Field, I moved into the identified field called Blawearie. What also drew me to this field was the recent receipt of a copy of the crash investigation, which had a hand-drawn sketch of the crash area. The definitive land mark on the small map was the runways of RAF Eshott, but the position of the mark regarding the aircraft involved indicated this field. I now had official evidence of the site.

Unidentified buckle; I have checked my Jimmy Choos and it's not mine! (Author)

Blawearie is twice the size, and skirts around Coach Roads Field. I began my search of the field from north to south, as this was the shorter crossing of the field and the easiest way to mark out the areas searched. Again, as expected with a low land site that has been ploughed for seventy years, my collection of bits to make my own plough was getting bigger. To the north-west of the field is a slight depression; here I did get a few readings, but they were deep and I didn't have permission to dig big holes as the field had been cultivated with winter wheat. The only positive sign of alloy was a retaining buckle, which would be used to help adjust a strap of some sort, but I could not confirm it to from an aircraft.

Official Documents

I firstly checked my reference books for any possibilities and came up with a 57 OTU crash, this being Supermarine Spitfire Mk I R6762.

I next contacted the National Archives for copies of the 57 OTU Operational Records Book (ORB); this came under AIR 29/683 for April 1944. This confirmed the crash of Supermarine Spitfire R6762, but not the site.

My next move was to contact the RAF Museum Hendon for the F1180 (Loss Card) for this aircraft. What I needed to know was, as near as possible, where the aircraft had crashed. This revealed that the aircraft had crashed at Eshott Hall Farm. This in its self is misleading, as there is no Eshott Home Farm; there was Eshott Hall Estate, which contained several farms, i.e. Home Farm, Park Farm (now Eshott Birnie), South and East Farms.

The Broomhill Police Occurrence Book for 14 April 1944 records a very brief account of the crash but provides no locations for the sites.

I then contacted the Registrar Office at Morpeth to obtain the pilot's death certificate; this revealed that 2322 Sergeant Kai Arthur Knagenhjelm had been killed in a flying accident at Eshott Hall Farm.

A Brief Account of the Crash

Supermarine Spitfire Mk I R6762 PW-E, piloted by Sergeant Kai Arthur Knagenhjelm, took off from RAF Eshott at 10.25 a.m. along with another Spitfire, piloted by a Lieutenant Hattren, also of the Royal Norwegian Air Force, for a training flight. Both had been instructed to carry out practice attacks on each other, not below 5,000 feet, for a period of thirty minutes. After this, they were to climb to a height of 8,000 feet to carry out further aerobatics.

At approximately 11.45 a.m., their exercise nearly completed, Sgt Knagenhjelm, in R6762, started his circuit of Eshott airfield, flying a 'left hand circuit' awaiting

Gravestone of Sergeant K. A. Knagenhjelm. (Sten-Arne Skulbru)

instructions to land. At the same time, a flight of four United States Army Air Force P47s, from 366th Fighter Squadron, 258th Fighter Group, 9th Air Force, RAF Milfield, had just completed a simulated attack on a convoy, south of Felton.

P47D 42-25530, piloted by First Lieutenant Anthony L. Serapiglia, disobeyed an order to break off his attack on the convoy. Flying west to east, in the opposite direction of R6762, he collided head on with Sgt Knagenhjelm. The P47 had a wing severed and burst into flames; it span into the ground a third of a mile south of the airfield, killing First Lt Serapiglia. Sgt Knagenhjelm's Spitfire, also on fire, went into a flat spin and dived into the ground three quarters of a mile south-east of the airfield, at Blawearie Field, Eshott Home Farm. At the subsequent enquiry into the accident, no representative of the USAAF attended.

The remains of Sgt K. A. Knagenhjelm were taken to Honour Oak, Southwark, London, for cremation on 17 April 1944. His remains were removed by the Officer in Charge, Kingston House, Prince's Gate (the Norwegian government in exile). The remains of Sgt K. A. Knagenhjelm were repatriated to his home town of Oslo, Norway, on 28 September 1945.

Sgt K. A. Knagenhjelm: Field 034, Row 03, No. 008, Vestre Gravlund Cemetery, Oslo

Sergeant Kai Arthur Knagenhjelm was born 22 October 1924, in Oslo, Norway. The Knagenhjelm family moved to New York to escape the Nazi occupation. He attended school in New York, and served one semester at Harvard University before joining the RNAF. A border record of 10 April 1943 places him in the Muskoka Air Port training camp of the RNAF, otherwise known as Little Norway.

The Site of the Crash

Supermarine Spitfire Mk I R6762 PW-E 57 OTU RNAF

Pilot:	2322 Sergeant Kai Arthur Knagenhjelm RNAF, age 19 +
Squadron:	57 Operational Training Unit RAF Eshott
Site:	Blawearie Field, Eshott Home Harm, Eshott
Grid:	NZ19443 97262
Map:	OS Explorer 325
Note:	No wreckage remains at site

Bibliography

Chorlton, Martyn, *Airfields of North-East England in the Second World War*
Corbett, Jim, *Air Crash Northumberland*
Morgan, E. B. and Shacklady, E., *Spitfire: the History*
Walton, Derek, *Northumberland Aviation Diary 1790–1999*

Reference

AIR 29/683 – 57 OTU ORB
Broomhill Station Police Occurrence Book
Commonwealth War Graves Commission
F1180 - Loss Card
Google Earth
Jeff and Duncan Clark
Local advisor, who wishes to remain anonymous
Mette Værnes, The Regional State Archives of Oslo
Mikkel Plannthin, Copenhagen, Denmark, RAF Commands website
Mrs Joan Rose, Northumberland and Durham Family History Society
Ordnance Survey Maps
Peter Davies, RAF Commands website
RAF Commands website, www.RAFcommands.com
Robert Nixon, RAF Commands website
Sten-Arne – Vetre Gravlund Oslo

DEFIANT N3364

Boulton Paul Defiant Mk I N3364
410 (Cougar) Squadron
RAF Drem

West Field
Beacon Hill Farm
Morpeth
26 March 1942

During my search for Vickers Wellington R1707-U at Benridge Moor Farm, Morpeth, I noticed in my copies of the Morpeth police records a report regarding a crash of a Boulton Paul Defiant at Beacon Hill Farm.

Beacon Hill Farm is 2.25 miles (3.5 km) to the north-west of Benridge Moor Farm, as the crow flies. This in mind, I returned to my police report, as there was a grid reference provided; this would be the best place to start.

Extract from Police Record

28th March 1942, PC M. Anderson received a report from J. R. Green of Haredene, Longhorsley; he had taken a crew member from a crashed aircraft to Longhorsley Observer Post. He interviewed the airman, and found him to be R/5373 F/Sgt H. E. Pallatiel, who was acting as Observer/Air Gunner, and that he had bailed out as the plane was in a steep nose dive. He was suffering from bruising and shock, he was taken by ambulance to RAF Acklington via Longhorsley police station.

At 11.15 p.m., the remains of a Defiant, single-engined fighter plane were discovered at Beacon Hill Farm, in the occupation of Major W. R. Stowell, Harelaw, Longhorsley, Map Reference 630119 (British Cassini Grid).

The wreckage of the aircraft covered 36 yards, the dead body of the pilot, R/73306 Sgt F. E. Haines, aged 19, was also found at the site; his body was later removed to Morpeth mortuary. Both crew were RCAF, from RAF Drem, Edinburgh.

One ewe, property of Major Stowell, was injured when the plane crashed.

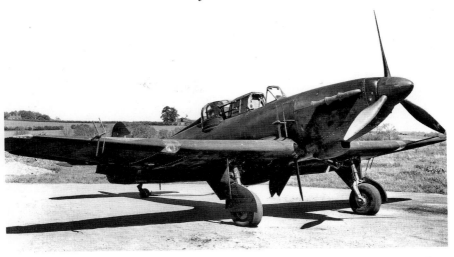

Boulton Paul Defiant in night camouflage. (Les Whitehouse, Boulton Paul Association)

October 2010

A simple and free method for converting British Cassini Grid references is the use of a good website called 'Where's the Path'. This site offers links for 1:50,000 Ordnance Survey maps which you can cross-reference with maps from the 1930s and 1940s. You can even split your monitor to show both at the same time.

Having a Cassini Grid reference, I matched the OS map and the 1940s maps. There was a difficulty: the 1940s map on the web site was slightly different to the 1940s Home Office OS map that I have. They are close, but the grid lines are slightly out of sync on the screen compared against my OS 1940s map.

I resolved this by checking the features of my OS 1940s map with the features on my screen. Placing my mouse arrow on the feature on the screen that matched my map, this is then replicated on the modern 1:50,000 map. The system gave me the ten figure grid reference on the modern map; this, I hoped, would put me to within ten to fifteen metres of the exact location.

I now had the site in the middle of a field, next to a road, to the west of Beacon Hill Farm.

21 October 2010

On 16 October, I had contacted Clare Moore, the owner of Beacon Hill Farm, to arrange access to the site. Explaining who I was and what I was researching, Clare asked where I thought the site was. I told Clare I believed the site was to the west and two fields from her farm, the field with a small copse in the corner,

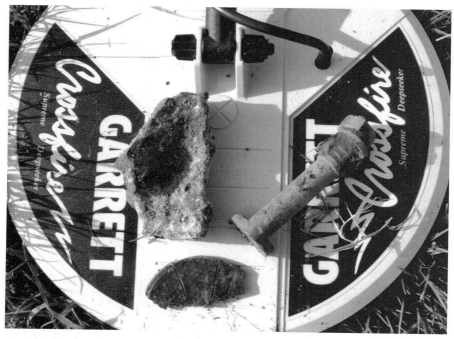

Fragments from N3364, 21 October 2010. (Author)

next to the road. Clare confirmed that was where she believed an aircraft had crashed during the Second World War. I arranged to visit the site on 21 October, my next day off work.

I arrived at Beacon Hill Farm at 9.15 a.m. with my air-crash-hunting poodle Penny, and also under training, Daisy. The forecast was for a cold northerly wind, brightening up by lunchtime. After a brief chat with Clare, all three of us headed towards the West Field. Clare was cantering her horse in the same field, so for the time being, access was restricted for Penny and Daisy until 10 a.m.

Having pinpointed an area in this field approximately 100 metres from the road, I started my search in the far west corner of the field; as with all the low ground sites I have visited, I expected to find more agricultural debris than aircraft wreckage.

After two hours on site, and many readings for metallic objects, I picked up a positive signal for what I expected to be alloy. At 11.35 a.m., I uncovered the oxidised remains of N3364's engine casing, typical of various sites I have searched. This was a positive indication of the exact crash site; I noted I was 135 metres from the road (not bad, as I had gauged 100 metres). I searched the perimeter 30 metre circle around my find (remember, the police report noted wreckage over 36 yards, approximately 30 metres), producing an indication of wreckage in this area. Penny and Daisy went straight into investigation mode when I started digging.

Daisy and Penny guarding fragments from the wreckage of N3364. (Author)

I have to admit at this point that Penny is more enthusiastic than Daisy; Penny kept checking on her location, bringing her towards each piece I excavated.

I revisited the site on 25 October. Only when on site can you see evidence of a crater; this is not clear to the eye, but visible. I completed a thorough search of the site, with only a few fragments being unearthed. Before leaving, I placed a Remembrance Cross at the gate to West Field.

Official Documents

Morpeth Police records held at Northumberland County Archives, Woodhorn Museum, Ashington, listed Boulton Paul Defiant N3364 as crashing on Beacon Hill Farm, Morpeth, on 28 March 1942.

The F1180 (Loss Card) for this aircraft gave an approximate date of the crash as 26 March 1942 and records the site as Haredean, 6 miles north-west of Morpeth. I can only surmise that the difference in dates between the police and RAF reports is an error in the police record.

410 (Cougar) Squadron: the History, completed by an anonymous author under the title 'The Air Historian', records the crash of N3364 as 27 March 1942.

My reference books also matched the same aircraft, listing the names of the crew, with the date of 26 March 1942.

I next contacted the National Archives for copies of the 410 Squadron Operational Records Book (ORB), which came under AIR 27/1802 for March 1942. The UK National Archives have recently introduced an extortionate price increase for providing copies of documents. Thanks to Edgar Brooks, I was provided with the 410 Squadron ORB. The ORB records the crash of N3364 as 27 March 1942; it also records the Observer/Air Gunner as F/Sgt J. G. Pelletier. Morpeth Register Office confirmed the name of R/73306 Sgt Frank Ernest Haines, RCAF, age 19, 26 March 1942; this I cross-referenced with the Commonwealth War Graves Commission. The Registrar has the deaths of the crew recorded as Beacon Hill Farm. The Register of Burials (War Graves) for Chevington Cemetery records the death of Sgt Haines as 26 March 1942, but the site as Haredene. The Commonwealth War Graves Commission also records this as 26 March 1942.

I checked the Canadian Virtual War Memorial site; this confirmed the death of Sgt Frank Ernest Haines RCAF, 26 March 1942.

I contacted Les Whitehouse, archivist for the Boulton Paul Association. He confirmed the details of N3364.

All this provided a bit of a headache. I now had three different dates, 26–28 March (all official documents), and three different spellings of the Observer/Air Gunner, F/Sgt H. E. Pallatiel, F/Sgt H. E. Pelletier and F/Sgt J. G. Pelletier.

A Brief Account of the Crash

410 (Cougar) Squadron had been formed on 30 June 1941. Previously, on 6 April 1941, Canadian Defiant crews of 151 Squadron had been posted to 410 Squadron, despite their vigorous protests.

Boulton Paul Defiant N3364 took off from RAF Drem, Edinburgh, at 20.45 hours. It was piloted by Sgt F. E. Haines and his Observer/Air Gunner was F/Sgt J. G. Pelletier. They were on a routine night patrol over the north-east of England, and were ordered to wait over the base for raiders. Due to thick fog and cloud, with their receiver and blind flying instruments out of order, the crew were lost. Losing control of the aircraft, N3364 went into a steep dive; F/Sgt Pelletier bailed out, parachuting down near Haredene, near Longhorsley, sustaining minor injuries after being struck by the tail of the aircraft. N3364 crashed at 22.30 hours. Nothing was heard from N3364 until 22.50, when control at RAF Drem was informed that Sgt Haines had ordered his gunner to bail out.

Sgt F. E. Haines died in the wreckage of his aircraft, 300 metres to the west of the main farmhouse at Beacon Hill Farm, six miles to the north-west of Morpeth.

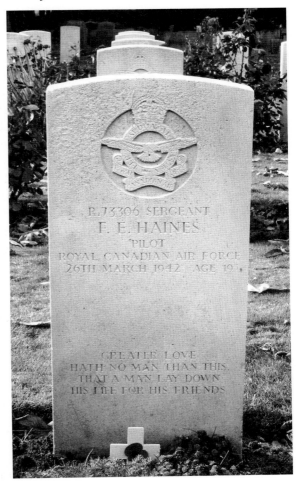

Gravestone of Sergeant F. E. Haines. (Author)

Confirmation of the loss of Sgt Haines and N3364 reached RAF Drem at 02.00 hours.

The funeral of Sgt F. E. Haines took place at 14.00 hours on Monday 30 March 1942, at Chevington Cemetery, Red Row, Northumberland, conducted by Revd J. Whinbread.

P/O D. B. Freeman, RCAF pilot, and F/Sgt E. Torby, RCAF Air Gunner, were present as 410 Squadron representatives.

The epitaph on his headstone reads:

Greater love hath no man than this that a man lay down his life for his friends.

Sgt F. E. Haines: Section H, Grave 202, Chevington Cemetery, Red Row

The Site of the Crash

Boulton Paul Defiant N3364 RAF Drem

Pilot:	R/73306 Sgt Frank Ernest Haines, RCAF, age 19 +
Obs/Air Gunner:	R/5373 F/Sgt J. G. Pelletier, RCAF, age unknown, i
Squadron:	410 (Cougar) Squadron, RAF Drem
Site:	West Field, Beacon Hill Farm, Morpeth
Grid:	NZ14316 91430
Map:	OS Explorer 325
Note:	Small fragments remain buried at this site

Bibliography

Eden, Paul, *The Encyclopedia of Aircraft of the Second World War*
Walton, Derek, *Aviation Diary of Northumberland 1790–1999*

Reference

410 (Cougar) Squadron, The History June 1941 to June 1945, Norman Malaney, Manitoba
AIR 27/1802 - 410 Squadron ORB, Copy provided by Edgar Brooks
Canadian Virtual War Memorial
Clare and Edward Moore, Beacon Hill Farm
F1180 - Loss Card
Google Earth
Les Whitehouse, Boulton Paul Association
Military Aviation Museum, Canada
Morpeth Station Police Occurrence Book
Mrs Joan Rose, Northumberland and Durham Family History Society
Ordnance Survey Maps
Penny & Daisy
RAF Commands website – www.rafcommands.com
Register of Burials (War Graves) Chevington Cemetery
Robert Nixon
'Wheres the Path' mapping service

AUTHOR'S NOTE

The following two chapters are of the tragic events witnessed and recalled by Basil Oliver, a young horseman working at Langleeford, Wooler, aged fifteen in 1944.

I have visited the sites several times, including following the routes the rescue team used.

Of the four shepherds and three hired lads who were involved in the rescue and recovery of the crews of Short Stirling EE972 OG-C and Avro Lancaster KB745 VR-V, four reached retirement age.

William Brown (Langleeford) died age 64
Robbie Brown (Langleeford Hope) died age 86
William Redpath (shepherd householder, Langleeford)
Tommy Douglas (Langleeford shepherd, hired lad)
Sidney Telfer (Langleeford Hope, hired lad)
Basil Oliver (Langleeford, horseman, hired lad)

To date, 1 December 2012, only Basil Oliver remains. Basil celebrated his eighty-third birthday on 12 April 2012.

SHORT STIRLING EE972

Short Stirling Mk III EE972 OG-C
1655 Heavy Conversion Unit
RAF Tilstock

Cheviot Summit
25 September 1944

The following story is written in the exact words as told to me by Basil Oliver.

The final flight of RAF Short Stirling bomber EE972 on 25 September 1944 ended on Cheviot summit with the death of three crew members. Two died on impact of the aircraft and one died four days later from severe head injuries. One of the crew was unconscious but later recovered without serious injury, suffering concussion.

Along with five other shepherds, I was involved in the rescue of the crew; this is a true record of the episode as I remember it.

At about 4 p.m., I was travelling from Langleeford to Langleeford Hope. I met with two pilots, who told me they had crashed a bomber on a hill top. They had followed a small creek until they met me. I took them back to Langleeford and a rescue party was formed. The information on the crash site was misleading: we had to follow the route taken by the airmen instead of the most direct route.

The rescue party was made up of the local shepherds, the names are as follows: William and Robbie Brown (the two Brown brothers were the tenant farmers at Langleeford and Langleeford Hope respectively), William Redpath (Shepherd householder, Langleeford), Tommy Douglas (Langleeford Shepherd, hired lad), Sidney Telfy (Langleeford Hope, hired lad) and Basil Oliver (Langleeford, horseman, hired lad).

The information given to us by the student pilot was that they were on a training flight, with a crew of nine, from Andover in Hampshire to a turning point in Galashiels and the Eildon hills. On the return flight, the navigator told the pilot he believed they were slightly off course. The pilot told the student to lift her up to 3,000 feet to clear all the high hills in the area. He then saw what he thought was hail, streaking past underneath the aircraft, when he realised it was the hill top. The aircraft belly-flopped and broke in two

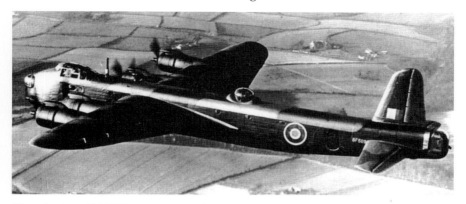

Short Stirling. (RAF Museum Hendon)

halves, the front of the aircraft turning back on its self. They made sure that all the crew were accounted for. The remaining crew members were left in the front section of the aircraft and parachutes were draped over the open end so they could shelter behind. Two pilots left the site to find help.

The two pilots, who I met coming from the direction of Langleeford Hope, did not stagger shocked and stunned into the farm, as some accounts have misquoted me as saying. They were very calm but subdued; they gave us a full report of the flight and the crash.

They returned with us to the crash site, a distance of four to five miles, taking a full part in the rescue of the two men who were more seriously hurt. Four of the uninjured crew took turns with us carrying the stretchers. One man had an injured knee; he used two shepherd's crooks as crutches, and he was helped by those taking a rest from carrying the stretchers. It was a slow journey, made worse by it starting to rain around midnight.

We arrived at Langleeford Hope around 2 a.m. We were met by RAF personnel and the fire service and the local police, who wanted someone to take them to the crash site. One police inspector got quite officious when we all refused, very impolitely (of course), to obey his commands; he would have to wait until daylight, after we all had had a rest.

I returned to the crash site the next day with the RAF and the police to recover the bodies of the two dead crew members from the site. It was the first time I had seen a dead body; I was only fifteen years old. It was quite a shock to me. When we discovered the body of the bomb aimer, he was half buried under the nose of the aircraft, with his head split open. The other man appeared undamaged, lying next to the side of the fuselage.

One of the sad things about this crash was that most of the day the skies had been clear with fluffy high clouds, but Cheviot started to cloud up in the afternoon. A light mist had started to build up on the summit, enough to cover

The author with a piece of engine cowling from EE972. (Author)

the very top for a time. During this time, the aircraft flew into the hill. The cloud lifted and the hill was clear later in the afternoon (after the crash).

The student pilot explained that at first, he thought they had collided with another aircraft, as several had had been flying the same route all day. He was serving with the Royal Canadian Air Force, on a training course for conversion to four-engine bombers. The instructor was from the Royal New Zealand Air Force and the rest of the crew were a mixture of allied aircrew.

Official Documents

Checking my local reference books, I found several variations of the crash, but all confirmed that EE972 had crashed on the summit of the Cheviot.

The National Archives provided the relevant entries from the 1655 HCU ORB, which located the site as Cheviot Hill, Northumberland.

Morpeth Registrar Office provided entries for the crews' death certificates. The location was recorded as 'Cheviot Hill, Selby's Forest'. This threw me for a while, as there is no 'forest' on the Cheviot massif. I contacted Walter Brown at Langleeford, who explained that the 'forest' was the Scottish word for a tract of land. Selby's Forest covered the area from Langleeford over to the College Valley, where the March (border) changed to Gray's Forest.

An oil cooler from EE972. (Author)

A Brief Account of the Crash

On 25 September 1944, Short Stirling EE972 OG-C, of 1665 Heavy Conversion Unit, 38 Group, was set for a cross-country training flight. The crew consisted of F/O J. H. Verral DFC (Instructor Pilot), F/O E. F. Insley (pupil pilot), F/Sgt P. S. Coronel (navigator), F/Sgt D. C. McLackland (A/B), Sgt D. C. Bisgrove (FE), Sgt T. K. Hatfield (2nd FE), WO J. A. Hay (W/Op), WO P. A. Allen (A/G), and Sgt A. Williams (A/G).

Leaving from RAF Tillstock, Shropshire, their intended course was to head towards a turning point at Galashiels, then over the Eildon Hills and turn towards their base. Realising they were in an area of high ground, and in low cloud, they tried to climb to a height of 3,000 feet. EE972 collided with the summit of the Cheviot massif, resulting in F/Sgt Coronel and F/Sgt McLackland being killed outright; Sgt Allen died on 29 September 1944 of his injuries.

Once all the crew had been accounted for, F/O J. H. Verral and F/O E. F. Insley left the site, following the Kadler Sike to the Harthope Burn, meeting with Basil Oliver between Langleeford Hope and Langleeford.

The 1665 HCU ORB entry for 25 September 1944 notes:

Stirling aircraft EE972 piloted by F/O J G VERRALL was involved in a flying accident. Two members of the crew were killed and the remainder injured.

Owing to the condition of the pilot no report on the cause of the accident is yet available. Information suggests that the aircraft struck a hill whilst cloud flying in the neighbourhood of the Cheviots. An investigation is being held.

The wreckage was recovered by 83 Maintenance Unit; the team sent to recover this wreck started by rolling two of the engines down Kadler Sike (what they believed was the easiest way, but it proved to be the hardest route). Ten days later, the recovery operation was taken over by another team tasked to recover Lancaster KB745 which had crashed at Goldsclough Burn Head, 1 km to the east.

Note: It is presumed the crash happened between 1 p.m. and 2 p.m. (taking into account the distance and time to travel from the site to seek help and meeting up with Basil Oliver).

F/Sgt P. S. Coronel: Section E, Row E, Grave 14, Harrogate (Stonefall) Cemetery
F/Sgt D. C. McLackland: Section P, Grave 300, Edinburgh (Seafield) Cemetery
WO P. A. Allen: By Vestry Door, Tilford (All Saints) Churchyard

Flight Lieutenant John Henry Verrall, DFC. Extract from his Distinguished Flying Cross Citation, 16 November 1943.

[214 Sqn RAF (Stirling)] A determined and skilful captain of aircraft, Pilot Officer Verrall has successfully attacked some of the enemy's most heavily defended targets always displaying the greatest determination to press home his attacks. On two occasions he cleverly out-manoeuvred enemy night fighters, without any damage to his aircraft.

F/O E. F. Insley, RCAF, was seriously injured while serving with 190 Squadron, 11 May 1945.

WO2 J. A. Hay, RCAF, was injured while serving with 190 Squadron, 11 May 1945

The Site of the Crash

Short Stirling Mk III EE972 OG-C RAF
Ins. Pilot: NZ415044 F/O John Henry Verrall, DFC, RNZAF, age unknown
Stud. Pilot: F/O E. F. Insley, RCAF, age unknown

Flt/Engineer:	Sgt D. C. Bisgrove, age unknown
Flt/Engineer:	Sgt T. K. Hatfield, age unknown
W/Op - Air Gnr:	R/138525 WO2 Joseph Arthur Hay, RCAF, age unknown
Air Gnr:	Sgt A. Williams, age unknown
Nav/B:	AUS427502 F/Sgt Paulus Senor Coronel, RAAF, age 29 +
Air/B:	1477936 F/Sgt David Colville McLackland, RAFVR, age 31 +
Air Gnr:	1180034 WO Peter Anthony Allen, RAFVR, age 22 + died 29/09/1944
Squadron:	1665 Heavy Conversion Unit, 38 Group
Site:	Cheviot Summit
Grid:	NT91077 20680
Map:	OS Outdoor Leisure 16
Note:	Evidence of this aircraft is still present at the site (oil cooler and fragments), also at Grid Ref; NT 91354 20035 (engine cowling and gear box)

Bibliography

Chorley, W. R., *Bomber Command Losses Vol. 8*
Chorlton, Martyn, *Airfields of North-East England in the Second World War*
Clark, Peter, *Where the Hills Meet the Sky*, 1st and 2nd edition, Glen Graphics, 1997
Earl, David W., *Hell on High Ground Vol. 1*
Walton, Derek, *Northumberland Aviation Diary 1790–1999*

Reference

AIR 29/614 – 1665 HCU, ORB
AIR 28/803 – RAF Tilstock ORB
Basil Oliver
Commonwealth War Graves Commission
Dennis Gray
Google Earth
Ian Hunt
Mike Hatch Air Historical Branch
Mrs Joan Rose, Northumberland and Durham Family History Society
Ordnance Survey Maps
RAF Commands website www.RAFcommands.com
Walter Brown

LANCASTER KB745

Avro Lancaster Mk X KB745 VR-V
419 (Moose) Squadron
RAF Middleton-St-George

Goldsclough Head Burn
Cheviot
4 October 1944

This is the first-hand account of Basil Oliver as he remembers it. Basil was the first on scene, finding the aircraft still smouldering on the hillside.

5 October 1944 started with a bright sunny morning. I left Langleeford at around 8 a.m. For several days the weather had been mostly fog. I was sent up the north side of the Harthope valley, up a hill known locally as Allis Struther, coming within full sight of the Cheviot, to 'look the ewes'. This hill forms part of the Cheviot itself.

I saw the crashed bomber about a mile or more away, on the part of the hill known locally as Goldsclough Burn Head. It was obvious that according to the contours of the land, any survivors would have moved into the College Valley, so I decided to investigate it.

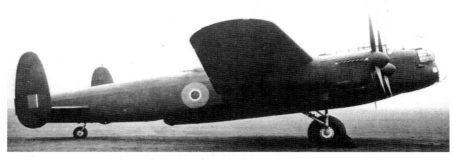

Avro Lancaster Mk X. (RAF Museum Hendon)

Arriving at the scene, my first sight was the rear gunner. He was dead, and lying as if he was asleep. I noticed his bright blue clear eyes; his body seemed undamaged. He was clear of his turret, and appeared to have climbed out and collapsed. I realised I was in for more than I bargained for, finding a further six bodies; some of these were badly mutilated. I twice travelled the length of the crash site, making sure no one was trapped and still alive. I found no survivors. The worst part was to find my dog chewing on one man's shattered leg; another one had his bowels dragged out; another was practically unrecognisable – his body was rolled up like a meatball, flesh and flying suite rolled up together – I am unsure of his position in the aircraft.

Having found there was nothing I could do, I ran all the way back down to Langleeford. I told the other shepherds what I had found. Then I cycled up to Middleton Hall to telephone the local police. I was picked up by the fire service and taken back to Langleeford. I took the police and the firemen up to the crash site.

The crash recovery crew from the Stirling bomber had arrived at the scene when I got back to the site. The two policemen I took to the site were PC Harold Winchester and War Reserve PC John Ellliot.

I was interviewed by two RCAF officers from the bombers' course at RAF Middleton-St-George and made a signed statement two days later.

For weeks afterwards I could see the bodies, in my mind. I do suffer from 'flashbacks'. Nowadays, I would have received counselling. All I got was 'pull yourself together and get on with your work'. Being in lodgings there was no one to talk to, give me a hug or a little sympathy. Even today, after sixty-five years, the scene is imprinted on my memory like a photograph, and comes into my head several times a day.

After the crash, the shepherds who went to the site after I had told them never talked about it, or discussed their feelings! These same lads took part in the rescue of the crew from the Stirling some ten days earlier.

Later the same day, I met with the Armaments Officer from RAF Milfield. He was to check the Stirling bomber for live ordnance, but mistook the Lancaster site for the Stirling site. His driver, a WAAF, ACW, went with him to the site. They returned the next day. His driver stayed with the car at Langleeford – she was asleep in the car. She was a local lass from the Berwick area; the shepherd at Langleeford invited her into the farmhouse for a fry-up and a sleep in comfort and she settled on the settee.

I met with her once again, years later, on 19 March 1995, as we were both invited to attend the memorial service and unveiling of the RAF Memorial at Cuddystone Hall in the College Valley. We had had a long talk. She told me that the thing she remembered most of the incident was the 'clear blue eyes of the rear gunner'. Later the same day, I was on BBC television, *Look North*. I had been interviewed at home two days before the unveiling by a TV crew;

that was my few minutes of fame! I had also been interviewed by BBC Radio reporter Barbara Henderson for BBC Radio Newcastle.

Over the two years I have talked to Basil, we tried to identify the WAAF driver. Various names were passed back and forth, but no positive lead could be found. After the memorial for Wellington R1535 GR-G, held on 13 November 2010, we waited for the local press releases. On Thursday 18 November, Basil called me as he had a copy of the *Berwick Advertiser*, which had published a very good article about the memorial service. The paper also ran stories of other events held on Remembrance Sunday. There was a picture published next to ours, regarding the Milfield Gliding Club service (the former RAF Milfield); Basil instantly recognised the woman in the picture – it was the WAAF we had been looking for, Mrs Linda Faragher. The article provided a contact area and Basil got in touch with Linda and confirmed she was the WAAF we were looking for.

Account of Florence Linda Faragher, *née* Sanderson

On 1 October 1943, Linda Sanderson had been promoted to Leading Aircraft Woman (LACW) within the Motor Transport Unit (MTU) at RAF Milfield. Part of her duties was to drive the recovery units, six to eight men, to the crash sites in Bedford or Fordson trucks.

Linda had already been to the site of Short Stirling EE972 OG-C, which had crashed on Cheviot massif on 25 September 1944.

Linda recalls spending the day at Langleeford; what stands out in her memories is that she was allowed to sleep on a red velvet settee, and that morning she was given a huge boiled egg for breakfast by someone she presumed was Basil's mother, but was in fact his landlady.

LACW Florence Linda Sanderson, WAAF

I was detailed as driver to the Armaments Officer, and on reporting to the Armoury was told to drive him to a crash site on Cheviot. He had to check a Stirling bomber that had crashed there a fortnight earlier for any ammunition. I drove him to his house so he could change to heavier shoes, and then to Langleeford. It was a beautiful day, and I asked if I could go up the hill with him, as I'd always wanted to climb Cheviot.

We set off behind Langleeford farmhouse and climbed steadily. We hadn't gone far when we were surprised to see the wreckage of a plane ploughed into the hillside well above us. I said, 'But that's not it; it should be further on than that'; the Armaments Officer said, 'It shouldn't be there, it should be further over.'

Realising it was a recent crash, we made for it as fast as we could. As we neared it, I called to the crew, 'It's all right, we're here,' before I saw they were all dead. There was one body clear of the tail; this was the rear gunner. He was lying on his back, looking quite peaceful, with a slightly surprised look on his face, almost as if he was pleased to see us. It was difficult to believe he was dead. He was not wearing a flying helmet, and his fair hair looked as if it had just been combed; his eyes were exceptionally blue. I noticed a comb sticking out of his pocket, just below his RCAF A/G half-wing. I tried to count the rest of the bodies as the Armaments Officer checked for bombs and live ammo, but the main part of the fuselage and the bodies in it were badly smashed. I thought there were seven bodies, but there were only six. I looked down towards Southern Knowe and saw the Crash Party making its way up the hill, so I went back to my vehicle to wait for the Armaments Officer.

At the Memorial Service on 19 May, I met the shepherd who, as a lad of 15, was looking at the sheep in the morning and had found the crashed plane. He too was amazed at how peaceful the rear gunner had looked – something which I have often thought about. He said there had been a small fire in the plane, but it had extinguished itself. When he saw that all the crew were dead, he had gone back down to Langleeford and then had cycled off to report the crash.

Official Documents

A quick check of my local reference books helped confirm that the site location was of Avro Lancaster KB745 VR-V. The RAF F1180 Loss Card records, 'The pilot had been briefed to fly at 2,000 feet on return, aircraft was 11 miles off track, suggests poor navigation, but AO I/C favours "poor captaincy" as navigator's assessments sound'.

The National Archives provided the ORB entry for 419 Squadron, which came under the reference AIR 27/1823. This located the crash site as Goldsclough, North Rothbury, Northumberland.

Morpeth Registrar Office was able to confirm the death certificates of all the crew; this resolved the ranks of the crew at the time of the crash, as three of the crew's ranks are different from the rank marked on their gravestones. R187513 F/Sgt William Russell Karstens, RCAF, R201765 Sgt Donald Alexander Trott, RCAF, and R188974 Sgt Thomas Bernard Tierney, RCAF. Their death certificates also record the crash site as being 'near Langleeford Hope, Selby's Forest'.

Harrogate (Stonefall) Cemetery, where most of the crew from Lancaster KB745 are buried. (By permission of the Commonwealth War Graves Commision)

A Brief Account of the Crash

Avro Lancaster KB745 VR-V, of 419 (Moose) Squadron, Royal Canadian Air Force, took off from its home base of RAF Middleton-St-George, County Durham, on 4 October 1944 with a crew of seven. The crew consisted of F/O G. R. Duncan (pilot), F/O W. G. Layng (navigator), F/Sgt W. R. Karstens (bomb aimer), P/O J. W. F. Hall (flight engineer), Sgt D. A. Trott, (air gunner – upper) and Sgt T. B. Tierney (air gunner – rear). P/O J. W. F. Hall was RAF, as at that time, the RCAF did not train flight engineers.

The raid consisted of 140 aircraft: 43 Lancasters and 93 Halifaxes. The target was the U-boat pens at Bergen, Norway. KB745 was planned to take off at 4.45 a.m., but the flight took off at 6.05 a.m. The weather over the airfield was 'low cloud and rain squalls'. This was a daylight raid and the squadron ORB records that 'the raid seemed well concentrated, and results seemed fairly good'. Local reports record that 'the surrounding dock facilities were seriously damaged, 3 U-boats were damaged along with 3 smaller auxiliary ships, two of which sank'. Bomber crews that took part in the raid were pleased with the 'cover 'provided by the fighter escorts.

Poole (Parkstone).
(By permission
of the
Commonwealth
War Graves
Commision)

All aircraft returned from the raid with the exception of one, KB745 VR-V. It was, at first, reported as having succumbed to enemy action on the return journey. No one knows why KB745 VR-V crashed into the side of Cheviot Hill, Northumberland, approximately 73 miles north of its intended course. The F1180 records as additional evidence, 'aircraft collided with high ground in low cloud and heavy showers'. There were no survivors; however, it is believed that the aircraft crashed at approximately 11.30 a.m. There was evidence of ordnance damage visible on the outer starboard engine of the aircraft, as a result of enemy fire.

The wreck was found by fifteen-year-old Basil Oliver, a 'horseman' at Langleeford on 5 October 1944, with all on board having perished.

All the crew are buried at Stonefall Cemetery, Harrogate, with the exception of Sgt T. B. Tierney, who is buried at Parkstone Cemetery, Poole.

Note: F/Sgt W. R. Karstens, Sgt D. A. Trott and Sgt T. B. Tierney were posthumously promoted to Pilot Officer. I do not know the criteria that were used for these promotions, but this would appear to be a common occurrence in late 1944 within the RCAF. Some sources maintain that these types of promotions were granted as the 'date of automatic promotion' was close to the date of death. RCAF personnel were promoted on average at six month intervals.

The Site of the Crash

Avro Lancaster Mk X KB745 VR-V RAF

Pilot:	J/35615 F/O George Ross Duncan, RCAF, age 21 +
Navigator:	J/38188 F/O William George Layng, RCAF, age 22 +
Wireless Op:	J/92361 (R187513) F/Sgt William Russell Karstens, RCAF, age 23 +

Bomb Aimer:	J/35101 F/O Andrew Gaddess, RCAF, age 21 +
Flight Engineer:	179851 P/O John William Frank Hall, RAFVR, RCAF, age 20 +
Air Gunner (Upper):	J/92914 (R201765) Sgt Donald Alexander Trott, RCAF, age 19 +
Air Gunner (Rear):	J/92476 (R188974) Sgt Thomas Bernard Tierney, RCAF, age 22 +
Squadron:	419 (Moose) Squadron RCAF
Site:	Goldsclough Burn Head, Cheviot
Grid:	NT91746 21291
Map:	OS Outdoor Leisure 16
Note:	Small fragments remain at the site

Bibliography

Chorley, W. R., *Bomber Command Losses Vol. 5*

Chorlton, Martyn, *Airfields of North-East England in the Second World War*

Clark, Peter, *Where the Hills Meet the Sky*, 1st and 2nd edition, Glen Graphics, 1997

Earl, David W., *Hell on High Ground*

Walton, Derek, *Northumberland Aviation Diary 1790–1999*

Reference

AIR 27/1823 – 419 Sqn, ORB

Basil Oliver

Canadian Virtual War Memorial

Commonwealth War Graves Commission

Dennis Gray

F1180 – Loss Card

Florence Linda Faragher, *née* Sanderson

Google Earth

Lancaster Archive Forum www.lancaster-archive.com

Mike Hatch, Air Historical Branch

Mrs Joan Rose, Northumberland and Durham Family History Society

Ordnance Survey Maps

RAF Commands website www.RAFcommands.com

RCAF casualty list No. 1019 (Ken Maclean)

Walter Brown